Internet Art

Internet Art
The Online Clash of
Culture and Commerce
Julian Stallabrass

Tate Publishing

Acknowledgments

This book was researched in part during the year
(1999–2000) I spent at Tate Britain on a fellowship
funded by the Paul Mellon Centre; I am very grateful
to both institutions. I have benefited a great deal from
conversations with many people: I would particularly
like to thank Alison Craighead and Jon Thomson who
patiently talked me through many of the issues of
Internet art. As I started out on what was new territory
for me, Heath Bunting and Rachel Baker gave me
helpful directions. I have also had some very useful
discussions with Josephine Berry, Sarah Cook, Honor
Hargar and Carey Young. Nicole Giles assisted me
with the research, and discussed many of the issues
with me – the book would have been poorer without
her. I am very grateful to Malcolm Bull, Sarah Cook
and Sandy Nairne who read versions of the manuscript
and made insightful criticisms and suggestions, and
especially to Eva Bensasson who did so in such detail.
I have also had much help from those associated
with the exhibition I helped to curate at Tate Britain,
from Alison and Jon again, and from Lise Autogena
and Joshua Portway, and James Wallbank of RTI.
My colleagues at the Tate were very helpful practically
and stimulating intellectually; special thanks to
Tim Batchelor, Stephen Deuchar, Mary Horlock,
Richard Humphreys and Sheena Wagstaff. Lastly,
thanks to all at Tate Publishing, especially my editor,
Judith Severne.

Contents

A New Art

To some surprise, online anti-corporate activists and pranksters RTMark – notorious for sponsoring, among many subversive acts, the swapping of voice boxes between GI Joe and Barbie dolls in toy shops – were selected for the prestigious Whitney Biennial in 2000. Like other participating artists, they were sent a package containing invitations to the event, including a letter implying that they were now part of the US art-world elite and would have the opportunity at the opening to schmooze with the top curators, collectors, dealers and art administrators. Rather than go along, RTMark sold the invitations through the auction site eBay.[1] They received $4,000, which went into their project fund.

This incident is symptomatic of the contentious relationship between the art world and the activist culture that has emerged online. It illustrates the attempts of the art institutions to co-opt parts of that culture by issuing an edict that elevates and brands it as art, and in the process limits its scope and character. It is also an indication of the suspicion felt by many online activists of the art world's archaic and elitist practices, which stand opposed to the apparently hyper-modern and democratic character of the Net. Yet, while some have argued that the two realms are simply incompatible, there has been

1 See RTMark's announcement posted on nettime, 9 March 2000.

increasing interchange between them, each side using the other to pursue their divergent ends.[2]

On the face of it, the great advantage of the Internet for artists, and for cultural and political agitators of all kinds, is that it cuts through the regular systems of media dissemination. Anyone with access to a networked computer can put work on the Net without the say-so of an art institution (public or commercial), and anyone with access to a networked computer can, in principle, take a look. Some of the art-world interventions in this area have had an air of desperation to them, a panicked rush to occupy a new and important territory, but also a glimmering realisation that the old rules of the game are changing, and the settled relations of power between artists and art institutions melting.

In a very brief period – at the time of writing, about seven years – Internet art has changed and developed dramatically, from being a minority pursuit practised and seen by a very small number of people to being a phenomenon that receives mainstream press attention, and is becoming a substantial presence in the art world. It covers a huge range of work, from slight but effective pieces in the form of pranks, hoaxes or jokes – scrawls across the face of the Net – to elaborate and earnest narratives in words and pictures;

from works of a new online formalism, to those that approach pure political action. Given this bewildering variety of form, content and technique, this book does not pretend to be a survey; rather it is an introduction that focuses upon one salient aspect of this art – its relationship to commerce, both the commerce of the online environment and that of the mainstream art world.

The question most insistently asked about this new art is both the simplest and the most difficult to answer: 'What is Internet art?' For the moment, this question will only be touched upon, though answers will begin to emerge throughout this account, and it will be explored in more detail near the end of the book. Given that the field is so new and changes so rapidly, the question cannot be answered without a detailed examination of the formation of Internet art as it currently exists. This account will take us through forms of Internet activity that are plainly and self-consciously art, but also into areas that are at the margins of art, or might only be taken as art by some viewers. Without the solace of objects and the sanction of art institutions, the boundaries of art (and even of the individual artwork) can be very hard to draw. What is more, there is a huge amount of art reproduced on the Internet that can hardly be counted as 'Internet art'. Among the computer's

2 For an argument claiming that the art world and digital art as a whole are fundamentally opposed, see Ewan Morrison, 'Ten Reasons Why the Art World Hates Digital Art', *Mute*, no.11, 1998, pp.23–5. This is, however, followed by an excellent article by Matthew Fuller elucidating the art world's love for digital art.

talents for simulation is the ability to replicate any reproductive medium, so that photographs, music and video can be placed on a Web page for publicity or sale. Bill Gates, for example, has spent hundreds of millions of dollars buying digital rights to pictures in assembling the collection of his company, Corbis, the world's largest image database.[3] So, given that it made sense to exclude, say, digital reproductions of Impressionist paintings posted on the Web, the first definitions of Internet art centred on the distinction of what was made specifically for the online environment.

Alexei Shulgin, one of the first prominent online artists, recounts a tale about the origins of what became widely known as 'net.art'. The story goes that Vuk Cosic (another 'pioneer', to revive a not entirely inappropriate avant-garde term) received a file consisting of scrambled ASCII characters, a common occurrence when there is some software incompatibility. Among the garbled letters, Cosic's eye lit upon the enticing conjunction 'net.art'. When the message was finally decoded, Shulgin says, it turned out to be much less interesting than the accidental syllogism it had thrown up, though he nevertheless offers apologies to 'future net.art historians' that it had been lost in a hard-disk crash.[4] In a striking reading, Josephine Berry argues that this story illustrates the Utopianism of the small group that came to adopt the name, for it was the computer itself that brought together the once-divided terms 'net' and 'art' (and by implication technology and culture) so that art may take on the Net's power over reality, while the Net could acquire art's capacity for revelation.[5]

While computers are agile in the realm of simulation, digital technology is not merely a matter of reproduction but just as importantly of production. If modernism was most strongly associated with new technologies of mass-production that had a profound impact on everyday life (such as electric lighting, cars, planes and ocean liners) and postmodernism with new technologies of reproduction that transformed domestic life (above all, television), then the new era is brought into being by their synthesis.[6] To take effective action online is to gain power that can have immediate consequences in the offline world. The emergence of art on the Net hands back to artists a prize and an obligation long since surrendered in liberal societies in favour of artistic licence and cottage-industry production values: an explicit social role.

To write about art on the Internet is to try to fix in words a highly unstable and protean phenomenon. This art is bound inextricably to

3 On Corbis, see Ernst Schmiederer, 'All Power Proceeds from the Picture', in Gerfried Stocker/Christine Schöpf (eds.), InfoWar, Springer, Vienna 1998. The site is at www.corbis.com
4 Alexei Shulgin, 'Net.Art – The Origin', posting on the mail forum, nettime, 18 March 1997.

5 Josephine Berry, 'The Thematics of Site-Specific Art on the Net', PhD thesis, University of Manchester 2001; www.daisy.metamute.com/ ~simon/mfiles/mcontent/ josie_thesis.htm
6 For this view of the division between modernism and postmodernism, see Perry Anderson, The Origins of Postmodernity, Verso, London 1998, pp.87–9.

the development of the Internet itself, riding the torrent of furious technological progress that brings back into illumination antique visions of modernism, torn from matter and hurled into the ether, and so made suddenly and curiously new. Until returning to the subject near the end of the book, this is all I shall say about the definition of Internet art. 'Art' itself is a term of dispute – rejected by some of those who have been called 'net artists' – and it is only used here tentatively, as a term of convenience under which a number of phenomena can be examined. Its coherence can only be judged later. 'Net.art' is a term that has become associated with a small group of early practitioners and a particular style, and it cannot be applied to online art as a whole. I will therefore use, as I say without wanting to make great claims for the term, 'Internet art'.

Before moving into an account of Internet art itself, there are a few more words that should be said about the approach taken here: about real and imagined futures, about the visual arts and other media, and about books.

With the convergence of a number of emerging technologies and bodies of knowledge – genetic manipulation, nanotechnology, quantum computing and the brain sciences – many theorists and futurologists have made Utopian pronouncements about the merging of humans with their digital creations, of augmented and artificial intelligence and even of the rise of a global collective consciousness.[7] Others warn of dangers equal in magnitude to these promises – of a runaway technology capable, for example, of transforming the entire planet into a homogenous, organic dust.[8] If these prospects are not imminent, they are probably a mere generation distant. In the meantime, it is clear that computer communication is expanding from personal computers to take in devices with embedded chips and wireless links (first mobile phones and security monitors but soon all manner of household appliances, clothing and consumer goods) further eroding the porous distinction between online and offline worlds.

My aim in this book is not to gaze into possible futures, as cyber-theory often does, but as much as possible to focus on the present and the immediate past of Internet art. As it currently exists, this art is the most conceptually sophisticated and socially conscious area of contemporary practice. While art on the Net can seem to be all bottled-up potential, ready to be released with the next technological wave, its current condition has no need of the crutch of an imaginary future.

7 For a powerful and informed account, see Ray Kurzweil, *The Age of Spiritual Machines: How We Will Live, Work, and Think in the New Age of Intelligent Machines*, Orion Business Books, London 1999.

8 A recent article in *Wired*, warning of such dangers, caused much controversy because it was written by someone with extensive knowledge of the potential of these technologies: Bill Joy, a co-founder of Sun Microsystems. See 'Why the Future Doesn't Need Us', *Wired*, April 2000; available at www.wired.com

To say that the Internet is a method for exchanging data is to say little about the character of that data. As we shall see, the Internet is not a medium, like painting, print or video, but rather a transmission system for data that potentially simulates all reproductive media. There has emerged on the Net a fast-developing scene not just of visual art but also of hypertext narrative, music, radio and video. Attempts are being made to create reproductive media that will cater to the neglected senses of smell and touch. This book will, however, concentrate on fine art because in this area the Internet poses a particular challenge.

In his short book, *Behind the Times*, Eric Hobsbawm convincingly argues that fine art has condemned itself to cultural marginality by refusing fully to embrace reproducibility.[9] While literature, music and film are industrially reproduced and widely owned, fine art has stuck to craft production and archaic systems of patronage. Internet art has the ability to change this, and it is hard to imagine that the art world will be able to continue with its old ways in the face of this wave of modernisation (though elements within it will no doubt strenuously try). The art world is in an analogous situation to an economy, long sunk in static agrarian activity, that finds it has the opportunity, not to follow through the stages that led the first industrialised countries to modernity, but to leap right over them into the present.[10] The consequences are likely to be profound and destabilising.

A series of pages on Vuk Cosic's site advertise some products that do not as yet exist, monographs devoted to the most prominent figures of net.art – Jodi, Heath Bunting, Alexei Shuglin and himself (visitors to the site are advised to contact Keiko Suzuki to order copies – we will come back to 'her' later). [001] Cosic writes, 'The collection "Classics of Net.art" was created because books are an unparalleled medium for the delivery of high-thought content.'[11] And this sly comment does smartly raise the issue: why write a book about Internet art?

Unsurprisingly, most information about art on the Internet is to be found online – in curated sites like Rhizome, in online magazines such as *Telepolis*, and in mailing forums, past and present, particularly nettime, Syndicate and 7–11.[12] There is also a little in print magazines such as *Mute* and a small though fast-growing amount in books.[13] Furthermore, the images you see in this book are highly inadequate representations of the art, much more so than photographs of painting, sculpture or even video. In an introductory article to Internet art, Rachel Greene warned that her accompanying

9 Eric Hobsbawm, *Behind the Times: The Decline and Fall of the Twentieth-Century Avant-Gardes*, Thames and Hudson, London 1998.
10 This type of situation was analysed by Trotsky as 'combined and uneven development', drawing on the exposure of agrarian Russia to Western industry. See Leon Trotsky, *The History of the Russian Revolution*, trans. Max Eastman, Pluto Press, London 1977, vol.1, chap.1.

11 Vuk Cosic; www.ljudmila.org/~vuk/books/
12 Even sites that are no longer current leave archives on the Web. I will be quoting from BBS postings, many of which were written as rapid interventions into a debate, often by people working in their second or third languages. Rather than litter the text with 'sics', where obvious grammatical and spelling mistakes are present that do not make the meaning questionable, I have corrected them silently.

13 Among the most useful books are Tilman Baumgärtel, *net.art – Materialien zur Netzkunst*, Institut für moderne Kunst, Nuremberg 2000; Peter Weibel and Timothy Druckrey (eds.), *net_condition: Art and Global Media,* The MIT Press, Cambridge, Mass. 2001; Vuk Cosic, *Net.art Per Me*, MGLC, [no place of publication] 2001. Useful sections on net art can be found in the following: Timothy Druckrey and Ars Electronica (eds.), *Ars Electronica: Facing the Future:* *A Survey of Two Decades*, The MIT Press, Cambridge, Mass. 1999; Josephine Bosma et al. (eds.), *Readme! Filtered by nettime: ASCII Culture and the Revenge of Knowledge*, Autonomedia, Brooklyn 1999; Lev Manovich, *The Language of New Media*, The MIT Press, Cambridge, Mass. 2001.

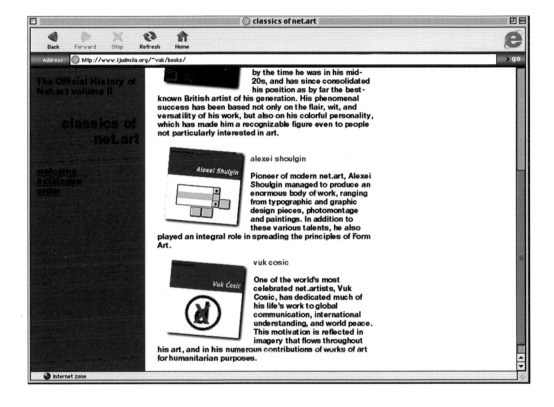

classics of net.art

The Official History of
Net.art volume II

**classics of
net.art**

welcome
catalogue
order

by the time he was in his mid-
20s, and has since consolidated
his position as by far the best-
known British artist of his generation. His phenomenal
success has been based not only on the flair, wit, and
versatility of his work, but also on his colorful personality,
which has made him a recognizable figure even to people
not particularly interested in art.

alexei shoulgin

Pioneer of modern net.art, Alexei
Shoulgin managed to produce an
enormous body of work, ranging
from typographic and graphic
design pieces, photomontage
and paintings. In addition to
these various talents, he also
played an integral role in spreading the principles of Form
Art.

vuk cosic

One of the world's most
celebrated net.artists, Vuk
Cosic, has dedicated much of
his life's work to global
communication, international
understanding, and world peace.
This motivation is reflected in
imagery that flows throughout
his art, and in his numerous contributions of works of art
for humanitarian purposes.

illustrations, torn from the Web, were like animals in a zoo.[14] In fact, they are even more confined and rigid than that. Isolated and deprived of interactivity, they are like the still and lifeless shells of taxidermy (there is an equivalent to zoo animals in various gallery exhibits of Internet art, but we will come back to those). The advantage of writing about Internet art online is that you can link directly to the works and to other texts, you can revise frequently and quickly in attempting to grasp this rapidly moving art, and most important of all, you can elicit immediate feedback.

So why write a book? First, because the book's very fixity confers advantages. Books abide for centuries, while the Web is like foam, its pages almost as transient as bubbles. I hope that a condensed and fixed account – imperfect and partial as it must be – can offer a distinct perspective and have a distinct use. Second, reading on the Web, currently from screens and perhaps on metered time, encourages a more hurried and instrumental type of attention than reading from paper.[15] Writers modulate their texts accordingly, and do so with the thought that they are brief interventions in an ongoing discussion rather than enduring statements.[16] Reading tends to be in bursts, skimming the surface of a text; writing tends to be telegraphic and is often

tailored to very well-informed insiders. Third, and most important, the Net is of great significance to everyone, whether they spend time online or not; Internet art is notable as a model of an emerging online culture, and for the incisive and complex statements it makes about the Net and its connection to the offline world. Yet many people, even those with Internet access, have little awareness of this art. So books, which do not require computer hardware and software, power supplies and telephone lines, and are indeed still the 'unparalleled medium for the delivery of high-thought content', have a contribution to make.

In the nettime debate over the term 'net.art', Alexei Shulgin argued that the neologism had its uses as long as the phenomenon did not gain acceptance in the galleries and the academies. He predicted (tongue in cheek) the emergence of Net art stars and poor but uncompromised Net legends, of Net art galleries, magazines and university departments, and finally of the writing of a 'few net art histories (contradictory, each describing completely different picture)'.[17] Perhaps this was not simply cynicism about the output of historians but also a comment about the character of the subject. This book will no doubt soon be contested by other accounts, for I am acutely aware that it casts a singular conceptual

14 Rachel Greene, 'Web Work: A History of Internet Art', *Artforum*, vol.38, no.9, May 2000, p.162.
15 This situation may change before too long: software displays that make electronic text more readable are already available, while screens that behave like fabric are at prototype stage; unmetered Internet access is becoming more common.

16 On this issue, and for example, the effectiveness of bulleted lists in website design, see the articles by Jakob Nielsen at www.useit.com, especially 'How Users Read on the Web', 1 October 1997.

17 Alexei Shulgin, 'Re: nettime: Art on Net', nettime posting, 13 March 1997.

net over its subject, confining it as it tries to capture it, and that others may take it as their task to sever its strands. Equally, however, to sink into the swamp of multiplicities is to play an outmoded postmodern game that renders its writers and readers powerless. In its attempt to break out of theoretical dead-ends, and in its dialectical interplay with artistic practice, online discourse has become forthright, practical and fractious. This book is an attempt to begin a similar dialogue among a different readership.

The Structure
of the Internet

To understand Internet art requires knowledge of the environment that it inhabits. Throughout the book, I will try to interweave accounts and analyses of the art with information about the Internet, but I will begin with a few general remarks about the Internet as a system.

The Internet is the overarching network of the many public networks of connected computers. The first computer network was established between a few machines used in academic and government institutions in the United States from the late 1960s. As is well known, the Internet, if not exactly invented for warfare, was sold to state funders as a defence system, designed to maintain government and military communications during nuclear war. If a communication structure is centralised and hierarchical, with a hub serving many nodes that branch from it like the spokes of a wheel, destroying that centre destroys the entire network. In contrast, if no single node in the system is more important than any other, and all are capable of routing messages independently, then even if the majority of nodes are destroyed, the system will continue to function, routing messages around the damage [see 018].[1] Funded by the Pentagon research body ARPA, the first computer networking system was set up at the height of

1 This was the vision of
Paul Baran, drawn on at a later
date in the making of the first
computer network. See Katie
Hafner and Matthew Lyon,
*Where Wizards Stay Up Late:
The Origins of the Internet*,
Simon and Schuster, New York
1996, pp.54–64.

the Vietnam War. Its initial node, shipped to UCLA in 1969, was a military specification machine encased in battleship-grey steel, weighing over 900 pounds and fitted with eyebolts so that it could be lifted by helicopter.[2] The early development of the Internet is deeply entangled with US military technology and the Cold War arms race – a link embodied in the drawings of efficient routes between a number of points made by systems pioneer, Larry Roberts, in which the nodes and routing of a computer network followed similar work in which he had tracked optimum paths for walking around the complex maze of the Pentagon building.[3] [002]

Decentralised networks must use digital signals. Computer networks, including the Internet, are designed to be indifferent to the particular routing of a message so that an email sent next door could conceivably go via another continent (indeed, due to US dominance of the Internet, this does in fact happen, with much intra-Asian traffic being routed via North America).[4] Given a degree of redundancy and routines for error-checking, digital signals do not alter as they are passed from one transmission station to another. Analogue signals, though, as in a game of Chinese whispers, degrade each time they are forwarded. So an analogue system must use the shortest routes and thus be hierarchical; a digital system can employ a network without hierarchy.[5]

For decades the Internet was the preserve of specialist users in academia, government, military and business circles. They could exchange information with other computers around the world, run programs on them, and trade currencies or shares but, while the system was united by wires, it was divided by software. The World Wide Web, on which the great majority of Internet art exists, was established as a means of making the online interface consistent, so that sites could be accessed without the need to learn how to use the many different types of networked systems. Its initiator, Tim Berners-Lee, came up with a set of rules or protocols, freely available and not commercially exploited, that became the de facto standard, uniting many areas of the Internet under a single interface.[6]

The innovation of the Web was to combine the technology of hypertext with computer communications. Hypertext, first conceived of by Vannevar Bush in a now famous essay published in 1945, is the free-form linking of texts or other fragments of data.[7] Just as in this book, numbers link the main text to notes, in hypertext highlighted links connect one piece of data to another, and the user has only to click on the link to move to the

2 John Naughton, *A Brief History of the Future: The Origins of the Internet*, Weidenfeld and Nicolson, London 1999, p.138; Hafner and Lyon 1996, p.150.
3 A few of these drawings are illustrated in Hafner and Lyon 1996, pp.48–50.
4 See Dan Schiller, *Digital Capitalism: Networking the Global Market System*, The MIT Press, Cambridge, Mass. 1999, p.35.

5 This point is made by Naughton 1999, pp.98–9. On the important issue of redundancy (the relation of entropy and information), the founding statement is Claude Shannon's 1948 paper, 'The Mathematical Theory of Communication', in Claude E. Shannon and Warren Weaver, *The Mathematical Theory of Communication*, University of Illinois Press, Urbana 1998.

6 For Berners-Lee's account of the Web, its development and his vision of the future, see Tim Berners-Lee (with Mark Fischetti), *Weaving the Web: The Past, Present and Future of the World Wide Web by its Inventor*, Orion Business Books, London 1999.
7 Vannevar Bush, 'As We May Think', *Atlantic Quarterly*, July 1945, vol.176, no.1, pp.101–8; also at www.theatlantic.com/unbound/flashbks/computer/bushf.htm

linked material. Unlike the relationship between text and notes in printed text, however, with hypertext no hierarchy is necessarily implied between linked data, and the form of linking can trace intricate patterns, suggesting complex relationships between the fragments. These systems can provide stimulating environments for learning, as in hypertext encyclopaedias in which text, images, video and music can be linked. Berners-Lee's inspiration was to see that this was the ideal way to handle the profusion of diverse material on networked computing systems, allowing users to skip from site to site in an apparently seamless environment.

The act of adding links to the Web had to be 'trivial', as Berners-Lee put it, meaning that it could be done easily, and without being subject to control. Since the organisation of data was to be sacrificed to its scalability, there would be no central database governing link-making.[8] This makes the system very different from the organisation of a library, for instance, with its singular system of classification, and its assessment and vetting of content. It makes the Web a rich but chaotic source of information, opinion, chat, gossip, propaganda, conspiracy theory and outright lies. Structure is imposed on the pre-existing mass of data and links by the various meta-structures that are search engines. It is important to note that Berners-Lee, like Bush, believed that everyone should be able to make links, not just the authors of pages, so that users could create their own structures as it suited them, developing a personalised set of associations drawn over the available data. As the Web was developed for mass participation, it became a more passive system, and the most widely used browsers are not integrated with web-page editors that allow the creation of links.

Through its standardisation of the interface, the Web brought the Internet to a much wider public. Its history is very brief: in early 1994 Internet service providers were founded, offering the public all that they needed to get online in a single package. The older service-providers, companies such as CompuServe, Prodigy and America Online (AOL), had discouraged their members from exploring the Internet, producing their own content as well as a connection service.[9] Their anodyne, pre-packaged material was offered as a safe and simple alternative to the complex, lawless and rude Internet, though initially it was AOL and CompuServe customers who formed the mass of users with the home equipment to browse the Net as a whole. Web browsers, first Mosaic, and then the widely popular Netscape

8 Berners-Lee 1999, p.18.

9 AOL has 17.6 million members and 20 million Instant Messenger users, some 15 per cent of the Web's population. See Korinna Patellis, 'E-Mediation by America Online', in Richard Rogers (ed.), *Preferred Placement: Knowledge Politics on the Web*, Jan van Eyck Akademie Editions, Maastricht 2000, p.52.

(released commercially in December 1994) suddenly made that other, wider realm accessible to ordinary users.[10]

Browsers alone, though they are sophisticated commercial tools, could only give access to the vast data space of the Web, not make it manageable. That task was left to search engines that filter and sort data using quasi-intelligent software agents or human judgement. The search-engine business has become large and highly profitable, dominated by companies such as Yahoo, Excite and Google, which serve as 'portals' for huge numbers of people looking for information or things to buy on the Web.[11] Yet 'portal' is not a term that quite captures what search-engines do, for a gateway, no matter how elaborate, does not govern the structure of what lies within. Search engines, through their criteria for inclusion and ranking of sites, certainly do. Money is generated by advertising on the search-engine sites, and sometimes by less scrupulous means. An excellent collection of essays about search engines and the structure of the Internet takes its title, *Preferred Placement*, from AltaVista's practice of selling preferential placing in their search lists, without informing users that the engine had been tinkered with in this way. Net activists forced AltaVista to abandon this particular practice, though it survives in other forms.[12] The competition for the first few places on the search engine lists for a query ('flights', say, or 'fashion' or 'sex') is intense, involving complex software tricks and the expenditure of large resources which favours the big players. In general, the more a site is linked to by other sites, the more likely search engines are to rank it highly, but organisations or companies with large resources can either set up their own links, or pay for inward linking by others.[13] The effect of these practices, as the contributors to *Preferred Placement* have it, is to 'depluralise' the Web.[14] The structure of the Web is fluid, shifting and continually contested, but nevertheless it has acquired a strong tendency towards homogenisation, closely reflecting the commercial and state powers that dominate both the Web and the offline world. It is a structure that makes it difficult for individuals or small groups – including artists – to get their sites noticed.

While search engines are passive, awaiting users' commands, intelligent computer agents designed to serve a more active role are emerging. These agents gather information about users from their online behaviour and analyse it to anticipate needs and desires. Cyberspace theorist Jaron Lanier is alarmed by the development of

10 This point is in Berners-Lee 1999, p.113.
11 Figures for the top websites can be found at www.mediametrix.com. The figures for June 2000 show the top sites as AOL (59 million visitors), Microsoft sites (50 million), Yahoo (48 million), Lycos (31 million), Excite (21 million). There is a very steep fall-off in numbers even in the top twenty, with the first few sites having a large majority of visitors.

12 See Richard Rogers, 'Introduction', in Rogers 2000. For the other arrangements, see Lucas Introna and Helen Nissenbaum's essay, 'The Public Good Vision of the Internet and the Politics of the Search Engine' in the same volume, p.33.
13 For a good overview of this competition, see Introna and Nissenbaum in Rogers 2000.

14 See Rogers 2000, especially the essay by Noortje Marres and Richard Rogers, 'Depluralising the Web, Repluralising Public Debate – The Case of the GM Food Debate on the Web', pp.113–36.

these autonomous agents that are supposed to learn users' preferences and act as their servants in fetching data from the Web:

Today's advertising agencies will become tomorrow's counteragent agencies. This might involve fancy hacking, but it might also be softer. Counteragencies will gain information about agent innards in order to attract them, like flowers wooing bees. Regular netizens won't have this information, so they will attract no bees and become invisible.[15]

So more active forms of searching, promising an individualised online experience, may in fact contribute to producing a yet more homogenous Web.

In a highly original work, the group I/O/D created a program, *Web Stalker* 1997, which gave users an unfamiliar view of the Web.[16] [003] As Alex Galloway describes it:

The Web Stalker ... takes the idea of the browser and turns it on its head. Instead of showing the art on the web through interpreting HTML and displaying in-line images, it shows the web as art through a making-visible of its latent structure.[17]

Web Stalker strips away the Web's content, displayed through the conventional processing of hypertext mark-up language (HTML) code, to reveal its armature in the form of beautiful little geometrical patterns, which (in the default colour set-up) stand out from the black screen like spiders' webs. Going to a heavily linked site throws up a fascinating and navigable diagram of links. While commercial browsers strive to give the user a standardised view of Web content in the style of a series of busy and often flashy magazine pages, the *Web Stalker* provides a stark, skeletal view. Its various windows map the links between sites and pages, different elements of single pages, and the stream of HTML as it is read, and can extract all the text from a site. Matthew Fuller, a member of I/O/D, describes the intended effect:

The Web Stalker performs an inextricably technical, aesthetic and ethical operation on the HTML stream that at once refines it, produces new methods of use, ignores much of the data linked to or embedded within it, and provides a mechanism through which the deeper structure of the web can be explored and used.[18]

The non-hierarchical structure of the Internet has provoked much theoretical writing celebrating the playful, liminal and deconstructive works and mental attitudes that it would spawn. These views included the idea that the dominance of the broadcasting media would be shattered as all

15 Cited in Steven Johnson, *Interface Culture: How New Technology Transforms the Way We Create and Communicate*, Basic Books, New York 1997, p.186. Lanier's views about agents are available at www.voyagerco.com and www.braintennis.com.
16 Web Stalker can be downloaded from http://bak.spc.org/iod/

17 Alex Galloway, 'New Interfaces, New Softwares, New Networks', rhizome article, posted at nettime, 19 January 1998.

18 Matthew Fuller, 'A Means of Mutation: Notes on I/O/D 4: The Web Stalker', www.axia.demon.co.uk/mutation.html

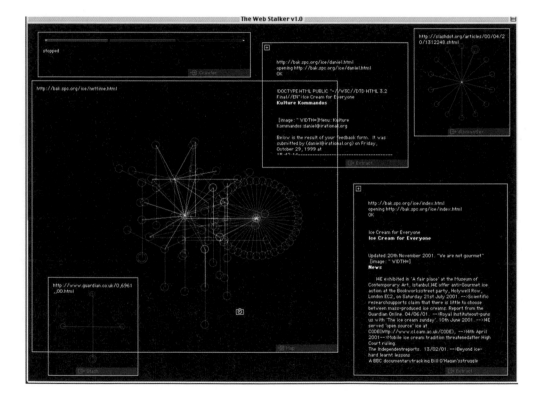

views acquire equal voice; that identities would fracture into a kaleidoscope of role-playing that would develop the self; and that Deleuze and Guattari's rhizome, a root-like fabric of radical indeterminacy that best captures the ungraspable condition of postmodern life, finds virtual embodiment in the Net.[19] These ideas seemed plausible before the mid-1990s when the Internet was still a specialist area in which computer enthusiasts and activists of various kinds talked to one another, exchanged ideas and software, and played games under a wide variety of guises.[20] They became much less compelling as business moved into the Net, swiftly introducing elaborate hierarchies, and as communication between groups of people was marginalised by the rise of websites publicising and selling things. Works such as *Web Stalker* are symptomatic of the response that emerged from this new situation, being pragmatic actions that aim to evaluate and judge the detailed circumstances of the Web as it exists. For Fuller, fascinated and appalled by the commercial colonisation of the Web, this is indeed an ethical matter.

The time of the flowering of Internet art is precisely the time of the commodification of the Internet, for both were set in process by the wide adoption of browsers and the rise of service providers. Browsers at once established a potential public for art along with 'eyeballs' for advertising and consumers for shopping. Yet there was a gap of a few years before the corporations fully grasped the potential of the Web during which the Internet was set alight by the ingress of new users. It was a time of myriad apparent possibilities, and of the brief life of the heroic, or rather Quixotic, period of net.art. Expectations were extremely high: in a self-consciously modernist posting to the mail forum nettime, Pit Schultz wrote of 'a noble and restrained art ready to undertake the vast subjects for which post-modernism had kept media artists totally unprepared', predicting that it would give rise to truly great works of art.[21]

19 For these various visions, see the essays in Michael Benedikt (ed.), *Cyberspace: First Steps*, The MIT Press, Cambridge, Mass. 1991; also Sherry Turkle, *Life on the Screen: Identity in the Age of the Internet*, Weidenfeld and Nicolson, London 1996; Gilles Deleuze and Félix Guattari, *A Thousand Plateaus: Capitalism and Schizophrenia*, trans. Brian Massumi, The Athlone Press, London 1988; for a telling critique of cybertheorists' enthusiasm for Deleuze and Guattari, see Richard Barbrook, 'The Holy Fools: Mute Mix', *Mute*, no.11, 1998, pp.57–65; a longer version appears as 'The Holy Fools: A Critique of the Avant-Garde in the Age of the Net', in Patricia Pisters and Catherine M. Lord (eds.), *Micropolitics of Media Culture: Reading the Rhizomes of Deleuze and Guattari*, University of Amsterdam Press, Amsterdam 2001.

20 For an eloquent account of the early Net, see Howard Rheingold, *The Virtual Community: Finding Connection in a Computerized World*, Secker & Warburg, London 1994.

21 Pit Schultz, 'The Net Artists', nettime posting, 31 May 1996. One of the mail addresses listed in this posting is guillaume@apollinaire.org

The Form of Data

Internet art, we have noted, is not a medium, so hard questions can be asked about its coherence. For Lev Manovich, in a controversial mailing to the Eyebeam atelier forum, the Internet is an agent of modernisation, enabling participation in global consumer culture, and the category of Net art is a mistake, for all its products are merely exemplifications of that modernisation.[1] In its as yet early, vestigial stages, however, Internet art has the *appearance* of a medium with regular, if not settled, ways of handling data. This appearance is due to both technological limits and the groping, exploratory attempts of its makers, a small group who look carefully at each other's work. As each month passes and as the variety of practices proliferates, it comes to look less and less like a medium, and its specificity, unity and avant-garde character may fade into history.

A linked concern is whether there be any coherence to the look of Internet art. In a long and thought-provoking posting to nettime, Pit Schultz argued that the Net has no visuality.[2] In principle, this is surely the case, since its visuality is defined only by the limits of what is calculable, and it is not confined to visual means of expression. Again, however, and more so in its early stages, the Net and its art was marked by a variety of

1 Lev Manovich posting, in Amy Scholder and Jordan Crandall (eds.), *Interaction: Artistic Practice in the Network*, Distributed Art Publishers, New York 2001, pp.54–5.
2 Pit Schultz, 'The Final Content', nettime posting, 4 April 1997.

004/Alexei Shulgin,
Form Art 1997

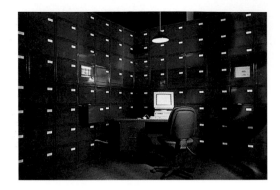

005/Antonio Muntadas,
The File Room 1994
Installation at the Lyons
Biennale 1995

histories and visual practices – of art history, of software interfaces, of previous 'computer art' and media art. Shulgin's 'form art' made formal, modernist patterns out of the standard components of the interface, in a highly self-conscious play on the link between modernism and the look of the new online realm. [004] Like graffiti, Internet art tends to be swiftly recognisable, and not only because of where it is seen.

The most fundamental characteristic of this art is that it deals with data, and can be thought of as a variety of database forms. Indeed, some important works have the familiar look of databases. Installation artist Antonio Muntadas's *The File Room* was one of the first works made for the Web, going online in May 1994. It is an extensive worldwide archive of cultural censorship, at first compiled by a team of researchers but later added to by the public, and covering incidents old and new, from Diego Rivera's dispute with the Rockefeller Center over his depiction of Lenin, through to the religious Right's assaults on the National Endowment for the Arts. It is a collaborative site to which users can contribute information within the framework established by the artist.[3] Naturally, censorship on the Internet itself was soon highlighted with subscribers

to AOL writing about the company's deletion of postings that it considers vulgar or sexually explicit. Aside from its continuing online display, *The File Room* was also established as an installation at the Chicago Cultural Center in 1994 where, censorship being a lively issue in the US, it was seen by 80,000 people.[4] [005]

In its physical form, Muntadas's *The File Room* was close to many Conceptual art projects that built physical databases, including card-index systems (such as Art and Language's *Index 01* 1972). Yet while the object lends itself to gallery display and, whatever the intention of its authors, tends to come across as fully formed, and to be venerated rather than used, this is not so of the same information offered in dematerialised form on the Web. The break from the aesthetics of the isolated art object and the move towards an art of discursive process that was begun by Conceptual art could be completed online where the provisional, ever-changing character of material is taken for granted. As Manovich puts it in his meditation on the database form, historically, artists made unique objects in particular media in which interface and content were inseparable (and in the assimilation of Conceptual art, we may say that they congealed). In the new media, the content of the work and the interface are

3 www.thefileroom.org: for an account of Muntadas's work, see Judith Russi Kirshner, 'The Works of Muntadas' at the same site: for an account of the installation of *The File Room* at Chicago, see the same author's 'The File Room' in Gerfried Stocker and Christine Schöpf (eds.), *InfoWar*, Springer, Vienna 1998, pp.285–9.

4 See Robert Atkins, 'The Art World and I Go On Line', *Art in America*, vol.83, no.12, Dec. 1995, p.60.

separated; a work in new media can be understood as the construction of an interface to a database.[5]

In another early work that takes the form of a database, Alexei Shulgin's *WWW Art Medal* (1995–7), pre-existing sites are linked together on a page that awards them virtual medals for their artistic appeal.[6] The artist 'draws' links between these sites, presenting them within a new frame, both conceptually and literally (a gilt picture frame is thrown about them). [006] The sites include what seems to be a philosophy page actually advertising beauty products, a collection of pretty if anodyne photographs (the medal being awarded 'for innocence'), and pages comprising song lyrics alongside examples of 'glamour' photography ('for correct usage of pink colours'). Shulgin further links these found pages with found fragments of art criticism, also re-illumined in their new context. As Andreas Broeckmann describes the work, strikingly characterising the structure of the Net:

all the millions of documents on the WWW are potentially linkable, they belong to the same horizontal surface of material, a felt of singularised objects, on which artists and designers can draw. The WWW Art Medal project, for instance, consists of links to WWW pages that are not meant to be 'art', but that have an 'arty' feeling to them. These pages, often accidentally found, are awarded the WWW Art Medal and are complemented by pirated art critical quotations which describe what may be seen as artistically valuable in the individual pages.

This influential work by Shulgin, a piece of online curation, or curation as artwork, is a particularly pure form of Internet art that links pre-existing data in a singular manner, as if it were the result of a database query. It is an act of appropriation, in the manner of Marcel Duchamp and so many artists who followed him, though of a particularly minimal and filmy kind. There is no movement or signing and dating of objects, just the throwing out of a pointer to what exists. Much of the Conceptual tradition is distinguished by striving to be free of the burden of aesthetic judgement, and Shulgin echoes Duchamp's remark about the readymades that they should reflect a total absence of good and bad taste.[7] Shulgin's work also highlights a matter particularly apparent on the Net where the boundaries of art are porous or unmarked: that often a mere switch of attention suffices to transform an object into something with the appearance of art. This work was symptomatic of net.art in many ways, including its self-conscious references to a

5 Lev Manovich, *The Language of New Media*, The MIT Press, Cambridge, Mass. 2001, pp.226–7.
6 www.easylife.org/ award/

7 Pierre Cabanne, *Dialogues with Marcel Duchamp*, trans. Ron Padgett, Thames and Hudson, London 1971, p.48; Rachel Baker, 'A Conversation with Alexei Shulgin', nettime posting, 16 March 1997. Shulgin's references to the history of appropriation are insistent. In this interview, he also says that art awards and art criticism turn shit into gold (a clear reference to Piero Manzoni's *Merde d'Artiste*), and also talks about an art system designed to win at roulette at Monte Carlo (which takes us back to Duchamp).

006/Alexei Shulgin,
WWW Art Medal 1995–7

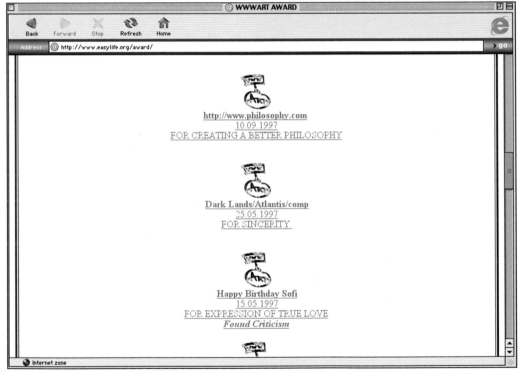

```
Hash House Harriers Home Page. Telephone country..
ANTECEDENTES. Historia del proyecto. El lanzamiento de la idea de...
Anchovy - I'm a weirdo that likes a laugh and is often considered a clown in public-even at

Quiet, unassuming, lonely, handicapped -- she's perfect. In the Company of Men.
Quiet, unassuming, lonely, handicapped -- she's perfect. In the Company of Men.
Quiet, unassuming, lonely, handicapped -- she's perfect. In the Company of Men.
Jay Harter
There are many things in this world of ours that make people upset.
Where am I??? Okay...maybe not at Stonehenge Well, unlike the previous version of this page,
A perfect place for love and fun
A perfect place for love and fun
Bubba Archive: July 1996: [BUBBA-L:39261 Hey ya'll

Hey, What's the PooP?!
Moja wielka milosc. Oczywiscie moja najwieksza miloscia jest Michal,
ich will. Mit Dir ... Schlaf gut. Anleitung....
Mäuschen "sitzlautlachendvormrechner" Wed Apr 16 23:40:39 MET DST 1997. hihi,
Where do you find me? IThet AS Hinderveien 5 Postboks 358 3201 Sandefjord Norway. Phone: Fax:
help me find a vespa!
```

modernist legacy, its questioning of the category of art, and its modest presence.

Similar in outlook, was Maciej Wisniewski's *Turnstile II* 1998, a sophisticated piece of programming that searched for, gathered and displayed material typed into chat rooms as it was posted, on web pages and from other online sources.[8] [007] This is spying, made all the more effective because viewers can click on the text to be sent to its source. The result was a strange, collective poem written in many languages, the lines composed and scrolling past irregularly yet as if with a hidden rhythm, speaking sometimes delicately, often crudely, of a great variety of personal themes. An example of one 'passage' reads:

Re: I cant see! Help me find some eyes!
There is only one meant for me. Its as though
I can see her and. know her but can not
What Ever Happened to Looking Out
for the Patient?
Thank you for being a friend.

Whilst Shulgin selected his material, Wisniewski established a set of criteria and let the program do its work. The results are unpredictable, if after a time strangely uniform, and to view the work is to feel as if one's finger presses upon some collective pulse of emotional expression, the passion of which is at odds with the cool, measured display of the work, just as the instrumentality of computer technology seems at odds with the intimate practices sanctioned by the apparent anonymity its use confers.

Other examples of basic play with Internet structure are found in Heath Bunting's work. When viewing a page of hypertext, one normally expects to see a few highlighted words offering links to further information. In Bunting's document, *readme.html* 1998 the user is presented with a text about the artist (taken from *Wired* magazine) in which almost every word is a link except those that, on the face of it, seem to be most interesting.[9] [008] The word 'he', for instance, links to Hurricane Electrical Internet Services at www.he.com. The links are very various, though naturally the effect is far from useful. *readme.html* is a playful formal trick that encourages the user to think about the conventional structure of linking on the Web.

Turnstile II makes use of constantly changing data, presenting it in a new context. Some artists have similarly used pre-existing sources of data but have handled them in a more elaborate visual manner. A particularly attractive online dataset, for obvious reasons, has been the movements of stocks and shares. There is the famous fountain at Xerox PARC (a celebrated lab where many of

8 www.stadiumweb.com/
turnstile/

9 www.irational.org/
heath/_readme.html

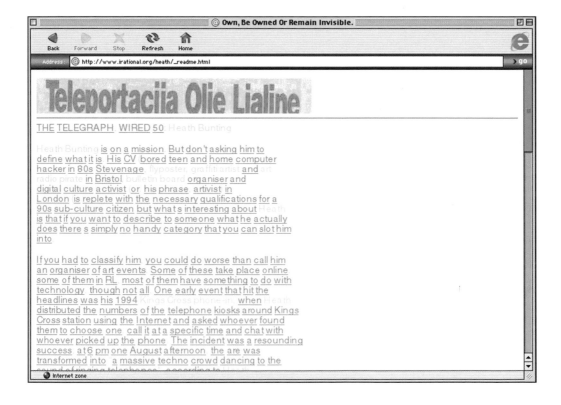

Own, Be Owned Or Remain Invisible.

Back Forward Stop Refresh Home

Address: http://www.irational.org/heath/_readme.html › go

Teleportaciia Olie Lialine

THE TELEGRAPH WIRED 50: Heath Bunting

Heath Bunting is on a mission. But don't asking him to define what it is. His CV bored teen and home computer hacker in 80s Stevenage, flyposter, graffiti artist and art radio pirate in Bristol, bulletin board organiser and digital culture activist or his phrase artivist in London is replete with the necessary qualifications for a 90s sub-culture citizen but whats interesting about Heath is that if you want to describe to someone what he actually does there s simply no handy category that you can slot him into

If you had to classify him, you could do worse than call him an organiser of art events. Some of these take place online some of them in RL, most of them have something to do with technology, though not all. One early event that hit the headlines was his 1994 Kings Cross phone-in, when Heath distributed the numbers of the telephone kiosks around Kings Cross station using the Internet and asked whoever found them to choose one, call it at a specific time and chat with whoever picked up the phone. The incident was a resounding success, at 6 pm one August afternoon, the are was transformed into a massive techno crowd dancing to the sound of ringing telephones, according to

Internet zone

the innovations of the modern computer interface were invented) in which the flow of water is linked to the performance of the stock market. Likewise, the *Stock Market Skirt* 1998 by Nancy Paterson, takes literally the adage that hem lines rise and fall with the value of the market, and relays the sartorial results of the movement of a single share price over the Net.[10] Less immediately a matter of visual representation and more intent on instrumental management is Ola Pehrson's experiment with a yucca plant wired to the stock market. Electrodes attached to the plant's leaves yield buy or sell orders, while profits reward the plant with light and water, and losses deny it the means to life. The *Yucca Invest Trading Plant* 1999 makes an attempt to harness nature's feedback mechanisms to yield accurate (and profitable) predictions.[11]

Combining the two concerns, for the show that I curated at Tate Britain, *Art and Money Online*, Lise Autogena and Joshua Portway made *Black Shoals Stock Market Planetarium* 2001. This work visualised the global stock market as an animated star chart, with stocks glowing brighter or dimmer depending on the volume of trading, and drifting together or apart according to the congruence of their trading histories. [009] So when IT stocks started to fall rapidly and concertedly, as they did over the course of the exhibition, their corresponding stars clustered together in the dome. Furthermore, artificial life creatures inhabited the work, reliant (rather like stockbrokers) on 'food' created by the buying and selling of shares, and evolving as they came to terms with what success means within the parameters of their world. They, too, may come to have an instrumental purpose, being cousins of functional software entities trading on the world's exchanges. Forms of visualisation such as the fountain and the skirt are very simple since they work using only one variable, the rise and fall of a single stock or the market as a whole. The movement of all individual stocks and shares is much harder to represent in a coherent visual field, though great prizes await those who can do so, since people are generally much better at understanding what changes are taking place when presented with a picture rather than an array of numbers. As Autogena and Portway comment:

The project links the earliest theories, such as astrology, to the latest scientific visualisation systems, in examining the urge to understand our environment, the desire to predict, recognise patterns and impose structure and the limits of this ambition. By exploring our desire to abstract

10 See http://nancy.bccc.com/
MediaWorks/Stock/stock.html
11 For a brief description of this work shown at the Tensta Konsthall, Stockholm, see Jörg Heiser, 'Palmreading: Does Money Grow on Trees?', *frieze*, no.49, 1999, p.53. It was also included in the Moderna Museet exhibition, *Organising Freedom: Nordic Art of the '90s*, Stockholm 2000.

and order our environment the project will act
as a focus for debate about how much control
is possible over complex systems such
as the natural environment or the economy.[12]
The systems that humans establish,
including the global financial system, exhibit
emergent behaviour, a product of their own
autonomous logic that exceeds the intentions of
their creators. (The title, incidentally, plays on the
name of a once highly successful mathematical
model for calculating the future value of stocks,
known as the Black-Scholes model, after its
inventors Fischer Black and Myron Scholes.)

Black Shoals is an extremely ambitious
project, and it is symptomatic of the collaborations
between artists, academics, scientists and
engineers that have been facilitated through
the Internet. Autogena and Portway have been
fostering such links for some time (for example,
in Autogena's project on the theme of breathing),
and while their piece for *Art and Money Online*
is displayed as a work of art, it may develop as
a new form of knowledge.[13] The work oscillates,
then, between two poles, weighing the vanity
of human ambition to achieve complete
understanding of a field against the potential
efficacy of blind, evolving agents, in their urge
to feed and breed, to yield knowledge.

Plainly, such works dealing with data,
classification and knowledge have precedents
in Conceptual art. As with much Conceptual art,
the character of the data on offer is ambiguous.
There is a broad critique of administered lives and
bureaucratised minds in much online art, drawing
on a similar assault on murderously rational
society in Dada during and after the First World
War, and revived during the period of Conceptual
art by the reaction against the genocidal actions of
the US armed forces in Vietnam. The arrangement
of information and ideas had an aesthetic in
Conceptual art, of design, play and subversion,
though one often eschewed by its creators who
were too fixed upon rebelling against a visual
aesthetic that was tied to objects and to the elite
circuits of the art world. Online, Conceptual
art potentially reinvents itself, without the burden of
material objects and the material constraints of
moving and showing them. The dematerialisation
of data offers great opportunities to artists,
not only because it provides essentially free
distribution and is rarely reified in the form of
index cards and filing cabinets that end up as
gallery furniture, but also because it is changeable
and manipulable.

While Internet art that plays on the database
brings back in purer form the idealism and

12 See www.stain.org/
shoals/html/frontpage.html
13 See www.autogena.org/
Breathing/home.html

sophistication of Conceptual art (reversing the general interpretation of such returns as degraded copies of their originals), other strands of online practice simultaneously raise the spectres of older modernisms.[14] The development of computer graphics appears to run modernism in reverse, starting with the simplest two-dimensional geometrical figures in monochrome, and gradually adding (as computing power increased and programmers learnt to render them) three-dimensional form, first wire-frame then filled solids, perspective, light and shade, texture, colour and fractal complexity.[15] Advanced computer graphics tend to be as obsessively naturalistic and fussy as nineteenth-century history painting. In modernism, the sign of the contemporary was a geometrical simplicity that mirrored mechanical forms, both being manifestations of a Platonic ideal; in the age of simulation, the sign of the contemporary is the completeness of naturalistic illusion. This is seen particularly in the computer games industry which drives the technology swiftly towards the ultimate goal of flawless Virtual Reality. This reverse movement, from geometric simplicity to complex illusion, was set in train once again on the Net, due to the low speeds at which data could be transmitted. Heath Bunting's first online artworks,

for instance, were built from plain text and very low-resolution black-and-white images. [010] Visual complexity slowly crept into Internet art, though much has remained geometrical and low resolution, if only as a stylistic marker.

Early Internet art was, however, not so much concerned with visual simplicity (though it often was simple) as with the fundamental characteristics of the Net itself. Such work first developed in reaction to the changes in the Internet environment introduced by the commercial giants, particularly the makers of browsers. As Vuk Cosic put it:

Sometimes I react to CNN, sometimes I do just abstraction. I maybe fall in love with something that happens new in the browser revolution. I say: 'Wow, frames! Look at this shit, it's so stupid, it must be good for something.'[16]

Cosic, like Shulgin, makes a point of invoking the heroic days of the early twentieth-century avant-garde, particularly Cubism and Dada. He talks of how he, Bunting, Shulgin, Olia Lialina, and Jodi, in effect, had neighbouring studios, 'like Picasso and Braque in Paris in 1907', so that each could see what the other was doing, respond to it, or collaborate: 'We steal a lot from each other, in the sense that we take some parts of codes, we admire each other's tricks.'[17] Furthermore,

14 The conventionally judged relationship between avant-gardes and neo avant-gardes is rightly criticised in Hal Foster, *The Return of the Real: The Avant-Garde at the End of the Century*, The MIT Press, Cambridge, Mass. 1996, chap.1.

15 For an account of this development in artistic practice, see Hervé Huitric and Monique Nahas, 'The Visual Artist Turns to Computer Programming', in Timothy Druckrey and Ars Electronica (eds.), *Ars Electronica: Facing the Future: A Survey of Two Decades*, The MIT Press, Cambridge, Mass. 1999, pp.81–5.

16 Josephine Bosma, 'Vuk Cosic interview', nettime posting, 27 September 1997.

Progress through Binary thought.

he describes his *net.art per se* project as an avant-garde manifesto, though one that was more interested in raising questions than providing declarative answers.[18] The questions – such as 'Is there a specific net.art?' – contained links to various art sites which in this context functioned as replies. Even so, the fundamental character of the questions, and the collective character of the grouping of the 'answers' had an avant-garde air. In their choice of the term 'form art', in their insistent references to modernist ideals, in their attempt to carve out an autonomous sphere in which to make work, the early Internet artists flirted with unfashionable and disreputable modernism (and even this has a modernist precedent, with the Surrealists looking back admiringly at the most despised style of their day, Art Nouveau).[19] Yet the Net formalists could not be formalists in the old way, if only because of their acute historical consciousness about the meaning and fate of modernism. Their historical distance from modernism is expressed with humour, yet the insistence of their references to it suggest the deep affinity felt with their predecessors, based upon a shared engagement with novel and fast moving technology.

The avant-garde has sometimes been ironically referred to by commercially successful recent art in the US and the UK, but to very different effect. This commodified art has indulged in displays of vulgarity and social irresponsibility, fetishising novelty, and in the case of the 'young British artists' containing a vestige of collective action that tartly raises the ghost of the avant-garde. Especially to those outside the art world, such elements actually appear to be avant-garde, and that appearance is very useful, for it allows the enjoyment of radicalism's allure without the danger of its content. In contrast, many of the actual conditions of avant-gardism are present in online art: its anti-art character, its continual probing of the borders of art, and of art's separation from the rest of life, its challenge to the art institutions, genuine group activity, manifestos and collective programmes, and most of all an idea of forward movement (as opposed to one novelty merely succeeding another).

In his well-known book, *Theory of the Avant-Garde*, Peter Bürger argues that the avant-garde comments critically on art for art's sake, the separation of art from the world beyond itself. Since its makers and viewers are dissatisfied with the world as it is, the avant-garde cannot simply return from formalist autonomy to a direct engagement with subject matter but instead takes the condition of autonomy as its subject matter.[20]

17 Tilman Baumgärtel, 'Interview with Vuk Cosic', nettime posting, 30 June 1997.
18 Josephine Bosma, 'Vuk Cosic interview', nettime posting, 27 September 1997.
19 Salvador Dalí, 'De la beauté terrifiante et comestible de l'architecture modern style', *Minotaure*, nos.3–4, 1933, pp.69–75.

While this is a definition that cannot adequately deal with the full range of self-consciously avant-garde movements (particularly those with reactionary political affiliations), it does offer a good description of much early Internet art: a play with the condition of autonomy, and more than that, given that the activity has been altered by Bürger's characterisation of it (along with other theoretical accounts of the avant-garde), a play with the idea of being avant-garde.

Yet those works that rest on raising awareness of the structures of the Internet, or explore the conventions of computer graphics, are not quite autonomous, no matter how arcane their concerns. Internet art is caught in a productive paradox similar to that which sustained modernist photography: the more photographers strove to make an autonomous art that used purely photographic means (with sharp focus, say, or high resolution), the more they immersed themselves in the subject in front of the lens. Likewise, the further online art moves into Net-specific realms, the more it is bound up with the instrumentality of the Net itself. So the recourse to archaic avant-garde concerns permits a distanced and critical engagement with the detail of the commercial and political present.

Jodi (Joan Heemskerk and Dirk Paesmans) present one of the best-known and exemplary avant-garde net.art sites. Pages are piled on top of one another, recent work over old. The site changes fast enough to be seen less as an art object than as a performance.[21] [011] Jodi play with dysfunction, causing users to wonder whether their machines have started to play up, perhaps due to some virus infection or badly programmed HTML. Windows shift, scroll-bars judder, text jumps about, colours flash. Indeed, in the early years of the Web, it was not unusual to find genuinely faulty pages that would create such effects. People even sent Jodi emails containing instructions for correcting their HTML.[22] Accessing the Jodi site may seize control of the machine from the user, who has to sit back and watch the strange display, perhaps clicking onto a different portion of the site, only to be confronted with another parade of interface weirdness. Jodi's pages often use few hypertext links (and they are hard to find), so other means of navigation are explored, or paths are imposed on viewers.[23] As Simon Lamunière points out, it is often difficult to know whether what you are seeing comes from over the Web, or is Jodi's manipulation of data already present on your machine, adding: 'Nowhere else does one so often have the feeling of being simultaneously

20 Peter Bürger, *Theory of the Avant-Garde*, trans. Michael Shaw, Manchester University Press, Manchester 1984.

21 This point is made by Peter Lunenfeld, *Snap to Grid: A User's Guide to Digital Arts, Media and Cultures*, MIT Press, Cambridge, Mass. 2000, p.82.
22 Tilman Baumgärtel, 'Interview with Jodi, *Telepolis*, 6 October 1997.
23 Josephine Bosma, 'Interview with Jodi', nettime posting, 16 March 1997.

011/Jodi
Clockwise from top left:
%Wrong 1998
http://404.jodi.org

Index.html 1996
wwwwwwww.jodi.org/
index.hmtl

%Transfer (GOODTIMES) 1996
wwwwwwww.jodi.org/
100cc/hqx/i904.hmtl

%Transfer HQX 1996
wwwwwwww.jodi.org/
100cc/hqx/i903.hmtl

012/Vuk Cosic,
Duchamp sign 1997

both here and elsewhere, and from one place
having access to such an infinite number of other
places.'[24] All this is presented without explanation
– there is nothing to say that this is an art site –
so that those who stumble upon it may well puzzle
about what they have found.[25]

Jodi describe their work as being the product
of anger at the administered and coercive
functionality of the Net and the computer interface
generally, an anger they hope is communicated
to the end-user:

It is obvious that our work fights against
high tech. We also battle with the computer on a
graphical level. The computer presents itself as
a desktop, with a trash can on the right and pull
down menus and all the system icons. We explore
the computer from the inside, and mirror this on
the net.[26]

As with work by Net formalists, the very
fact of presenting a forceful alternative to
commercialised convention carries with it a
refusal. Jodi themselves say, 'The work we make
is not politically oriented, except that it stands in
the net like a brick.'[27] Heemskerk and Paesmans
spent time in Silicon Valley where they came
to understand the thinking of the major software
producers, including those who make the
dominant Web browsers. As a result:

it's a bit of a personal matter to turn
Netscape inside out for instance. I have a picture
in my mind of the people that make it. And not
just how they make it, but also of how they view
it themselves within the States and Canada.
How they see their Internet. 'Their' Internet,
you can say that for sure.[28]

Jodi turn software inside-out, bringing the
coding that normally operates Web pages to the
surface of the work. Playfully, this reversal of
expectation runs both ways: on the page, where
pictures would be expected, there is code, and in
the HTML code (which can be read by any user),
there are sometimes pictures.[29]

Jodi's work, which they say has to grab
people as quickly as possible, 'to give them a
karate punch in the neck', is of the type needed
to wrest the attention of those hurried, skimming
European users whose online time is metered.[30]
Their aim is to break the habit of rapid surfing,
to undermine the page paradigm of Web content,
to rupture the expectation that hyperlinks will
work rationally and transparently. Against the
premium assigned to cool design and the latest
software tools, Jodi gives its pages a deliberately
clunky, old-fashioned look. Their technique of
throwing up functioning code for the examination
of the user, revealing aspects of its ideological

24 Simon Lamunière, text
on Jodi on the Documenta X
website, now at: www.
interversion.org/n2lib/display/
project.php?id=16&textid=23
25 See Paesmans's statement
that this is a matter of principle
in Tilman Baumgärtel, 'Interview
with Jodi', nettime posting,
28 August 1997.

26 Tilman Baumgärtel,
'Interview with Jodi, *Telepolis*,
6 October 1997.
27 Josephine Bosma,
'Interview with Jodi', nettime
posting, 16 March 1997.

28 Ibid.
29 This point is made by
Lunenfeld, who illustrates one
of them. See Lunenfeld 2000,
p.83.
30 Tilman Baumgärtel,
'Interview with Jodi, *Telepolis*,
6 October 1997.

function, marks a strong, didactic, break in the parade of simulacra.[31] Both Jodi's work and *Web Stalker*, materialist projects engaged with the specific details of the Net, reveal what lies behind the regular run of spectacle.

There are various reasons why avant-gardism and an interest in autonomy were strong currents in the early years of Internet art. First, there was the need to carve out a recognisably distinct area of interest for this novel art. Second, since modernism and the avant-garde were once more lively models, the issue of autonomy had to be addressed. Third, it was a way of hitting out against disabling and over-recursive strands of postmodern theory that had been used to shelter an increasingly conservative art world, while propagating over-heated apocalyptic visions that had sunk their readers in helpless inactivity, the pleasant strains of sublime catastrophe wafting over their armchairs.[32] By contrast, detailed engagement with the way software and hardware worked and was used produced Internet art's own subject, and at the same time, since this was a realm that tied production to reproduction, gave it an engagement with the social world.

31 On this subject, see Josephine Berry, '"Another Orwellian Misnomer?" Tactical Art in Virtual Space', *Inventory*, vol.4, no.1, 2000, pp.78–9.

32 For a well-informed account of European new media theory, see Geert Lovink, 'From Speculative Theory to Net Criticism', *Mute*, no.8, 1997, supplement, pp.1–2. The recent critique of postmodern theory is not confined to online culture: see, for example, Terry Eagleton, *The Illusions of Postmodernism*, Blackwell, Oxford 1996.

013/Brighid Lowe,
Now Here/Nowhere 1998,
www.e-2.org.
Commissioned by e-2
Courtesy the artist and e-2

Time as Space,
Space as Time

The abolition of waiting time is the Grail of the Internet and of computing as a whole. Yet, in contrast to the impatience at seconds or minutes spent waiting for pages to load, the easy slipping away of hours spent online is caused by the constant urge to move on to the next thing. Marlena Corcoran talks of the awareness of passing time on the Net, registered by on-screen clocks, and of how the impulse to move on means that most people spend longer downloading an image than looking at it.[1] Time on the Net is not experienced unfolding smoothly but in an irregular, juddering pattern, for the command to move to a new location initiates, not mobility but a pause, and then (with a slow link) a page loading element by element or (with a faster link) apparently all at once.

Perry Hoberman has argued that the experience of time in Internet art is a peculiar one. The time spent before painting, sculpture or installation is a matter for the viewer; with music, dance, performance or video, time is imposed upon the viewer in an unbroken flow. With Internet art, time comes in fits and starts. It imposes time on the user, while the user imposes time on the work in a discontinuous rhythm. Internet art may also contain representations of the other arts, bearing within them their own temporal frames. Unlike the time of either the static or temporal

1 Marlena Corcoran,
'Digital Transformations of Time:
The Aesthetics of the Internet',
Leonardo, vol.29, no.5, 1995,
pp.375–8. This article includes
an account of a project in which
she participated that highlighted
the character of online time.

This is the beginning.

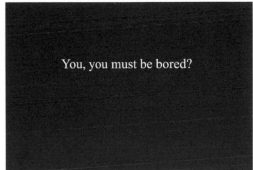

You, you must be bored?

arts, which can be shared, the experience of online time tends to be individual, regularly punctuated by the user's choices, and hard for others to grasp.[2]

The experience of the Internet, and art on it, is strongly marked by inequality since those with fast machines and connections experience it very differently from those whose hardware and software is ageing. Although it is sometimes mistaken for a form of leftist Puritanism, this is one of the reasons why those online artists who are engaged with radical politics often make simple, fast-loading work that does not exploit the latest and flashiest software tools. Jodi, again taking their stand in diametrical opposition to conventional wisdom, use the slowness of Net connections in creating their effects, claiming 'the slower, the better'.[3] To the extent that time itself is explicitly commodified in the digital world – not only in metered online browsing but with advertisers' logging how long users spend on particular pages – and extra time is purchased with fast computers and network links, tactics such as those used by Jodi cut against this commodification.[4]

Encouraging thinking about the experience of online time has naturally concerned many artists. As with the *WWW Art Medal* project, in

Shulgin's *Refresh* 1996, pre-existing material was once again appropriated and set within a frame, this time a temporal loop of art pages through which the browser moves automatically. The temporal experience of the work depends upon the workings of Shulgin's program, the user's computer and network link, the speed of the appropriated sites' servers, and the general traffic flow on the Web, encouraging the user to dwell on the halting flow of online time.

In *Now Here/Nowhere* 1998, a fine work by Brighid Lowe that starts out reflecting on the experience of time on the Net, and goes on to make subtle suggestions about a wider social and textual exhaustion, phrases float slowly one-by-one across the screen while users wait to read them[5] [013].

Here are some of them:
Are you bored already?
I am bored.
I am bored with it all.
I find it all too much;
that simultaneously there is too much
and that it is all the same.
You, you must be bored?
Angry, even.
Are you angry with waiting?
Waiting for this?

2 Perry Hoberman, 'Free Choice or Control', in Hannes Leopoldseder and Christine Schöpf (eds.), *Prix Ars Electronica 96*, Springer Verlag, Vienna 1996, p.56.
3 Tilman Baumgärtel, 'Interview with Jodi, *Telepolis*, 6 October 1997.

4 For reflections on the commodification of time in digital culture, see D.N. Rodowick, *Reading the Figural, or, Philosophy After the New Media*, Duke University Press, Durham, NC 2001, chap.7.

5 www.dnp.co.jp/museum/nmp/c-ship/acbl.html

The text refers to the experience of net browsing itself, and to the online culture's obsession with the present (in time and space) but also to a wider obsession in mass culture as a whole, and its structural connection with the administered character of work and leisure.

The mass of the Internet, caught up with ephemeral pop culture, and obsessed with the temporarily 'hot', changes fast. That continual transformation makes many online artworks, particularly those that contain numerous outward links, look less like art objects than temporary interventions. For instance, many of the links in Shulgin's *WWW Art Medal* project now throw up the familiar 'page not found' error as the sites they referred to have been moved or deleted. *Refresh* has suffered the same fate, though Shulgin claims not to mind, saying that it reflects wider dysfunction in the Net.[6] Similarly, works that act as online anthropology, collecting and displaying as found objects fragments of Net culture, tend to degrade quickly. Opening *Pet Pages* 1998 [014] by Thomson & Craighead fills the screen with dozens of browser windows in the form of little game cards bearing pictures of pets. Each is a link to someone's pet page, a homage to their cat, dog, rabbit, pig or budgie. Many of the links are now dead, perhaps because

the page has expired along with the pet.[7] To see the swift decay of such unmaintained online works is like witnessing, greatly accelerated, the disintegration of a fresco, as if fragments of plaster were falling before one's eyes. Yet even those works that aspire to fixity do not remain unchanged for very long. The character of these more permanent works is more like graffiti than performance art, since they leave mutable but fairly durable traces that affect what comes after them. Like graffiti, they degrade with their environment, and their decline and eventual destruction is an integral part of their allure.

Linking to changing sites is not the only reason for the rapid ageing of Net art. Almost every online work requires maintenance, and complex ones require a great deal. Muntadas's *The File Room*, for example, needs labour and money to maintain its many links, keep information up to date and provide the servers on which it runs. It has undergone a number of difficulties over the years, losing its funding in 1998, only to re-emerge later on another server. Other works are reliant on particular features or even bugs in software, particularly browsers. As software is updated, these works, too, degrade or break down altogether.[8] It is often assumed that such works are simply lost, as

6 Tilman Baumgärtel, 'Interview with Alexei Shulgin', nettime posting, 4 November 1997.

7 Thomson & Craighead, *Pet Pages*: www.thomson-craighead.net
8 Jodi's work sometimes relies on such features. See Josephine Bosma, 'Interview with Jodi', nettime posting, 16 March 1997.

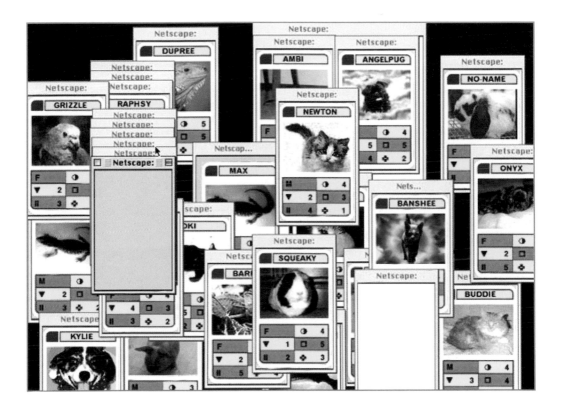

irrecoverable as, say, the Dada performances at the Cabaret Voltaire, but this is not quite true. Art organisations have set out to preserve these works, through running simulations that operate on new machines, or by preserving old computers and software. Rhizome, one of the best online art sites, asks contributing artists how and if they would like their works preserved.[9] Furthermore, a public organisation called the Internet Archive Project (which claims that the average life of a web page is only seventy-five days) backs up the data of the entire Internet, a process that takes a few months even at the 120 million pages they record a week. While this process produces a long and blurry exposure, it will nevertheless give a good impression of the Net at a particular time, and of the place within it of artworks.[10] The amount of information stored is vast but not wholly unimaginable. The Archive's forty terabytes of data, or four billion webpages, is equivalent to about double the text of all the books in the Library of Congress.

The Net has the potential to be the ultimate archive, the repository of all human knowledge, opinion and culture, yet it combines that ideal with an aggressively amnesiac urge. It could be the perfect memory system with everything ever uploaded stored, digital and thus unchanging, a Library of Alexandria for the contemporary age but without the fragility (or flammability) of books. At once robust (copied in many places, error-checked) and delicate (reliant on the flux of electrons and magnetic traces), data on the Net is in principle eternal and in practice usually ephemeral. Deletion is the Net's métier, its content and its processes being tied to the moment, both technically, since many pages are designed for particular browsers and plug-ins, but more important culturally, as the gale of fashion drives web pages before it, and fickle viewers skate only over the new. Likewise, there is a strong contrast between the unchanging character of digital artworks for those who hold to fixity as an ideal, and the reality of the process-led and temporary character of Internet art. The former is a dream of the immutability of the art object; the latter a visible manifestation and dramatisation of the condition of art even in the offline world, its original meanings changing, growing and eroding as its social, political and institutional framing shifts.

Online business, like business generally, favours short-term memory. The promised confluence of the Internet and television is indicative of the urge to make the online realm a flowing, disposable experience. The market must

9 Peter Schaeur, 'Keeping Net Art Live' [interview with Alex Galloway], *The Art Newspaper*, no.113, April 2001; also available at www.rhizome.org
10 The archive was started in 1996; until 2000, however, it only stored text. See www.archive.org; also Ann Kellan, 'Company Aims to Preserve Web History', CNN news site, 7 July 2000.

015/*Xanadu* 1972
Simulation of transpointing
windows in 1972 with
cardboard-and-plastic model
on top of a Selectric typewriter.
Photo and cardboard model
by Ted Nelson. Human model:
Pat Crepeau

constantly tear up the old and the static in a perpetual revolution of products, momentarily recuperating the old only to force onwards with nostalgia some renovation of the present. Faced with this situation, as Thomas Frank points out, there are business manuals that seriously recommend 'an epistemology of constant forgetting, of positive militancy against cultural memory'.[11] Again, the Internet only brings into dramatic contrast the situation that exists offline, in which the glut of information, the vast memory systems of the administered world, strive to record all useful knowledge, while cultural and historical amnesia proceed apace.[12] Artworks, online and off, can sometimes act as points of resistance against that continual erosion. The most systematic project of this resistance is Ted Nelson's *Xanadu* (1972 onwards). [015] Nelson coined the term 'hypertext' in 1965, and has thought deeply and written extensively about its potential.[13] *Xanadu* is a project of enormous ambition, intended to give computer text the temporal depth that it currently lacks. The consequences, thinks Nelson, will be profound:

imagine a new accessibility and excitement that can unseat the video narcosis that now sits on our land like a fog. Imagine a new libertarian literature with alternative explanations so that anyone can choose the pathway or approach that best suits him or her; with ideas accessible and interesting to everyone, so that a new richness and freedom can come to the human experience; imagine a rebirth of literacy.[14]

The most important feature of *Xanadu* is that it has no option to delete: once something is published, it remains in place forever, and newer versions of the text, instead of replacing the old ones, simply step to the fore, linked to their ancestors. These links, which are always two-way (unlike the hierarchical one-way links of the Web), also adhere to content so that if data is moved, the links are maintained. Texts can also be compared, and differences between them highlighted. Citations establish links, or are like windows in which a text appears in its host, and given this mechanism could be used to compensate their authors automatically.

Nelson has been pursuing this project for three decades, and it is often discussed as though it were the ultimate in 'vapour-ware', a project that will never become a product.[15] A working version has, however, been produced.[16] Yet the issue of *Xanadu's* technical viability is not the most pressing criticism facing the project: it offers a purely technological solution to what is also a social, economic, political and cultural problem.

11 Thomas Frank, 'Dark Age', in Thomas Frank and Matt Weiland (eds.), *Commodify Your Dissent: Salvos from The Baffler*, W.W. Norton & Co., New York 1997, p.269.
12 On this issue, see Theodore Roszak, *The Cult of Information: A Neo-Luddite Treatise on High-Tech, Artificial Intelligence and the True Art of Thinking*, University of California Press, Berkeley 1994.

13 Theodor Holm Nelson, *Literary Machines*, Swathmore, Pa. 1981; for more information on *Xanadu*, see www.xanadu. net

14 Nelson 1981; cited in George P. Landow, *Hypertext 2.0: The Convergence of Contemporary Critical Theory and Technology*, The John Hopkins University Press, Baltimore 1997, p.274.

15 For such an account, see Gary Wolf, 'The Curse of Xanadu', *Wired*, June 1995; www.wirednews.com/ Nelson's own account can be found at http://xanadu.com/
16 It is available at www.udanax.com

016/Mark Napier,
Digital Landfill 1998
www.potatoland.org/landfill

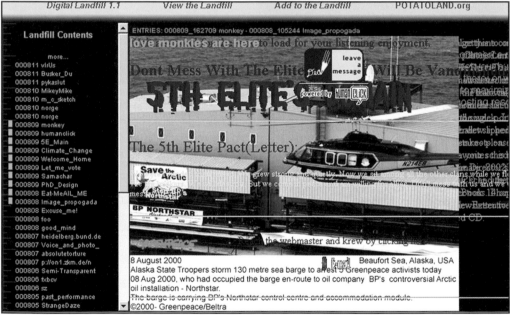

Given this, it is an open question whether Nelson's program, even if it was successful, would not merely add to the glut of unassimilated data. While *Xanadu* sets the parameters within which process and history can be grasped, it cannot in itself offer any prospect that it will produce the opportunity and the will to do so.

As the Net stands, deletion does remove material, and any grasp of the way the online environment, including artworks, has changed is reliant on people's memories. If Internet artists meet so often in conferences and colloquia, and if bulletin board systems are so important to them, it is in part because talk and written conversation keep memories alive. Some artists have also made visible the process of continual deletion. Potatoland, run by Mark Napier, highlights the junking of data with works such as *Digital Landfill* 1998, a live visualisation of text and image fragments being laid over one another in the process of disposal (visitors can add their own data to the dump). [016] The work also offers an archaeological palimpsest of online material, which can be excavated to reveal users' interests or hates ranging from politics to pornography. Napier has also made a site called *Shredder 1.0*, which does what its name suggests to data on a site the user chooses.[17] This work, says Napier

'strips away the illusion of permanence and solidity, and exposes the frailty of a medium that relies on software instructions to create the appearance of a consistent environment.'[18]

While Potatoland makes manifest the disposal of data, Redundant Technology Initiative (RTI) do the same for hardware.[19] Computers age far more rapidly than the physical deterioration of their components as complementary developments in software and hardware move on at speed. RTI persuades businesses and individuals to donate their 'redundant' machines which they then put to two main purposes: machines are built into art installations, either stripped down into components or as functioning displays akin to video-walls [048]; or the machines are renovated, loaded with free, Open Source software and put to use in the group's Sheffield-based community computing centre. RTI is devoted to the ideal of 'no cost technology', and with donated hardware and free software, it approaches this goal. The main cost of its work is labour but for many people in the Sheffield area, one of the most deprived in Europe, time is plentiful. Users of the computer centre who help out can earn, not money, but RTI credit slips that can be set against the centre's fees. In its creation of an alternative micro-economy (a limited form of

17 www.potatoland.org
18 Mark Napier, statement in Hans-Jörg Bullinger et al. (eds.), *Net Art Guide*, Fraunhofer IRB Verlag, Stuttgart 2000, p.287.
19 RTI's site is at www.lowtech.org

Local Exchange Trading System scheme), and in its refusal to take corporate sponsorship to create art using expensive, up-to-date technology, RTI established a functioning alternative to the general run of gallery-based media art, one that is in sympathetic alignment with the alternative economic practices of many activists online.[20]

Vuk Cosic, asked about his activities before he became a Net artist, talked of his political activities in Belgrade but also of his training as an archaeologist, commenting that this was in fact highly relevant to his current work, since all you had to do was turn the apparatus around, to point towards the future.[21] In both, there is the same examination of scraps for clues, and the same extrapolation from the present condition to the circumstances of a different era. Net art, then, is seen as an archaeology of the future, drawing on the past (especially of modernism), and producing a complex interaction of unrealised past potential and Utopian futures in a synthesis that is close to the ideal of Walter Benjamin. This is aided by the reprise of early computer graphics found in much Internet art. Cosic's own project to cross-breed out-moded ASCII graphics with video is an attempt to concertina different time frames in this way.[22] In Benjamin's dialectical images, future and past are encapsulated in frozen, radical forms, the utopian dream images of the past proving strangely contemporary, and projected into poignant relevance for viewers in the present.[23] This is just Internet art's relation to modernism.

Time online takes the form of a complex, congealed space, a space that is both experiential and physical. The Net has its own soft and hard space of sites and links, and of servers, wires, satellite and radio links, the two being intimately conjoined, so that virtual and physical space react continually in response to one another.

Two persistent and pervasive myths about the Internet run as follows: there are vast numbers of people online, and they are to be found in every corner of the globe. In fact, there are few people online, and they are geographically concentrated. Internet provision is heavily concentrated in the US, and in Europe and Japan to a lesser extent, and there are many areas of the world that have little or no access. Estimates of the number of people online are inexact, but in January 2001 a site that averages out numerous surveys gave a figure of just over 374 million, which is around 5 per cent of the world's population. While over 130 million of those live in North America, over 83 million in Europe, and 27 million in Japan, fewer than 11 million live in South America, and about 2.5 million in Africa.[24] National growth has been

20 RTI's statements about corporate sponsorship can be found on their website. For an account of LETS, see Finn Bowring, 'LETS: An Eco-Socialist Initiative?', New Left Review, no.232, Nov.–Dec. 1998, pp.91–111. See also www.gmlets.u-net.com
21 Tilman Baumgärtel, 'Interview with Vuk Cosic', nettime posting, 30 June 1997.
22 See www.ljudmila.org/~vuk/

23 See among Benjamin's work, especially The Arcades Project, trans. Howard Eiland and Kevin McLaughlin, The Belknap Press of Harvard University Press, Cambridge, Mass. 1999. This work was left uncompleted; for a fine account of it, see Susan Buck-Morss, The Dialectics of Seeing: Walter Benjamin and the Arcades Project, The MIT Press, Cambridge, Mass. 1989.
24 See the Nua Internet Surveys: www.nua.ie/surveys

018/Vuk Cosic,
War in Yu 1999

extremely uneven, being generally reliant on state incentives and co-ordination. China's effort to get its population online is one of the few examples of such state initiatives outside the First World. The unevenness of Internet access can be grasped by looking at the many attempts to map the geographical shape of cyberspace. [017][25] Globally, most people do not own telephones, let alone multimedia computers, and there are of course many places that have no electricity supply, or one that is intermittent and unreliable. If Africa (barring South Africa) has been largely untouched by the Internet, this is due not just to the poverty of most of its inhabitants but also to unreliable and scantily provided electricity supplies and phone lines.[26] While there is no simple divide between First World and Third (for the privileged and the impoverished are found everywhere, and the very wealthy make use of their own power supplies and satellite links where the local infrastructure fails), the overall disparity is deep.

The number of people using the Net in Eastern European countries is very small (generally 2 per cent of the population or less), except in Slovakia.[27] The disastrous economic trajectories of many former Eastern Bloc countries, pushed into precipitous neoliberal 'reform' by Western ideologues, have left little

room for such development except among tiny elites. Growth is, however, being encouraged by the large numbers of Eastern Europeans living and working abroad who are using online communication to stay in touch with those they leave behind, especially when these émigrés have fled from war zones where other methods of communication prove unreliable.[28] (Vuk Cosic has made a fascinating animated map of Yugoslav Internet routing infrastructure over ten days in May 1999, showing the way the system responded to the damage done by NATO bombing.)[29] [018]

Despite its rapid growth, the Internet is still dominated by elite users. A useful indication of Net user's profiles comes from an analysis of AOL members: most were college graduates; most had executive, technical or academic jobs; more than half were women (due in part to concerted efforts on the part of corporations and advertisers to attract them); and nearly a quarter of them earned more than $100,000 a year.[30] A recent survey of Internet access in the UK showed that, while home access was growing fast, the poorest households were least likely to have access: in the bottom 20 per cent of households grouped by income, between 4 and 5 per cent were online; in the top 10 per cent of households, it was very

25 For an atlas of cyberspace, see www.cybergeography. org/atlas/atlas.html Earlier world maps showing the growth of Internet hosts were published in Castells, and these clearly show the lack of access in the Third World. Manuel Castells, *The Information Age: Economy, Society and Culture*, vol.I: *The Rise of the Network Society*, Blackwells, Oxford 1996, pp.346–50.

26 See Castells, vol.III: *End of the Millennium*, Blackwells, Oxford 1998, pp.92–3, 122–3.
27 Comparative figures are given in Gary S. Schaal, 'Democracy and Censorship in the Net: The Internet in Eastern Europe', in Steven Kovats (ed.), *Ost-West Internet: Elektronische Medien im Transformationsprozess Ost und Mitteleuropas*, Edition Bauhaus/Campus Verlag, Frankfurt 1999, pp.154, 156.

28 This point is made by Kostadina Iordanova, 'The Internet: Opportunity, Intervention, Commitment', in Kovats 1999, pp.168–70.
29 Vuk Cosic, *War in Yu*, www.ljudmila.org/~vuk/ warmov/
30 See Korinna Patellis, 'E-Mediation by America Online', in Richard Rogers (ed.), *Preferred Placement: Knowledge Politics on the Web*, Jan van Eyck Akademie Editions, Maastricht 2000, p.53. Women outnumbered men

online in the US for the first time in the first quarter of 2000. For information about Internet demographics, see http://cyberatlas.internet. com/ For corporate attempts to attract women to the Web, see Dan Schiller, *Digital Capitalism: Networking the Global Market System*, The MIT Press, Cambridge, Mass. 1999, pp.138–9.

nearly half. There were also strong regional differences (which can themselves be partly correlated to income), showing high take-up in London and the Southeast, and low take-up in the Northeast, Scotland and Northern Ireland.[31] While there has been much talk of a 'digital divide', in which new forms of inequality spring from the adoption of information technology, the divide seems to follow closely the old lines of disadvantage. Making a different but connected point, Manuel Castells, reviewing and analysing data from various countries, concluded that the familiar divisions of nation and region, gender, race and age were much stronger determinants of advantage and disadvantage than that of access to or working with high technology.[32]

While the provision of Net access is concentrated among the fortunate, the production of content for the Internet is more concentrated still. Looking at the geographical distribution of Internet art production raises a number of questions, for it does not quite correspond either to the prominent art-world centres, or to the geographical production of Internet content.

While the US is very prominent globally in use of the Internet, it is far more so in the production of online content. This concentration of online production fits in with broader trends

in the globalised economy. Since globalised businesses deal with complex and changing situations across many countries and cultures, they require varied and specialised skills and services. These services have become concentrated in developed countries, and in small areas of those countries, particularly large cities of global renown. So while the physical production of goods may be widely scattered, its co-ordination tends to be concentrated in cities where networks of financial, legal, accounting, advertising and other corporate services tend to cluster.[33] Internet provision, particularly of broadband services, is not only uneven between countries, but between and within regions, and even within the global cities themselves that tend to have large areas housing pools of impoverished and intermittently employed workers.[34] In this way, as Saskia Sassen points out, digital services are part of an organisational chain of business that is both dependent upon and helps to form the built environment. Good transport links, for instance, complement, and are not replaced by, advanced online communications infrastructure. The great cities communicate, invest and trade intensively with each other and, as they do so, tend to separate themselves off from the local conditions of the areas that surround them.[35]

31 The report was produced by the Office of National Statistics; www.cabinet-office.gov.uk/e-envoy/ See also Paul Kelso and Guy Adams, 'As One in Four Homes Go Online, the Country's Digital Divide Widens', Guardian, 11 July 2000, and the supplement 'People Online' to The New Statesman, 18 December 2000.
32 Castells, I, 1996, p.220.

33 On this point, see Saskia Sassen, Losing Control? Sovereignty in an Age of Globalization, Colombia University Press, New York 1996, pp.10–11.
34 Sassen makes this point in relation to New York and Los Angeles. See Saskia Sassen, 'Private and Public Cyberspace', in Josephine Bosma et al (eds.), Readme! Filtered by Nettime: ASCII Culture and the Revenge of Knowledge, Autonomedia, Brooklyn 1999, p.98. See also Schiller 1999, pp.111–12.

35 Saskia Sassen, 'The Topoi of E-Space: Global Cities and Global Value Chains', in Catherine David and Jean-François Chevrier (eds.), Politics-Poetics: Documenta X – The Book, Cantz Verlag, Ostfildern-Ruit 1997, pp.737–8. For a thorough account of the interactions between online and urban space, see Stephen Graham and Simon Marvin, Telecommunications and the City: Electronic Spaces, Urban Places, Routledge, London 1996.

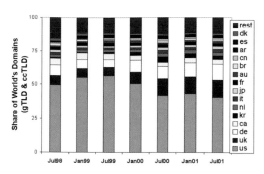

019/Matthew Zook, *Domain Names Worldwide* 1998–2001

Matthew Zook has researched the geographical distribution of online producers, revealing the striking degree to which the Net is centralised.[36] [019] Prominence in this arena does not simply follow raw economic power, but is instead often associated with those economies most reliant on financial services and armaments. The UK, which has many online producers, is unusual in that its financial economy is not merely larger but vastly greater than its productive economy.[37] In contrast, Japan, an ailing though massive industrial economy, has the lowest proportion of online producers in all the OECD countries. This is perhaps due to rigid state-directed industrial innovation programmes and the strong hold of traditional hierarchies, but also perhaps to difficulties with producing content in English, still the dominant language of the Web.[38] While the production of Internet content is slowly diffusing, the dominance of the US remains extraordinary – ninety-four of the top 100 websites are based there. David Rothkop, a commerce official in the Clinton administration, rightly claimed that the US 'is the world's only information superpower.'[39] Within the US, content production is highly concentrated, three regions standing out above all others – San Francisco, New York and Los Angeles. Online as well as offline, US citizens hold a special place in the consumption of culture since their home product is also the dominant global cultural force.[40]

Yet the early production of Internet art poses a puzzle, for it did not follow this pattern. The dominant centres were found in parts of Europe including Britain, Russia, Slovenia, Germany, and the Netherlands, and only to a lesser extent in the United States. The situation in Eastern Europe is perhaps the easiest to explain. It could not have happened without the fall of the Communist regimes from 1989 onwards and the exposure of those countries to neoliberal economic strictures, with very mixed results, ranging from modest economic success in the Czech Republic and Slovenia to historically unprecedented catastrophe in Russia. Education, including art schools, had been well funded under the old regimes, and standards had been high. Furthermore, some Eastern European artists had long been used to making underground art that had no ready market, that subverted dominant ideological images, that had to be distributed outside mainstream channels, and for which the character of the audience could only be guessed at.[41] This gave them a considerable head-start in the mind-set required for Internet art. Online activists were aided by the philanthropic efforts

36 Zook's work can be found on www.zooknic.com/ For a brief account of this work, see Jamie King, 'Alongside Us, Them', *Mute*, no.15, 1999, p.17.
37 See the figures for transborder financial flows in Castells, I, 1996, p.94.

38 A recent survey estimated that just under three-quarters of the pages on the Web were written in English; Japanese was the next most common language but registered only 7 per cent. See Geoffrey Nunberg, 'The World Wise Web', *Guardian Editor*, 14 April 2000.
39 Cited in Schiller 1999, p.82.

40 See Fredric Jameson, 'Notes on Globalization as a Philosophical Issue', in Fredric Jameson and Masao Miyoshi (eds.), *The Cultures of Globalization*, Duke University Press, Durham, NC 1998.
41 See, for example, Margarita Tupitsyn's essay in *Sots Art*, New Museum of Contemporary Art, New York 1986.

of the Soros Foundation which supplied Internet equipment and training as part of its attempts to build 'civil society' in the vacuum left by the evaporation of Communist Party structures.[42] The purpose behind this effort was to accustom people to computer communications technology, a precondition for bringing former Eastern Bloc countries into the globalised economy. (Recently, this funding has been scaled down, as Soros no longer considers these countries to be special cases, having achieved the transition to being averagely impoverished nations.)[43]

Much early Internet art was also made in Britain.[44] Among the legacies of the Thatcher government, with its contempt for high culture and withdrawal of state funds from the arts, was a bifurcation of the art world. Of the two factions that developed in the years of Thatcher's second recession, the first was the market- and PR-savvy, sensationalist tendency of so-called 'young British art'; the second, the development of a disparate group of practices that maintained a degree of social engagement, making performance work, some forms of installation, community arts, street actions and also Internet art.[45] As the first strand became notorious, the second modelled itself in explicit opposition, preferring action over spectacle, contact with an audience over publicity, and conversation over visual catchphrases. The growth of Internet art was helped by factors that favoured the development of computer culture as a whole: the common language with the US; the traditionally early and rapid national take-up of consumer technologies (compared, for instance, to the rest of Europe); and a strong IT sector, including the computer-games industry. So in the mid 1990s Britain had a fertile mix of technological opportunity and dissident opinion.

For diverse reasons, other countries in Western Europe made an early contribution to Internet art. These included strong state support for Internet communities (especially in the Netherlands). Furthermore, small countries have traditionally found communicable media art attractive since regional centres have more to gain from remote communication than global cities which find it easy to attract collections and exhibitions of rare art objects. The importance of the English language should not be underestimated, and may be one of the reasons for the prominence of Net activism and culture in those European countries where English is most widely and effectively taught – Germany and the Low Countries.

That the US did not immediately dominate the Internet art scene is a surprise. After all, it has huge

42 On Soros's Internet programs, see the email exchange between Geert Lovink and Jonathan Peizer, 'The Ins and Outs of the Soros Internet Programme in Former Eastern Europe', in Frank Boyd et al (eds.), New Media Culture in Europe, Uitgeverij de Balie/ The Virtual Platform, Amsterdam 1999.

43 See Nina Czegledy, 'Shifting Paradigms – Shifting Grounds', in Kovats 1999, p.185.
44 This point is made by Robert Adrian, 'Net.Art on nettime', nettime posting, 11 May 1997.

45 For an analysis of 'young British art', see Julian Stallabrass, High Art Lite: British Art in the 1990s, Verso, London 1999; for the alternative strand, see Duncan McCorquodale, Naomi Siderfin and Julian Stallabrass (eds.), Occupational Hazard: Critical Writing on Recent British Art, Black Dog Publishing, London 1998, and Ikon Gallery, Out of Here: Creative Collaborations Beyond the Gallery, Birmingham 1998.

advantages, including the size of its unified market, the wealth of its consumers, and the lead of its industry in every element of hardware and software manufacture. Yet these advantages were matched by the power of the US art world. The recession that produced both 'young British art' and its alternative shadow was less severe and prolonged in its effects on the US art world, which had begun to recover by the time Web browsers were marketed in the mid 1990s. At its inception, Internet art was a marginal and oppositional practice produced in reaction to various failures in the wider art world. The centres of the US art world were (and are) the least marginal and best connected on Earth. If it was not prominent at the birth of Internet art, the US became increasingly so as the new art was drawn into the mainstream. Strong US support for Internet art has since come from prominent art institutions, including the San Francisco Museum of Modern Art, the Walker Arts Center and the DIA Center.

Similar considerations can account for those places where relatively little Internet art is produced. The manner in which computer communications technology has been deployed has often increased inequality, both between and within countries and regions. So far, there has been relatively little in the way of Third World

Internet art.[46] This reflects the fact that little online content of any kind is produced outside the developed countries. The exceptions are instructive in themselves: the large and fast-growing Indian software industry caters to export markets, producing little that is sold in India, and less in local languages. There, the Net has been embraced by small urban elites, many of them involved in the rise of right-wing Hindu politics.[47] Popular usage of computing in India is confined to networks established by small local entrepreneurs, previously involved in pirate cable television, and (like RTI) using recycled equipment.[48] Other Third World voices gain access to the Web, but only by proxy. The Zapatista rebels, based in the southernmost Mexican state of Chiapas, are renowned for their online presence, particularly the affecting, poetic writings of their spokesperson, Subcommandante Marcos. Yet their communiqués cannot be uploaded to the Web by the Zapatistas themselves (much of Chiapas lacks electricity, and in any case operating mobile links invites bombs or missiles) but must be committed to paper and smuggled through army lines.[49]

A Mexico City-based site, the home of Mejor Vida Corp run by Minerva Cuevas, uses the Web to advertise the offer of free goods to anyone

46 *Third Text*, a journal that examines Third World perspectives on contemporary art and culture, devoted a special issue to the subject, guest edited by Sean Cubitt in Summer 1999.
47 See Ravi Sundaram, 'The Nineteenth Century and the Future of Technocultures', *Mute*, no.11, 1998, pp.46–51.
48 For a fascinating account, see Ravi Sundaram, 'Recycling Modernity: Pirate Electronic Cultures in India', *Third Text*, no.47, Summer 1999, pp.59–65.
49 See Juana Ponce de Léon, 'Travelling Back for Tomorrow', in Subcommandante Insurgente Marcos, *Our Word Is our Weapon: Selected Writings*, ed. Juana Ponce de León, Serpent's Tail, London 2001, p.xxiii.

who wants them, including student cards, and various items to help you survive Mexico City's subway system, including tickets, caffeine pills and tear gas. MVC also offers barcode stickers which can be printed out to reduce the price of supermarket shopping.[50] Cuevas's activism thus centres less on the development of community and conversation than on the amelioration of poverty and protection of the person.

The difficulty with making Internet art in much of the Third World is not merely technological but social and cultural. Online activity – contributing not merely looking – is the fastest way to make sense of Internet art, and without it, as Ravi Sundaram comments, the avant-garde of Net artists seem 'grounded in a bizarre self-referentiality, which is quite puzzling to a critical Third World observer.'[51] It can be hard enough for culturally informed Westerners to grasp much of this work, let alone for those of different cultures and languages, and those with expensive and uncertain access to the Net (and it should be remembered once again that the vast majority of the world's population has no access at all).

This discussion of the national conditions for the production of Net art applies only to the area of production. Its reception is, in principle, something else again, and artists have used the Net precisely

to escape from their national branding. Shulgin says that when he worked with objects, his work was always seen as specifically Russian, and was only considered within that cultural niche. Yet his online work is treated as if it has no nationality.[52] This advantage has to be fought for, as the number of available names for sites shrinks, leading to many sites being identified by a national extension such as 'uk' or 'nl'. Dirk Paesmans of Jodi argues that artists should use their own named domains, rather than put their work on other pre-named sites. One advantage is a matter of identity – that artists or groups can establish their own name without intermediaries – but another, if an extension such as 'org' or 'com' is available, is that the nation of origin will not be immediately known.[53]

So far we have looked at the intersection of physical and online space, at the imprint on the apparently borderless virtual world of material infrastructure and nationhood. Yet what does site mean on the Net itself? As the process of online commercialisation gathered pace, with a few significant differences, it came to mirror the hierarchies of offline space. Accessibility in cyberspace, writes William J. Mitchell, can be judged by the average number of hyperlinks needed to take a user from a random starting

50 Mejor Vida Corp;
www.irational.org/mvc/english.
html
51 Sundaram 1999, p.51.

52 Josephine Bosma,
'Interview with Alexei Shulgin',
nettime posting, 14 May 1997.
53 Josephine Bosma,
'Independent Net.Art', nettime
posting, 6 July 1997.

point to a particular site. Online 'neighbourhoods' are formed of linked sites, and may be large, dense and frequently visited, or small, isolated and rarely visited. (One of the practical uses of I/O/D's *Web Stalker* is that it maps out the link structure of an online locality.) On the Web, the equivalent of having a sign facing the street is putting an advert on a much-visited site, though, of course, there are many streets to be covered, and each sign serves also as a gateway to the advertised site. Advertising space on mainstream entertainment sites or search engines is scarce and valuable, just as it is in top tourist spots.[54] Unlike physical space, online space is not isometric: relations of nearness do not have to be reciprocal, since many sites link to others that do not link back. Many commercial sites make a point of never linking out, so a path that is easy to traverse one way may have a much steeper gradient on the return journey (which is why the 'Back' button that allows a user to retrace their steps is the most frequently used function of Web browsers, and why some sites disable it).

It has become a commonplace of postmodern theory that it is impossible to grasp the complexity of cyberspace, just as it is to grasp that of postmodern capital as a whole.[55] Yet, as with the visualisation of the movement

of stocks and shares, cyberspace mapping is of great usefulness, and is itself evolving into a sophisticated technology.[56] Such maps can show the national distribution of Internet traffic [as in 017] but can also be used to illustrate the data-space of the Internet itself. While the dataset on which these maps are based is very large and complex, it is also well-defined and, of course, digital (a site either links to another or does not, there are no shades of analogue uncertainty). Contour maps have been developed to show the prominence of certain subject areas by the number of pages devoted to them, and their relatedness by their proximity to each other.[57] Such maps become tools in the battle for Web supremacy, since their visualisations allow the more effective positioning of a viewpoint or product as spatially central.[58]

Given that links (rather than mere hits) have become an important tool in gauging online reputations, any conception of online space should connect infrastructure and content.[59] As Korinna Patellis has forcefully argued, infrastructure and content cannot be separated into analyses focusing respectively on politics and culture. Rather, the online world is the intersection of five industries: telecommunications, software, Internet service provision, navigational tools and

54 William J. Mitchell, 'Replacing Place', in Peter Lunenfeld (ed.), *The Digital Dialectic: New Essays on New Media*, MIT Press, Cambridge, Mass. 1999, pp.123–5.

55 On mapping the space of late capitalism, see Fredric Jameson, *Postmodernism or, the Cultural Logic of Late Capitalism*, Verso, London 1991, especially chap.1; for an example of the mantra that online space cannot be grasped, see William J. Mitchell, *City of Bits: Space, Place and the Infobahn*, The MIT Press, Cambridge, Mass. 1995, p.8.

56 On cyberspace mapping, see Martin Dodge, 'Mapping the World Wide Web', in Rogers 2000. For a selection of cyberspace maps, see www.cybergeography.org/atlas/
57 As discussed by Dodge in Rogers 2000, p.85. See www.newsmaps.com
58 An additional complication is that as the Internet goes mobile, attempts to map it statically are rendered obsolete. While surveillance of mobile

users is commercially driven, civil liberties are also at issue here. On mapping the mobile networks, see Leon Forde, 'Roadmaps for the Superhighway', *Guardian*, Online section, 29 June 2000.
59 On links as the basis for online reputation, see Richard Rogers and Ian Morris, 'Operating the Internet with Socio-Epistemological Logics', in Rogers 2000, p.149.

the provision of content.[60] The experience of a site is dependent upon the interaction of all these elements, and links in and out of a site are as much a part of its character as the content it carries. The Net can be thought of as a space for the exchange of information, or more crudely a competition of views, in which content and the structure in which it is delivered influence one another. As in four-dimensional space-time, in which large bodies (such as stars) distort the flow of space and time around them, pulling objects into their orbit, similarly sites with many links in, and 'sticky' sites (those which are good at keeping their visitors once they arrive) govern the virtual space around them, pulling in people and links, slowing the usually rapid pulse of online time. Seen this way, the very space of the Net, a socially constructed force that nevertheless appears to be as pervasive and inescapable as gravity, is structured by economic power.

Given that search engines select sites to display, and order them to favour the best connected and funded, even the best-known art websites can be missed by people new to looking for them (type 'Internet' and 'art' into a search engine and you will generally get a list of sites selling paintings). Jon Thomson, noting this difficulty, writes:

faced with such a murky mass of disorganised data, many online artworks are actually built around the need to advertise their presence, or alternatively end up commenting on the communication processes which are inherent to the network itself.[61]

Various commonly used Internet art techniques (which we will look at in more detail later) are employed to alter the shape of online space-time. There are many sites that are reluctant to let the user go once they have arrived, taking over control of the browser. This is a primitive form of stickiness, indicative both of the difficulty of getting users to little-known sites and of persuading them to stay, but also a sabotage of the usual onward flow of surfing. Capturing users by, say, hacking search engines, as Etoy has done, introduces a wormhole into the commercial space of the Net. Similar effects can be generated by establishing fake sites for well-known companies or celebrities, as RTMark has for Shell and George W. Bush, among others [029, 030]. Most importantly, activists may also shape online space-time with the force of their own unpaid labour, establishing structures that compete with those in which influence is purchased.

The experience of online space, though linked to hierarchy, is strongly differentiated

60 Korinna Patellis, 'E-Mediation by America Online', in Rogers 2000, passim.

61 Jon Thomson, 'Old Tricks', Art Monthly, no.227, June 1999, p.52.

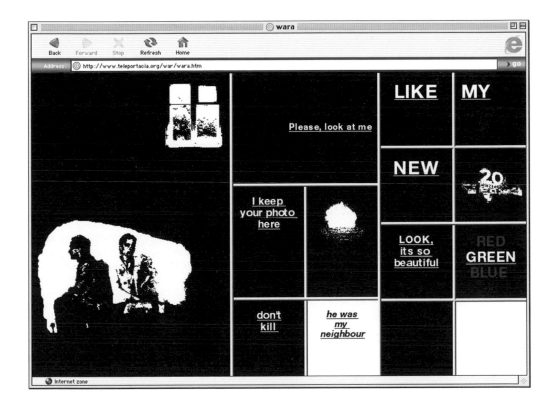

in more subjective ways, depending on many variables, not least the user's capacity for spatial visualisation. Many people have difficulties navigating online space. Indeed, people's ability to navigate virtual spaces varies widely, and is not confined to the usual clichés about, say, gender or profession (a study of male engineers found a twenty-fold difference in their virtual orientation abilities).[62] The broad, shallow space of the Web is a complex branching structure laid out in low relief. This quality is well indicated by the musings of Shelley Jackson, a hypertext author, on the character of her creation in a piece of writing buried deep within the work itself:

My reading is spatial and even volumetric. I tell myself, I am a third of the way down through a rectangular solid, I am a quarter of the way down the page, I am here on this page, here on this line, here, here, here. But where am I now? I am in a here and a present moment that has no history and no expectations for the future.[63]

The flat intersecting plains of reading are familiar from books: How far am I down the page? How far am I through the book (are there more pages before or after the bookmark, how far to the end of this chapter? and so on). The experience of hypertext seems more than merely two-dimensional (especially for those who trace and retrace their steps) but at the cost of abandoning linear narrative, so that time ceases to run, like the progress through a book, in one direction. Olia Lialina's *My Boyfriend Came Back from the War* 1996, an online hypertext narrative, employs such a structure, the user being presented, as they click through its links, with a proliferating number of windows carrying phrases and pictures about the difficulty of communicating with a boyfriend returned from war. No guide is given about the sequence in which the links should be followed.[64] [020] Josephine Berry argues that *My Boyfriend…* sets up an antagonism between the author and the user, alienation between the two being established both by the content of the messages displayed ('Nobody here can love or understand me') and the format of the piece, as the user clicks through screens without orientation.[65] The shuffling back and forth through different elements of the narrative strands is like the laying out and relaying out of a pack of cards. As in Raymond Queneau's *Cent mille milliards de poèmes*, in which each line of each poem sits on its own strip of paper so that it can appear in any poem in the book, the number of combinations in *My Boyfriend…* multiplies enormously until one is presented, bit by bit, with a vast number of alternatives forged from the same limited material.[66]

62 This is discussed in Andrea Moed, 'European Union's i3', in Janet Abrams (ed.), *If/Then Play*, Netherlands Design Institute, Amsterdam 1999, p.34.
63 Cited in Robert Coover, 'Literary Hypertext: The Passing of the Golden Age', *Feed Magazine,* 8 February 2000; www.feedmag.com (now available on nickm.com/ vox/golden_age.html). The quote is from Jackson's *Patchwork Girl,* available as a CD-ROM from Eastgate Systems.

64 www.teleportacia.org/war/
65 Josephine Berry, 'The Thematics of Site-Specific Art on the Net', PhD thesis, University of Manchester, 2001; www.daisy.metamute.com/ ~simon/mfiles/mcontent/ josie_thesis.htm
66 Raymond Queneau, *Cent mille milliards de poèmes,* Gallimard, Paris 1961. Queneau was interested in the potential of computers to generate poetry.

The making of such complex structures, using blind links which leave the user disoriented, is so regularly employed as to have become a cliché of Internet art. Such works create their own involuted space, and users tend to flounder through them with due aimlessness. George Landow has argued that these spaces are salutary manifestations of postmodernism, encouraging the realisation that texts are borderless, being collages of other textual elements, and are created by the reader as much as the writer.[67] In tracing our way through such intricate works, however, we should not forget their place within the strongly hierarchical, well sign-posted and ordered space of the Net. Since the two kinds of space are so different in character, it is not surprising that one may annihilate the other. For writer and electronic-text theorist, Robert Coover, the 'golden age' of hypertext narrative was based on discrete objects – CD-ROMs and diskettes – which, like books, can be shelved, located in physical space and are available, unchanged, for repeated viewings. The Web, by contrast has not been a hospitable place for hypertext narrative:

It tends to be a noisy, restless, opportunistic, superficial, e-commerce-driven, chaotic realm, dominated by hacks, pitchmen, and pretenders, in which the quiet voice of literature cannot easily be heard or, if heard by chance, attended to for more than a moment or two. Literature is meditative and the Net is riven by ceaseless chat and chatter. Literature has a shape, and the Net is shapeless.[68]

While it may be a mistake to think of the Net as shapeless, it is true that a slow, meditative approach to reading is not encouraged by the very openness of the Net, the constant anticipation of the currently hidden. More than this, delicate works that should act as lessons in the postmodern virtues of the borderless, the liminal, the self-referential are contending with powerful commercial hierarchies.

Online space and time are as effectively moulded by economic power as are their counterparts in the physical world. Nevertheless, users may work against the overall character of online space-time; individually, through acts of concentration and engagement, and in simple acts like printing out pages to read at their leisure; and more importantly, collectively in forging their own environments by discourse and with labour. Peer-to-peer networking, in which users communicate and exchange files with one another without centralised control, is helping to undercut hierarchies built on the Web. In all these ways, the very malleability of online space-time continues to offer extraordinary opportunities.

67 George P. Landow,
Hypertext 2.0: The Convergence of Contemporary Critical Theory and Technology,
The John Hopkins University Press, Baltimore 1997, passim, but especially pp.25, 81, 156.

68 Coover 2000.

Interactivity

Aside from being distributed data, Internet art has another feature that distinguishes it from much other art production – it is interactive. The spectrum of interaction on offer shades from the minimal choice involved in clicking through a set sequence of pages to permitting users to create the work themselves.

There are many examples of collaborative works of art in which users add to a project within a frame set up by the initiator. Among the best known is Douglas Davis's *The World's First Collaborative Sentence* 1994 [021], one of the first Internet artworks, to which tens of thousands of people have made contributions.[1] The idea is simple: anyone can add to the sentence, the only rule being that no one is allowed to finish it by adding a full stop. Over the years, its changing character has come to reflect developments on the Web. As Davis puts it:

> The contributions are now much more graphically sophisticated than before. The Sentence is hot pink now, pulsing with Java, video, audio, colour, everything. In the beginning it was black and white but rich with soul and personality.[2]

It also reflects the character of Net discourse in other ways, with its fractious rants, self-advertisements and myriad minor obsessions, its links to homepages and porn sites, its many

1 http://artnetweb.com/projects/
projects.html
2 Tilman Baumgärtel, 'Interview with Douglas Davis', Rhizome, 17 May 2000. For Davis's own account of the *Sentence*, see Douglas Davis, 'The Work of Art in the Age of Digital Reproduction (An Evolving Thesis: 1991–1995)', *Leonardo*, vol.28, no.5, p.382.

dead links, and in being the victim of vandalistic hacks (including, of course, the addition of full stops).[3] Likewise, John Maeda made a piece with the same structure called *One Line Project* 1999, using an unbroken line to which people can add but never finish.[4] Such works allow contributors freedom of expression within certain rules but the limits that matter most are not about periods or broken lines, but about the appropriation within the artist's frame of everything uploaded to the work. In an interview with Davis, Tilman Baumgärtel asked whether the *Sentence* was truly interactive or was rather just another kind of form-filling, common on the Net.[5] That question acutely raised the issue of whether contributors to such works are any more than sociological specimens who supply data for the artist.

In principle, interaction holds out great cultural and social benefits. It should empower users, encourage cultural activity, rather than mere spectating, and make art more responsive to its audience, opening art's exclusive and (for many) intimidating spaces and discourse to the breezes of inclusiveness and democracy. Yet there appears to be a fundamental problem with interactivity as it has actually developed in Internet art, which is inscribed in the suspicions of many online artists about the term, and in the surprisingly

impoverished character of interactivity that many of their works offer. Alexei Shulgin articulated common doubts among artists about the much-vaunted term:

I don't believe in interactivity, because I think interactivity is a very simple and obvious way to manipulate people. Because what happens with so-called interactive art is that if an artist proposes an interactive piece of art, they always declare: 'Oh, it's very democratic! Participate! Create your own world! Click on this button and you are as much the author of this piece as I am.' But it's never true. There is always the author with his name and his career behind it, and he just seduces people to click buttons in his own name.[6]

Shulgin claims that his own response, to organise a competition for 'form art' with a prize, was more honest: people still worked for him but at least he paid them something.[7]

There is certainly little interactivity offered by the many web-based works of art that simply require the user to click blindly through a series of screens. Implementing greater interactive depth over the Web, involving an exchange between people, or people and machines that have a degree of autonomous action, requires complex, sophisticated programming that

3 The *Sentence* is now owned by the Whitney Museum of American Art, New York, and will be printed out to make 'The World's First Collaborative Book'.
4 www.maedastudio.com/olp98/index.html
For Maeda's work as a whole, see his book *Maeda@Media*, Thames & Hudson, London 2000.
5 Baumgärtel, 'Interview with Douglas Davis'.

6 Shulgin cited in Tilman Baumgärtel, 'Art on the Internet – The Rough Remix', in Josephine Bosma et al. (eds.), *Readme! Filtered by nettime: ASCII Culture and the Revenge of Knowledge*, Autonomedia, Brooklyn 1999, p.237.
7 http://remote.aec.at/form/competition.html (now expired)

021/Douglas Davis,
The World's First Collaborative
Sentence 1994
Commissioned by the Lehman
College Art Gallery
Diskette
Whitney Museum of American
Art, New York. Gift of Barbara
Schwartz in honour of Eugene
M. Schwartz

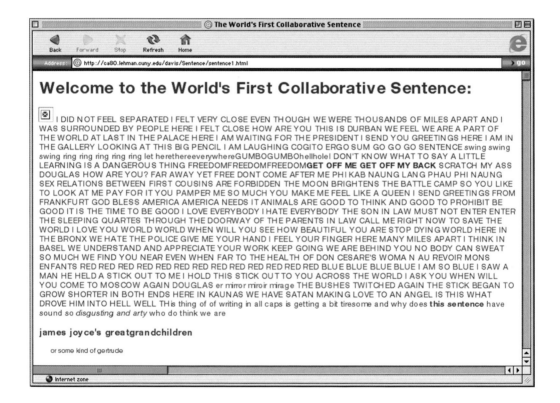

Welcome to the World's First Collaborative Sentence:

I DID NOT FEEL SEPARATED I FELT VERY CLOSE EVEN THOUGH WE WERE THOUSANDS OF MILES APART AND I WAS SURROUNDED BY PEOPLE HERE I FELT CLOSE HOW ARE YOU THIS IS DURBAN WE FEEL WE ARE A PART OF THE WORLD AT LAST IN THE PALACE HERE I AM WAITING FOR THE PRESIDENT I SEND YOU GREETINGS HERE I AM IN THE GALLERY LOOKING AT THIS BIG PENCIL I AM LAUGHING COGITO ERGO SUM GO GO GO SENTENCE swing swing swing ring ring ring ring ring let herethereeverywhereGUMBOGUMBOhellhole! DON'T KNOW WHAT TO SAY A LITTLE LEARNING IS A DANGEROUS THING FREEDOMFREEDOMFREEDOM**GET OFF ME GET OFF MY BACK** SCRATCH MY ASS DOUGLAS HOW ARE YOU? FAR AWAY YET FREE DONT COME AFTER ME PHI KAB NAUNG LANG PHAU PHI NAUNG SEX RELATIONS BETWEEN FIRST COUSINS ARE FORBIDDEN THE MOON BRIGHTENS THE BATTLE CAMP SO YOU LIKE TO LOOK AT ME PAY FOR IT YOU PAMPER ME SO MUCH YOU MAKE ME FEEL LIKE A QUEEN I SEND GREETINGS FROM FRANKFURT GOD BLESS AMERICA AMERICA NEEDS IT ANIMALS ARE GOOD TO THINK AND GOOD TO PROHIBIT BE GOOD IT IS THE TIME TO BE GOOD I LOVE EVERYBODY I HATE EVERYBODY THE SON IN LAW MUST NOT ENTER ENTER THE SLEEPING QUARTES THROUGH THE DOORWAY OF THE PARENTS IN LAW CALL ME RIGHT NOW TO SAVE THE WORLD I LOVE YOU WORLD WORLD WHEN WILL YOU SEE HOW BEAUTIFUL YOU ARE STOP DYING WORLD HERE IN THE BRONX WE HATE THE POLICE GIVE ME YOUR HAND I FEEL YOUR FINGER HERE MANY MILES APART I THINK IN BASEL WE UNDERSTAND AND APPRECIATE YOUR WORK KEEP GOING WE ARE BEHIND YOU NO BODY CAN SWEAT SO MUCH WE FIND YOU NEAR EVEN WHEN FAR TO THE HEALTH OF DON CESARE'S WOMA N AU REVOIR MONS ENFANTS RED RED RED RED RED RED RED RED RED RED RED RED BLUE BLUE BLUE BLUE I AM SO BLUE I SAW A MAN HE HELD A STICK OUT TO ME I HOLD THIS STICK OUT TO YOU ACROSS THE WORLD I ASK YOU WHEN WILL YOU COME TO MOSCOW AGAIN DOUGLAS er mirror miroir mirage THE BUSHES TWITCHED AGAIN THE STICK BEGAN TO GROW SHORTER IN BOTH ENDS HERE IN KAUNAS WE HAVE SATAN MAKING LOVE TO AN ANGEL IS THIS WHAT DROVE HIM INTO HELL WELL THis thing of of writing in all caps is getting a bit tiresome and why does **this sentence** have sound so *disgusting and arty* who do think we are

james joyce's greatgrandchildren

or some kind of gertrude

Address: http://ca80.lehman.cuny.edu/davis/Sentence/sentence1.html

Internet zone

8 Douglas Rushkoff,
'Coercion and Countermeasures:
The Information Arms Race', in
Gerfried Stocker and Christine
Schöpf (eds.), *InfoWar*,
Springer, Vienna 1998, p.226.
9 Paul Virilio in conversation
with Derrick De Kerckhove,
'Infowar', in Timothy Druckrey
and Ars Electronica 1999,
p.330.

many artists lack the skills and resources to produce. Douglas Rushkoff describes the results on the Web:

Unlike bulletin boards or chat rooms, the Web is – for the most part – a read-only medium. It is flat and opaque. You can't see through it to the activities of others. We don't socialise with anyone when we visit a web site; we read text and look at pictures. This is not interactivity. It is an 'interactive-style' activity. There's nothing participatory about it.[8]

Is the freedom offered by the artist to the user illusory, or rather, if freedom is offered as opposed to taken, must it be illusory? The offer of participation, as in computer games with their rigid constraints and criteria for success, may merely intensify conformity.

Paul Virilio has argued that the Internet is not an example of liberty but of 'social cybernetics'.[9] In other words, humans act as the feedback mechanism in a system that has its own autonomy: in visiting and clicking through sites, atomised users provide data about themselves that guides the machine to perfect itself; and it changes not quite to serve their needs but to exploit the dataset that is the sum of their inputs. Exercising the freedom to chose between limited and discrete options, they feed the system.

Much Internet art, far from providing meaningful interaction, plays on its very paucity. The bitter-sweet work of Thomson and Craighead subverts the illusion of interactivity.[10] Their piece *Weightless* 1999, for instance, presents the viewer with a collage of found elements taken from the Web, including animated GIFs (the generally cheesy little animation files that decorate pages), muzak, and lines of often cryptic or obscene communications from chat rooms. [022] *Weightless* comments on the commercialised banality of much Web content and pitches that against the raw communication of the chat rooms, suggesting that they have much in common: telegraphic style, immediate effect, and self-conscious shallowness. Furthermore, while users can activate the work by selecting from a sequence of buttons, their interaction with the piece is of the most basic point-and-click kind, triggering a series of events over which they have no anticipation or control. Such devices are often used to bring the user to realisation about the character of online interactivity.

The poverty of this interaction is enforced by the standard web browsers and the conventions of programming used to make websites. These demand a solipsistic view, and allow for only one kind of simple, one-way link. In hypertext narrative

10 Thomson & Craighead's work
can be found at www.thomson-
craighead.net

as it developed outside the Web, many different types of links were used, contributing to the richness of structure in these works, and opening up a wider variety of choices for the user.[11] On the Web, however, the user's choice is generally confined to clicking on a particular link or not.

In a fine essay about the computer games industry, Allucquère Rosanne Stone discusses the conditions laid down for genuine interactivity by Andy Lippman of MIT, which he defined as 'Mutual and simultaneous activity on the part of both participants, usually working towards some goal but not necessarily'. Five corollaries followed from this:

1 The process should be open to interruption by each participant
2 It should exhibit graceful degradation (if something comes up that the system cannot deal with, it should not stop the dialogue)
3 There should be limited pre-planning (because of 1. only so much can be planned in advance)
4 Paths should develop from interaction
5 The users should have the impression that the database they are engaging with is infinite.[12]

Stone claims that in the 1980s the gaming industry had little conception of meaningful interaction, thinking of interactivity only as ordered turn-taking, in which a user would push a button and the machine would then do something.[13] Since then, however, examples of such interaction have emerged, particularly in some online gaming worlds where many thousands of people playing roles make up the plot as they go, trading and talking, joining or forming factions, and altering the environment, while the machine provides a set of parameters, the sphere of play.[14]

In her book *Hamlet on the Holodeck*, Janet H. Murray has outlined with impressive vision the possibilities of computer-mediated narrative, particularly in thinking through the trade-off between narrative coherence and interactivity.[15] She sees authorship in electronic media as procedural. The artist or author writes the rules for the user's involvement, setting the conditions under which the program will respond to their actions.[16] This is how online gaming worlds usually function, though sometimes the hosts introduce their own narrative events – perhaps grand events that affect the entire environment – rather than allowing the story to emerge purely from the sum of individual interactions. The ideal for Murray is that the system of machine

11 For a description of these different types of link, see George P. Landow, *Hypertext 2.0: The Convergence of Contemporary Critical Theory and Technology*, The John Hopkins University Press, Baltimore 1997, pp.11–20.
12 Allucquère Rosanne Stone, *The War of Desire and Technology at the Close of the Mechanical Age*, The MIT Press, Cambridge, Mass. 1995, pp.134–5.

13 Ibid., p.135.
14 Among the earliest and most popular of the graphical online game worlds is *Ultima Online* at www.uo.com
15 Janet H. Murray, *Hamlet on the Holodeck: The Future of Narrative in Cyberspace*, The MIT Press, Cambridge, Mass. 1997.
16 Ibid., p.152.

communication does not act as a social cybernetics but as a facilitator of playful and dramatic human interaction and dialogue, so that genuine conversation, the fostering of ideas and collaboration emerges – in short, a society based on discourse.

Yet the obstacles to the realisation of such an ideal are not only technical. Such works must face a society in which as mobility increases so does purely instrumental behaviour towards others. This condition is reflected in online gaming worlds where virtual war-war is generally favoured over jaw-jaw, and perniciously in those games like *The Sims* that set up scenarios in which interacting with virtual characters has predictable, calculable effects (for example, what daily rate of kisses and embraces does it take to keep one's partner sweet?).[17]

A simple form of narrative interaction is found in hypertext stories. For instance, in Olia Lialina's *Anna Karenin Goes to Paradise* 1996, search engines are used to garner texts from the Net to push forward the story line. Anna, the protagonist, looks for love on Magellan, trains on Yahoo, and paradise on Alta Vista, each search throwing up a poignant mix of results. Lialina, incidentally, rendered the search engines in black and white – 'spoiling' them, as she put it.[18]

In this, and many other hypertext narratives, users feel disoriented, but also, through their puzzlement, amused at the unfolding sequence of screens.

Perhaps such disorientation, linked to spatial confusion online, has a positive dimension. For Robert Coover, the narrative flexibility of hypertext enables people to write and read as they normally think – in fragments, with skips between various associations – making it not a tool of fantasy but of 'neorealism'.[19] Similarly, as we have seen, George Landow accepts that hypertext can be confusing and disorienting but sees this as a postmodern virtue.[20] The very complexity of some hypertext narrative means that users cease to share the same reading experience and the social bond that emerges from discussion of the same text, for each experiences it differently.[21] The solitary aspect of Web browsing, that users do not know who else is online visiting the same site, let alone who they are or what they are doing, reinforces this effect of isolation. Murray, by contrast, criticises many postmodern hypertext pieces that leave open multiple readings for 'privileging confusion itself' and frustrating people's desire for narrative agency, for having a story unfold as a result of their own meaningful choices.[22]

17 *The Sims* is published by gaming giant, Electronic Arts.
18 See Josephine Bosma, 'Olia Lialina interview Ljubljana', nettime posting, 5 August 1997.

19 Robert Coover, 'Literary Hypertext: The Passing of the Golden Age', *Feed Magazine*; www.feedmag.com
20 Landow 1997, pp.121–2.
21 This point is made by Steven Johnson, *Interface Culture: How New Technology Transforms the Way we Create and Communicate*, Basic Books, New York 1997, p.126.
22 Murray 1997, p.133.

The interactivity of online art is a minor symptom of the limits of interactivity on the Internet as a whole, and that in turn reflects the lack of democratic values, and the increasing dominance of a business ethos, which is uninterested in the content of discourse itself, seeing it only as a means that leads to the all important 0/1 choice, to buy or not to buy. In this sense, Lialina's narratives reflect a wider alienation, both in their form and content. While hype about interactivity should not blind activists to its potential, the obvious point should be raised that it can hardly be expected that people crippled in other walks of life by mass-media trivialisation and the instrumentality of work will be able to slough off such ingrained influences and so realise rational discourse online. Yet somehow online communities have sheltered these discourses in the past, and do so now, developing their users through discourse. Shulgin, in eccentric English that echoed the stern proclamations of the Russian Constructivists, urged the following:

Media artists! Stop manipulate people with your fake 'interactive media installations' and 'intelligent interfaces'! You are very close to the idea of communication, closer than artists and theorists! Just get rid of your ambitions and don't regard people as idiots, unable for creative communication. Today you can find those that can affiliate you on equal level. If you want to of course.[23]

If there is little sign of such productive interactivity in online artworks, perhaps they are the wrong place to look. In the chapter 'Free from Exchange?', we shall see that there is another area in which collective action and participation has reached an impressive level of development.

23 Alexei Shulgin, 'Art, Power and Communication', nettime posting, 7 October 1996. Compare this manifesto statement from *Lef*: 'So-called Artists! Stop making patches of colour on moth-eaten canvases. Stop decorating the easy life of the bourgeoisie. Exercise your artistic strength to engirdle cities until you are able to take part in the whole of global constructions!' 'Declaration: Comrades, Organisers of Life!', *Lef*, no.2, April–May 1923; John E. Bowlt (ed.), *Russian Art of the Avant Garde: Theory and Criticism, 1902–1934*, Thames and Hudson, London 1988.

The Rise of Commerce

It was indeed the Age of Information, but information was not the precursor of knowledge; it was the tool of salesmen.[1]

As the Internet became a space for mass participation, the shelters of specialist discourse in which its inhabitants had once taken refuge were undermined, and as big business moved online, along with millions of people making their own home pages, celebrating their families, lifestyles, enthusiasms, home furnishings and pets, Alexei Shulgin wondered, 'imagine if everybody is online, if anybody makes webpages, it will become overwhelming. Who would search for grains of gold in all this shit?'[2]

There are two major aspects to the commercialisation of the Internet, one more visible than the other. As we have seen, browsers, such as Mosaic and later Netscape and Microsoft's Internet Explorer, transformed the Net from being the realm of academia, state bodies, the military and a small number of technically adept hobbyists into a space of mass participation. Yet, despite the huge growth of public online space, it encompasses only a part of the world's computer communications systems, many of which are private. Writing in 1997, Saskia Sassen noted that just over a quarter of the IP-compatible networks

1 Earl Shorris, *A Nation of Salesmen*, cited in Thomas Frank and Matt Weiland (eds.), *Commodify your Dissent: Salvos from The Baffler*, W.W. Norton & Co., New York 1997, p.23.
2 Tilman Baumgärtel, 'Interview with Alexei Shulgin', nettime posting, 4 November 1997.

formed the public Internet, the rest being locked away in proprietary and secret systems.[3]

Since the 1980s, these global computer networking systems, public and private, have enabled the extraordinary growth of the financial markets which have far out-paced other types of economic activity.[4] They have played a considerable role in accelerating the neoliberal global economic system by dramatically lowering the cost and increasing the speed of cross-border transactions and services, so undercutting state regulation of national economies.[5] Giant transnational companies bestride the globalised economy. The media and entertainment sectors are particularly dominated by conglomerates that provide content alongside the infrastructure on which it is consumed. It is likely that technological convergence, globalisation and the concentration of ownership are linked: economic pressure to make businesses operate internationally leads companies to offset the risks of this expansion with mergers and alliances, and these, in turn, lead to thinking about symbiotic technological cross-overs.[6]

A major consequence of the neoliberal globalised economy, in which companies and money are free to move but people are not, has been the increasing casualisation of labour in a now all-too-familiar pattern of low wages, short contracts and job insecurity. While the digital industries have a reputation (at least in media cliché) for enlightened employment practices, they are in fact as ruthless as any business. Microsoft was singled out by Human Rights Watch for maltreating its 'perma-temps', those people who work for but are not directly employed by the company, and thus lack insurance, pensions and holidays.[7] Workers at Amazon complain about low wages, harsh working conditions, unpaid meal breaks and the company's resistance to union representation.[8] Software firms are also at the forefront of prejudice: IT industries in the US employ very few Latino and black workers, and some firms have been fined or sued for racial discrimination or failure to meet federal diversity standards.[9] Even so, the software industry appears benign when compared with those companies involved in building computer hardware, often forgotten in the romance of apparently dematerialised bits. Andrew Ross describes these hazardous and environmentally dirty semiconductor factories, which use toxic gases, and discharge many pollutants, while consuming environmentally unsustainable quantities of water. The workers in these factories – a large proportion of them women – have high

3 Saskia Sassen, 'The Topoi of E-Space: Global Cities and Global Value Chains', in Catherine David and Jean-François Chevrier (eds.), Politics-Poetics: Documenta X – The Book, Cantz Verlag, Ostfildern-Ruit 1997, p.745.

4 For instance, in 1992 foreign exchange transactions were sixty times larger than world trade. See Saskia Sassen, Losing Control? Sovereignty in an Age of Globalization, Colombia University Press, New York 1996, p.43.
5 This is one of the major themes of Dan Schiller's excellent book, Digital Capitalism: Networking the Global Market System, The MIT Press, Cambridge, Mass. 1999, especially chap.2.

6 This argument is made in Jill Hills, 'The US Rules. OK? Telecommunications since the 1940s', in Robert W. McChesney, Ellen Meiksins Wood and John Bellamy Foster (eds.), Capitalism and the Information Age: The Political Economy of the Global Communication Revolution, Monthly Review Press, New York 1998, p.111.

7 See Julian Borger, 'Workers' Rights "Abused in the US"', Guardian, 30 August 2000. Microsoft's workforce contains proportionally more of these temps than most companies. See Schiller 1999, p.207.
8 Kevin Maguire, 'UK Workforce Attacks Amazon', Guardian, 14 April 2001.
9 See Mike Davis, Magical Urbanism: Latinos Reinvent the US City, Verso, London 2000, pp.101–2.

rates of sickness, and not only the eyestrain and carpal-tunnel syndrome one would expect but, due to their exposure to a multitude of contaminants, increased rates of miscarriage and birth defects, cancer, leukaemia and asthma.[10]

As the Internet first emerged, it was often discussed as a political forum, a repository of knowledge or a builder of community. In the last few years, however, business has become its most publicised aspect. There was first the dramatic rise of companies such as Yahoo and Amazon which made large losses but had stock valued at billions of dollars. At the end of trading on the day when Netscape launched its stock, the company was worth $4.4 billion – this was the largest IPO in history.[11] In the late 1990s, high-tech stocks made vast gains, buoying up the stock market as a whole and leading to such profligate consumer spending that certain rash commentators declared that the economic cycle had succumbed to technological progress, and that the downturn would never come. There swiftly followed, of course, a wave of spectacular failures, with the bankruptcy of Internet companies formerly awash with funds, and plunging values in the IT sector as a whole. In 2000, the NASDAQ fell by the mind-boggling sum of $2 trillion in a few months.[12] Even the continuing viability of one of Web commerce's greatest successes, Amazon, was put in doubt following large falls in its stocks, major losses and gigantic debts. These precipitate rises and falls, caused by frantic speculation in fragile and greatly over-inflated stock markets, should not, however, blind us to the underlying transformation that computer communications brings to the world economy.

For while the Internet is a tool of globalised capital, like all tools, it is one that transforms its maker. Bill Gates has written of 'friction-free capitalism', by which he means that the complete market information that classical economists always assumed was available to buyers and sellers actually will be available to them.[13] Such talk has met with contempt from some postmodernist theorists who consider it sheer fantasy.[14] Yet it is clear that when consumers can compare prices between many companies in a matter of seconds, this is an advance on trawling through Yellow Pages, or tramping around the high street. Indeed, the current tribulations of dot.com companies can be blamed partly on their customers having more price information than is good for profit-taking. For Gates:

Capitalism, demonstrably the greatest of the constructed economic systems, has in the past decade proved its advantages over the

10 Andrew Ross, 'Going at Different Speeds: Activism in the Garment and Information Sectors', in Josephine Bosma et al. (eds.), Readme! Filtered by nettime: ASCII Culture and the Revenge of Knowledge, Autonomedia, Brooklyn 1999. For further information, see Ron Chepesiuk, 'Where the Chips Fall: Environmental Health in the Semiconductor Industry', Environmental Health Perspectives, vol.107, no.9, September 1999.

11 As noted by Tim Berners-Lee (with Mark Fischetti), Weaving the Web: The Past, Present and Future of the World Wide Web by its Inventor, Orion Business Books, London 1999, p.116.
12 For an amusing and pointed site devoted to high-tech stock mania, and the prospects for a severe recession, see the well-named http://itulip.com

13 Bill Gates with Nathan Myhrvold and Peter Rinearson, The Road Ahead, revised ed., Penguin Books, London 1996, chap.8, especially pp.180–4.
14 See, for example, Slavoj Žižek, The Plague of Fantasies, Verso, London 1997, p.156. Žižek makes the telling point that among the frictions eased in Gates's vision is any consideration of social conflict.

alternative systems. As the Internet evolves into a broadband, global, interactive network, those advantages will be magnified. Product and service providers will see what buyers want a lot more efficiently than ever before, and consumers will buy more efficiently. I think Adam Smith would be pleased.[15]

There are indeed profound and positive consequences that follow from this integration of economic information into the very structure of production, distribution and consumption, though (as we shall see later) they go beyond what Gates envisages here.

The more visible aspect of the commercialisation of the Internet is the transformation of the Web itself. Search engines and content providers make the Web more homogenous and regulated. The vast and diverse news and entertainment conglomerates that were assembled by merger from the mid 1980s onwards see the Web as an important platform on which to consolidate their interests.[16] What is of particular concern is the vertical integration of the Web's layers so that service providers are melded with content providers, as in the $300 billion merger of AOL and Time-Warner, creating the world's fourth largest corporation.[17] Unsurprisingly, users of AOL are much exposed

to Time-Warner products. Microsoft's partnerships with Disney, Time-Warner and other media companies raised similar concerns, based on the default integration of these companies' content into Internet Explorer, by far the most successful browser on the market.[18] Where such alliances take place, it is an easy matter for search engines to also be configured to favour the content of merged companies, and exclude or demote that of rivals.[19] Indeed, many think that the Net has already changed to become, with its portals and selective hyperlinking practices, a 'neatly landscaped' space.[20]

Commercialisation on the Web has also produced a uniformity of its look, imposed by browsers, themselves based on another design standard, Windows – with its own familiar apparatus – and the habitual elements of web design: frames, banner advertising, animated GIFs, changing cursors, rollover effects and so on. It was partly market reasoning that lay behind the rapid proliferation of frames which meant that navigation devices could be kept in place while the user scrolled about the page, along with adverts and other commercial messages.[21]

Typical commercial web pages, Paul Zelevansky argues, parallel the design of magazine pages, particularly in art, music, fashion and

15 Gates 1996, p.207.
16 This point is made by Schiller 1999, p.99.
17 For an analysis, see Jane Martinson, 'A Media Giant Caught in the Web', *Guardian*, 11 January 2000.

18 Schiller 1999, p.103.
19 This is a worry of Berners-Lee. See Berners-Lee 1999, p.141.
20 Richard Rogers, 'Introduction', in Richard Rogers (ed.), *Preferred Placement: Knowledge Politics on the Web*, Jan van Eyck Akademie Editions, Maastricht 2000, p.12.

21 This point is made by Steven Johnson, *Interface Culture: How New Technology Transforms the Way we Create and Communicate*, Basic Books, New York 1997, p.93.

lifestyle magazines which systematically blur the distinction between editorial and advertising material. Both use visual and verbal information acting together and both are intended to convey condensed 'hits' of information.[22] Print and online pages act in concert, influencing one another, though obviously magazine adverts cannot act directly as navigation devices, and fragments of information are generally more condensed on the Web. Net technology furthers the logic of the consumer magazine, bringing about a tighter integration of editorial content and corporate propaganda. These trends affect the content as well as the look of paper and virtual pages, as advertisers pressure newspapers, magazines, television companies and web sites to ensure that their messages are not disrupted by inconvenient facts or disturbing news stories.[23]

Another powerful homogenising software metaphor is the 'desktop' which makes of the screen an office environment, and the user an employee.[24] This has been analysed in Foucaultian terms as an apparatus of power that bends the user to conformity, and disciplines those who err. Yet, while it may be an emulation of the office desk, the Graphical User Interface (GUI), first made widely available on Apple Macintosh machines, and later taken up by Microsoft's

Windows, encouraged playfulness, with many features of animation and customisation that went far beyond mere function.[25] The interface appears magical. Instead of instructing the computer by typing an order to do something, pressing the Enter key and then seeing the result, commands were expressed by small actions of hand and fingers, the time span between command and result shrank, and it seemed as though the user performed the task themselves. As Steven Johnson points out, this was a paradoxical result, for while the spatial character of the GUI interface made data seem closer at hand, that program sits on top of the old text-command interface, adding another layer of mediation between user and machine.[26] Discipline and playfulness are united in Microsoft's animated help assistants, including Word's notorious paper clip, that cheerfully chivvy users into matching their style of working with the program's capabilities.

Thus, in a compact that Adorno would have immediately recognised, work became playful, and play training for work.[27] In the GUI, work and leisure programs are demarcated by window frames, and each realm lies only a click away from the other, and in both, the computer does indeed act as a disciplinary and conformity-inducing machine, not with the harsh face of a prison regime but with

22 Paul Zelevansky, 'Shopping on the Home Image Network', *Art Journal*, vol.56, no.3, Fall 1997, pp.46–7.
23 For an account of some recent scandals of advertisers determining copy, see Schiller 1999, pp.124–5.
24 See, for instance, Sean Cubitt, *Digital Aesthetics*, Sage, London 1998, p.3.

25 Johnson 1997, p.49.
26 Ibid., p.21.
27 See Theodor W. Adorno, 'Free Time', in *The Culture Industry: Selected Essays on Mass Culture*, ed. J.M. Bernstein, Routledge, London 1991.

023/Tomoko Takahashi,
Word Perhect 2000
Commissioned and
produced by e-2 in
association with
Chisenhale Gallery

(at least to habitual users) a friendly feeling of ease. Unified by interface and style, and dominated by standard corporate content, the Web as a whole tends to become, less a forum or library than an over-arching commodity.

Much Internet art stands in opposition to this conventional background, frustrating the expectations of users who are accustomed to the familiar ways that programs look and behave. Net art has adopted and preyed on the rapidly evolving tricks of commercial display, sometimes placing them in a different frame, and rendering them strange; sometimes by abjuring them in favour of stark simplicity. The sparseness of some art sites is directed against the lurid colour and flashy designs of commercial display. As we have seen, there was much play with expectations about where hyperlinks are to be found and what they are likely to do, by for example not using them at all or putting in so many that the user becomes bewildered. Some works have directly addressed standard software programs: Tomoko Takahashi made an amusing skit on Wordperfect (which she called *Word Perhect*), allowing users to type their own messages over scans of items in her possession, using a scrappily drawn and only partly functional interface.[28] Clicking on the 'undo' function, for instance, brings up a message that things cannot be undone, and you should be responsible for your actions; likewise, the 'cut' function advises you to be careful when handling scissors [023].

The urge behind such oppositional work was the fear that this uniformity of content, look and interface creates in users a uniformity and passivity of behaviour. As commercialisation gathered apparently unstoppable impetus, various prominent Net activists, including Heath Bunting, Geert Lovink and Critical Art Ensemble, suggested that the battle was already lost.[29] Here is Lovink in 1998:

Against all expectations, the Internet is creating a new Mass of 'users' that just shut up and click/listen. They are 'watching Internet', a phrase that would have been impossible to come up with a few years ago. This silent majority in the making, which will only know the red 'Buy' button, was not envisioned by the early adapters and the visionaries of the first hour.[30]

These sentiments may have been over-hasty but they capture the drama of the change as Web use erupted.

The conformity of these Web-watchers is recorded, valuable data being mined from their behaviour so as to better target advertisements and services at them. The Net is the ideal

28 Tomoko Takahashi, *Word Perhect*, www.wordperhect.net
29 As pointed out, for example, by J.J. King, 'Bringing it all Back Home: Life on the New Flesh Frontier', *Mute*, no.12, 1998, p.49.
30 Geert Lovink, nettime mailing, 21 July 1998; cited in King 1998, p.49.

commercial surveillance tool, for every expression of a preference (in the form of a click or a pause, a decision to save or print) can be automatically and covertly logged. Such facilities were built into browsers from Netscape onwards. Internet users are subject to particularly intense corporate surveillance, not only because the technology allows it, but because they tend to be wealthy, and the greater the income of a social grouping, the more businesses finely grade their assessments of its members.[31]

In 1995 Julia Scher, who has worked extensively with CCTV and online surveillance issues, set up a site called *Security Land* in which the surfer was told what sort of computer and software they had and their email address. This was followed by the question, 'How do you feel now?'[32] Scher was aiming to make users aware of the consistent but invisible surveillance they were subject to online.[33] Anna Best's work, *error 404* 2000 (the error number returned for missing pages) throws up many pages at once that float across the screen – their addresses taken from sites that people had visited while browsing at an East London library, so giving a sample of their interests and concerns.[34] In this way, data not normally seen by users was made public, the subject of a gentle curiosity mixed with the disturbing undercurrent of spying. In *CCTV – World Wide Watch* 1997, Heath Bunting turned the general worry about surveillance around by providing live CCTV images of various city locations around the world, and encouraging users to fill out forms to send information to local police stations if they witnessed a crime being committed.[35] This was to turn Web users into snoopers rather than the habitually snooped-upon.

Another consequence of commercial surveillance online is the swamping of people's inboxes with junk post, also known as 'spam'. Bunting, like many Net enthusiasts, overwhelmed by such messages, came up with a couple of devices to defeat the spammers: one was a little tool that allowed you to redirect your junk mail to other junk-mailers, so that eventually all junk mail would end up circulating between the spammers (this was a variant on an old suggestion for dealing with postal junk mail, but while few people can be bothered to readdress junk mail, online the process could be automated).[36] The other was to change his email address in line with the month, this being a change that humans could readily understand but automated mass mail-out programs could not. Similarly, Joachim Blank and Karl Heinz Jeron,

31 The point about wealth and data-gathering is made by Schiller 1999, p.140.
32 This work is discussed in Tilman Baumgärtel, 'Some Ado About Nothing, Really', nettime posting, 8 January 1998. Scher's work can be found at http://adaweb.walkerart.org/ project/secure/corridor/sec1.html
33 See Tilman Baumgärtel, 'Interview with Julia Scher', *Rhizome*, 20 August 2001.

34 Best's *error 404* can be found at e-2.org. This work is discussed in Michael Gibbs, 'I Can't Find It', *Art Monthly*, no.238, July–Aug. 2000, p.60.

35 www.irational.org/heath/ cctv/
36 www.irational.org/heath/ junk/ See also Josephine Bosma, 'Ljubljana Interview with Heath Bunting', nettime posting, 11 June 1997.

addressing email overload more generally, offered a service, *re-m@il* 1999, to which email could be forwarded, to be answered anonymously by whoever chose to do so.[37]

The consumer desire most successfully catered to online has been the demand for pornography. While industry research houses do not list turnover figures for online pornography, it accounts for a sizeable fraction, perhaps the majority, of online commerce. The porn industry has been one of the most powerful and innovatory driving forces of Web commerce. This is a matter about which the online commercial world is often coy, omitting sexual terms from charts of popular search words published by Yahoo, for example, which they would otherwise dominate. Again artists, particularly feminists, have been drawn to the subversion of the porn industry's rigid mores and the conformity that it imposes on its users. The pages of Shulgin's *FuckU-FuckMe* website [024], with its order forms, technical descriptions, warranties and illustrations offer the glossy but ludicrous offer of 'teledildonics', or virtual sex at a distance, an over-hyped technical possibility that received much airing during the brief period when Virtual Reality was in vogue.[38]

It is ironic that one of the main motivations for users searching for porn on the Web is to escape the embarrassment of the newsagents or the sex shop, yet surveillance online, though not face-to-face, is far more intense and systematic. Rachel Baker's join-the-dots piece [025] lures users to enter their details with the promise of pornographic pictures which, as on many sites that seem to offer something for nothing, are never delivered.[39]

We have seen that the rise of Internet art and online commerce were both founded upon the Web browser. The two are bound up together, the latter allowing the former, the former sometimes kicking against that which permits it to exist, just as nationalist resistances are forged by globalisation. Often the relations between the two are more comfortable. Many online artists who do not make saleable objects, are employed in the commercial world. Hypertext narrative artist, Mark Amerika, for example, does consultation work for companies running websites. I/O/D, who produced the *Web Stalker*, fund their activities out of commercial software design work.[40]

Naturally, some artists who make a living in this way build their experiences into their work. In a witty piece, Carey Young (who works for a major IT design firm) purchased shares in companies called 'Art' and 'Life' and mapped their performance against each other. [026]

37 Blank and Jeron, *re-ma@il*, www.sero.org/re-mail/
38 www.fufme.com

39 www.irational.org/tm/dot2dot/
40 For a discussion of the interaction between digital art and business in the UK, see Lisa Haskel, 'Selling Out, Buying In: Art vs. Design in UK Media Culture', in Frank Boyd et al. (eds.), *New Media Culture in Europe*, Uitgeverij de Balie and The Virtual Platform, Amsterdam 1999.

025 / Rachel Baker,
Dot2Dot 1997

Download Dot2Dot Porn Files.

Thank you for your interest in downloading files from our server. Below
you will find a listing of the files available for download. Select the
file you want then fill out the form and press submit. The informaiton
gathered from the form will be held in strictest confidence. You will
receive a confirmation page to verify the file you want and the
information you entered.

At the present time you can only download one file at a time.

Name: [_____]
E-mail: [_____]
Company: [_____]

[Submit] [Reset]

© 1998, Trina Mould

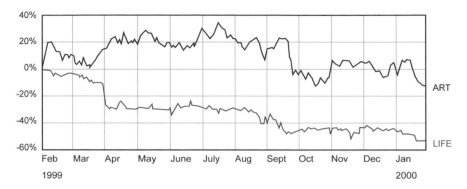

The reduction of these disputed terms, so often thrown into opposition and alliance, to competing shares mapped to the penny is both an absurdity and the regular practice of corporations in auditing the value of their charitable ventures in the arts, and the cost of the well-being or otherwise of their employees and customers.[41] In making such work, there is no necessary conflict; rather, the detailed insight that may come in working for business illuminates art made about business operations.

Conservative views of the Internet and the market have also found resonance with some artists. In the US, and in line with Gates's thinking, the dominant ideology of the Net has been formed by a group of proselytisers, especially associated with the magazine *Wired*, who see the technology as the destiny of capitalism, finally freeing it to work at greatest efficiency and creativity, and cutting it loose from the bonds of the state.[42] This libertarian strand of thinking wilfully forgets the origins of the Internet as a state-funded programme, and indeed the long-established and ongoing symbiosis between high-tech capitalism and the vast military expenditure of the US, which now exceeds that of Russia, China and Europe combined. Rather, according to this view, weightless capitalism, left to itself and unfettered by regulation, will deliver undreamt of wealth,

choice and information to all. Despite their resolutely pro-market stance, these libertarians think of themselves as daring rebels, and continually employ the rhetoric of revolution. This way of thinking has also affected artists, who draw a parallel between lack of state regulation over commerce and freedom of expression. As Douglas Davis has it, arguing that the forms of expression liberated by online discourse cannot be predicted: 'I pleaded with the US Congress, in considering legislation to advance the building of the Internet, *to leave us alone*. Let anarchy thrive.'[43]

Aside from the libertarian and market-led model of *Wired*, there is another ideological approach to the development of Net culture, governed by the various diluted forms of Western European social democracy. This would see a compact formed between art, industry and government in which all would benefit, embodied in such initiatives as the Europe-wide i3 research lab which combines the ideas of designers, academics and business people.[44] Such a vision does not apply only to digital art, for in the UK the Labour government has set out to foster such links in the hope that art will leaven industry with creativity, and aid the integration of fractured, antagonistic identities into a unified society.[45] In digital art, however, in which the links with

41 www.careyyoung.com/ artandlife/
42 For a typical but intelligent expression of this view, see Nicholas Negroponte, *Being Digital*, Hodder & Stoughton, London 1995, especially chap.4 for his views on deregulation, which contain interesting remarks about copyright law.

43 Douglas Davis, 'The Work of Art in the Age of Digital Reproduction (An Evolving Thesis: 1991–1995)', *Leonardo*, vol.28, no.5, p.385.
44 For an account of i3, see the section devoted to the organisation in Janet Abrams (ed.), *If/Then Play*, Netherlands Design Institute, Amsterdam 1999.

45 See Chris Smith, *Creative Britain*, Faber and Faber, London 1998; for a discussion of government policy, see my book *High Art Lite: British Art in the 1990s*, Verso, London 1999, chap.6.

026/Carey Young,
Art and Life 2000
Web site, commission of
£1,000 made to the artist
from Film and Video Umbrella,
cheque, email conversations,
online share portfolio graphing
tools, financial data from the
international stock markets
Commissioned by Film &
Video Umbrella, and thanks
to Paul Khera

business are particularly strong, and in which the role of government in fostering information technologies and businesses is key, the compact is explicit. Symptomatic is the Souillac Charter for Art and Industry, drawn up in 1997, which proposed a framework for collaboration: art is seen as 'fundamental research', and artists as communication specialists who can contribute new ideas to industry; for its part, industry can provide resources to the arts; the state can stimulate economic growth, guard the cultural heritage, protect intellectual property rights and educate its citizens.[46] Similarly, for Manuel Castells, in a society otherwise riven by technology, lacking a significant conception of time and space, and in which people relate through the exchange of goods and symbols without genuine dialogue or communication, art is the salve that brings meaning. This very fragmentation opens up a role for art, which can 'reunite us and make us able to live together', being no less than 'the cultural bridge between the net and the self'.[47]

Such ideas and policies are an attempt to undercut the dangerous contradiction laid out by Saskia Sassen: that the increasing use of computer communications technology, linked as we have seen to the rise of neoliberalism, leads to a draining away of the income of the middle ground of consumers on which that very economy depends.[48] While this European vision elides conflicts of interest, it is instructive because it clearly expresses the ideal, and increasingly the reality, of the technocratic and instrumental use of art, particularly of an art that is inextricably linked to the concerns and the techniques of business.

It was unsurprising, then, that some in the art world saw the renewed social role for art offered by the online environment as an opportunity, not for radical action, but for more effective submission. The Net could be used to lever fine art into a more prominent cultural position. For Benjamin Weil, founder of ada'web:

It was my belief that the development of the web would be an extraordinary opportunity for art to desegregate itself, and (re)gain a central position in ambient cultural discourse and practice … Rather than knocking at the corporate door asking for 'charity', we thought we could convince them that art could be a valuable asset … it could be understood as a form of creative research which could make them understand better the medium they were investing in, and draw attention to their corporation as being innovative.[49]

So ada'web tried to sell the commodity of creativity to companies. This view has much

46 See 'The Souillac Charter for Art and Industry', in Boyd 1999, pp.101–7.
47 Manuel Castells, 'The Culture of the Network Society', in Boyd, p.16.

48 For a concise formulation, see Sassen 1996, p.40. On the creation of a 'white collar proletariat', see Manuel Castells, *The Information Age: Economy, Society and Culture, vol.I: The Rise of the Network Society*, Blackwell Publishers, Oxford 1996, pp.229–30.
49 Weil cited in Josephine Bosma, 'Is it Commercial? Nooo … Is it Spam? Nooo – it's Net Art!', *Mute*, no.10, 1998, p.73.

practical justification, and is based on sound information about corporate thinking. The modernisation of the art world online could serve exactly this purpose, though it is rare to hear it stated with such clarity within that world itself.

Even so, a strong current of online culture has run in the opposite direction. Sassen has argued that the growing digitalisation and globalisation of financial sectors, and the increasing economic importance of electronic space has thrown the public Internet into contention with the private sphere in a clash of the corporate sector and civil society.[50] Just as the spread of US-style cultural homogenisation, of chain stores, movies and pop songs across the globe provokes sharp local resistance, and often serves to delineate the borders of other identities and of activism itself, so the wave of online commercialisation did the same.[51] The Net became the easiest place to find anti-corporate information and organise anti-corporate activities. It became the home for a wide range of such movements, ad-busters and other 'jammers' of commercial culture, those protesting against genetically engineered products, anti-McDonalds campaigners, including supporters of the 'McLibel' campaign, and agitators against companies using sweated labour to make expensive branded goods.[52]

More significantly, it became a forum in which diverse movements and single-issue concerns grew together in realisation of common interests and experiences.[53]

This is not quite what those who praised the Net for delivering complete market information had in mind. Even for Gates, the free market in data cannot by itself be guaranteed to produce a 'consensual' picture of the market. Instead, some form of top-down management is required to regulate those consumers with gripes or grudges against certain companies (Microsoft, of course, has a large share of these). Gates wants some (unspecified) tool for reducing the volume of 'slanderous' voices while protecting freedom of expression.[54] Yet such complaints, or sites devoted to the proposition that some corporation or other 'sucks', are merely the specific end of a continuum of anti-corporate and anti-capitalist opinion that has found a means of transmission online, given its long and consistent exclusion from the print and broadcast media.

Anti-commercial sentiment on the Web achieved dramatic expression in February 2000 when successful blocking attacks were launched against some of the most prominent commercial sites, including CNN, Yahoo!, eBay and Amazon. They were less an articulate

50 Saskia Sassen, 'Private and Public Cyberspace', in Bosma, *Readme!*, p.100.
51 Dan Schiller describes the attempts to protect national culture in the face of this homogenisation, and the role of WTO legislation in undermining such action in *Digital Capitalism*, pp.79–82.
52 See Naomi Klein, *No Logo: Taking Aim at the Brand Bullies*, Flamingo, London 2000; Kalle Lasn, *Culture Jam: The Uncooling of America*™, Eagle Brook, New York 1999;

Thomas Frank and Matt Weiland (eds.), *Commodify your Dissent: Salvos from The Baffler*, W.W. Norton & Co., New York 1997; and George McKay (ed.), *DIY Culture: Party & Protest in Nineties Britain*, Verso, London 1998. Klein's book, in particular, is an excellent guide to the anti-corporate movements, and the advantages and drawbacks of their new forms of political organising. For McLibel, see www.mcspotlight.org

53 On the movement as a whole, see Emma Bircham and John Charlton (eds.), *Anti-Capitalism: A Guide to the Movement*, Bookmarks Publications, London 2001.
54 Gates 1996, pp.185–6.

critique of mass commerce than a loud cry of protest. In an often prescient series of lectures, published as *Art and Technics* in 1952, Lewis Mumford outlined the hypertrophied worship of technology that led to both over-rationalism in some areas and, as compensation, wildly subjective reactions in others: 'In this impersonal and overdisciplined machine civilisation, so proud of its objectivity, spontaneity too often takes the form of criminal acts, and creativity finds its main outlet in destruction.'[55]

If this is often the recourse of those dissatisfied with a seemingly universal system of administration, it is a consequence of the system's apparently totalising rationality, one that has until recently so far efficiently stifled the development of coherent alternatives. Herbert Marcuse, who drew on Mumford's work, laid out a chilling vision of technocratic efficiency. He describes the way the landscape is organised by the highway, and how signs and posters signal and label its wonders in advance, and how parking spaces are provided at the best viewpoints. All this is for the driver's benefit, comfort and safety, and it would be simply irrational to kick against such a system.[56] This description can also stand as a vision of administered, regulated online space.

The next chapter will look at artistic responses that have been in sympathy with this strain of anti-corporate and anti-capitalist opinion, but one work comes particularly close to the spirit of the blocking attacks. Etoy's *Digital Hijack* (1996) promised users novel material about popular subjects. Those affected had typed in keywords such as 'Madonna', 'Porsche' and 'Penthouse' into a search engine, and clicked on etoy's top-rated site, being greeted with the response: 'Don't fucking move. This is a digital hijack', followed by the loading of an audio file about the plight of imprisoned hacker Kevin Mitnick, and the hijacking of the Internet by Netscape.[57] Of this action, which trapped hundreds of thousands of users before etoy ended it due to the strain on their servers, they have said that it demonstrated the 'room' that lies behind popular interfaces and 'twilight zones' that can become the place of action.[58] *Digital Hijack* moved beyond barbed emulation and satire, revealing the vulnerability of the Net user, and indeed bringing about awareness of unknown online 'spaces'. It also attracted the attention of the CIA, until its agents were seen off by etoy's lawyers. Etoy used the tools with which the Net is commercially exploited, and in a direct, forceful way subverted that exploitation.

55 Lewis Mumford, *Art and Technics*, University of Columbia Press, New York 1952, pp.10–11.
56 Herbert Marcuse, 'Some Social Implications of Modern Technology' (1941), in *Technology, War and Fascism: Collected Papers of Herbert Marcuse*, vol.I, ed. Douglas Kellner, Routledge, London 1998, p.46.

57 *Digital Hijack* no longer runs but a simulation can be seen at www.hijack.org/ Mitnick became a cause célèbre for the hacking community, and for those wishing to ensure freedom of expression on the Net generally. He has been released but on the extraordinary condition that he does not have anything to do with computers, or speak or write about them publicly. For a site devoted to his support, see www.kevinmitnick.com For an account of Mitnick's

activities and arrest written from the point of view of those hunting him, see Tsutomu Shimomura with John Markoff, *Takedown*, Martin Secker & Warburg, London 1996.
58 Hannes Leopoldseder and Christine Schöpf (eds.), *Prix Ars Electronica 96*, Springer Verlag, Vienna 1996, pp.73, 84.

Politics and Art

The earliest visions of computer-mediated communication envisaged that the technology would revivify the political sphere. Joseph Licklider, one of the first to conceive of a computerised information retrieval network, believed that such systems could create a political world in which all citizens, being connected and informed, would make meaningful contributions to debate.[1] It has since become common to say that the Internet will renovate democracy. While the Internet is very far from transforming mainstream democratic government, which in most nations involves a shuttling between more or less efficient plutocracies, tinged blue or faintly pink, it has had a political effect that lies beyond that system.

For obvious reasons of online access, these effects have been very uneven. We should remember that there are many areas of the world, even parts of Europe, where the Net has made little impact, and that some political struggles resonate more forcefully with online groups than others. Yet there are areas that the Net has transformed. As we have seen, supporters of the Zapatista rebels who have held control of part of the southern Mexican state of Chiapas since their dramatic uprising at the time of the signing of the NAFTA treaty in 1994, have made effective use

1 See Katie Hafner and Matthew Lyon, *Where Wizards Stay Up Late: The Origins of the Internet*, Simon and Schuster, New York 1996, p.34.

of the Net. The Zapatistas, a highly democratic indigenous people's movement, have been negotiating with the Mexican government in an attempt to push the country towards meaningful democracy, less by force of arms than by the fact that their very existence and resilience engenders debate. The fall in 2000 of the PRI, Mexico's party of government for seventy years, the election of Pablo Salazar as governor of Chiapas the same year, and the dramatic procession of the Zapatistas into Mexico City in 2001 to negotiate with the new government are indications of the partial success of their project. Their survival for so long, surrounded by government troops who have blockaded their communities and committed atrocities against indigenous people, hoping to provoke the rebels into open conflict, is partly due to the alliances the Zapatistas have fostered in Mexican civil society, but also to considerable international sympathy and support. Remarkably, the Zapatistas even staged an international conference to discuss the effects of neoliberalism on economics, politics, society and culture that brought several thousand people to spend a week with them in their territory.[2] Given the indifference or hostility of the mainstream media to the Zapatista cause, the Internet has played an important part in sustaining international interest.

Due to this continual attention (news of massacres of indigenous people in Chiapas have been rapidly disseminated on the Net), the Mexican government and military have not felt able to launch a full-scale assault against the rebels, as the World Bank urged them to do. The Zapatistas' situation remains highly precarious, yet without the international network of online activists, they might not have survived this long.[3]

Online support of the Zapatistas is just one example of the Internet's powerful role in the fostering of transnational politics. Opponents of the NAFTA treaty, which brought the economies of the US, Canada and Mexico into a neoliberal economic compact, organised extensively online. They failed to stop the signing of the treaty, of course, but laid the basis for later, more successful action.[4] Slowly there grew, online and off, a cohering of fragmented single-issue campaigns into a broad anti-corporate politics that came to dramatic prominence in the demonstrations against the World Trade Organisation in Seattle in October 1999.[5] The Seattle protest was a striking demonstration of the power of this loose grouping of activists who communicate and organise in part by using the Internet. While the Seattle demonstrators were split between those

2 The conference discussions are published in EZLN, *Crónicas intergalacticas EZLN: Primer Encuentro Intercontinental por la Humanidad y contra el Neoliberalismo*, Planeta Tierra, Chiapas 1996; for a shorter version in English, see Greg Ruggiero and Stuart Sahulka (eds.), *Zapatista Encuentro: Documents from the 1996 Encounter for Humanity and Against Neoliberalism*, Seven Stories Press/Open Media, New York 1998.

3 For online information on the Zapatistas, see (among many sites) www.ezln.org/ Castells notes the effect of Internet activism on the Zapatista struggle: Manuel Castells, *The Information Age: Economy, Society and Culture*, vol.II: *The Power of Identity*, Blackwells, Oxford 1997, pp.79–81. For a US Army sponsored account, concerned by this new obstacle to the usual exercise of repression, see David Ronfeldt, John Arquilla, Graham E. Fuller and Melissa Fuller, *The Zapatista*

Social Netwar in Mexico, RAND, Santa Monica 1998.
4 There is a good account of progressive online activism in Douglas Kellner, 'New Technologies: Technocities and the Prospects for Democratisation', in John Downey and Jim McGuigan (eds.), *Technocities: The Culture and Political Economy of the Digital Revolution*, Sage Publishers, London 1999. See also Castells 1997, pp.79–81.
5 For an account of the Seattle protests, see Alexander Cockburn, Jeffrey St. Clair and

Allan Sekula, *Five Days that Shook the World: Seattle and Beyond*, Verso, London 2000.

favouring solidarity with Third World peoples and those attempting to protect US jobs through protectionist policies, the Internet has generally made links between activists in the Third World and the First easier and quicker, and has raised consciousness of the global interconnection of issues.[6] This has aided the work of the anti-sweatshop movement, which brings together in consumers' minds the brand identification of fashion goods with the appalling working conditions of those who make them.[7] Similar groupings have also mounted successful opposition to the proposed Multilateral Agreement on Investment, a global bill of rights for corporations against the regulatory powers of the state and the litigation of individuals.

Online politics is not, of course, just a matter of Third World–First World exchanges in global solidarity. While networked computing may not appear to be a priority for the poorest and most disadvantaged, it can provide information that can be used to political ends, building communities and bringing people with common interests together in virtual dialogue where physical contact is expensive or dangerous. The remarkable work of the Committee to Democratise Information Technology (CDI) founded by Rodrigo Baggio which operates in Brazil's favelas is just one example.[8]

The Net, however, has not been a cosy refuge for left- and liberal-leaning rainbow coalitions of activists, divorced from the rough politics of the offline world. Indeed, the first beneficiaries of the Net were the far right who, like the left excluded from the mainstream media, were swift to organise online. Loose, non-hierarchical organisation is as useful to the far right as it is to anti-capitalists, and is forced upon both by the apparatus of secret service and police surveillance and infiltration. Likewise, Internet and mobile-phone-based methods of political organisation used by anti-capitalist demonstrators are open to activists of any persuasion, as the UK government discovered recently in its encounter with protestors against fuel duty. Part of AMPCOM's (Andy Best and Merja Puustinen) work, *Dad@* 1995–6 framed and displayed far-right and state intelligence sites, among them the CIA, the British National Party and the Finnish Fatherland Patriotic Union.[9] In their new setting, they shifted from being sites of information and propaganda to exemplars of hatred and the urge to control. Likewise, Julia Scher provides a listing of 'The Right Side of the Web', including Christian music and Pro-Life sites, the links emerging from a black screen as they are clicked on, as if they were stepping out of the shadows.[10]

6 For an account of this, see Naomi Klein, *No Logo: Taking Aim at the Brand Bullies*, Flamingo, London 2000, pp.443–6.
7 On the anti-sweatshop movement, see Andrew Ross (ed.), *No Sweat: Fashion, Free Trade, and the Rights of Garment Workers*, Verso, London 1997.
8 See www.cdi.org.br This work is described in Alex Bellos, 'Digital Hope in the Slums', *Guardian*, 18 November 1999, online section, pp.16–17.

9 www.kiasma.fi/taide/verkkot/DADA/index.html (now expired).
10 http://adaweb.walkerart.org/project/secure/glossary/gl1.html Many of these links are now outdated.

States and corporations are far from defenceless against online dissidence. Governments, including those of the US and the UK working in concert, run vast surveillance programs monitoring email. States can control the Internet, either directly by requiring Internet service providers (ISPs) to block particular sites as in Singapore or China, or indirectly by harassing, jailing or killing those who act against their interests, just as they would with troublesome journalists in the print media.[11] The Net's material basis (servers, buildings, staff) is only too evident when the state sets out to attack it, as the Yugoslavian government did to suppress dissident views during the conflicts in Bosnia and Kosovo; in the latter war, NATO bombing directed at Yugoslavia's infrastructure, including the telecommunications system and power plants, further aided its efforts (as we have seen, Cosic's animated map showed how the Net responded as it was designed to do).[12] [018] While government sites are often targeted by hackers (either simply rising to the challenge of taking on government security, or for political reasons), states have been known to mount online attacks themselves. The Indonesian government was implicated in a successful attack on an Irish-based ISP that hosted sites carrying information about East Timor.[13] More generally, though, cyber-warfare, a burgeoning and well-funded military concern, remains highly secret.[14]

Similarly, corporations have taken to monitoring what is said about them on the Internet, on competitors' sites, on anti-corporate and other rogue sites, and on discussion forums. Internet surveillance companies compile statistical reports of Internet opinion, and recommend action that may take the form of counter-propaganda or legal sanction.[15] A crude example is the deal Altavista struck with Shell so that users entering search terms on environmentally sensitive issues, such as 'climate change' would see Shell banner adverts boasting the company's green credentials.[16]

So the Net has been a space for contention between governments, corporations and activists, and (in marked contrast to the often acquiescent or cynical conditions of the offline art world) artists have regularly made pointedly political work. The group Mongrel, which emerged out of the London community computing space Artec, have made work bearing on the racial classification of people by search engines, hoping to break through the propaganda of official multiculturalism.[17] Their very name points to the growth of a racially mixed working class

11 For information about the Chinese government's efforts to control access to information on the Web, see John Gittings, 'China Blocks Internet Explosion', Guardian, 27 January 2000; also John Gittings, 'Shanghai Noon', Guardian, Online section, 24 August 2000.

12 Geert Lovink, 'War in the Age of Internet: Some Thoughts and Reports Spring 1999', in Steven Kovats (ed.), Ost-West Internet: Elektronische Medien im Transformationsprozess Ost und Mitteleuropas, Edition Bauhaus/Campus Verlag, Frankfurt 1999, pp.323–4.

13 Gittings, 'China Blocks Internet Explosion', side panel.
14 Cyberwarfare is the subject of some of the essays in Gerfried Stocker and Christine Schöpf (eds.), InfoWar, Springer, Vienna 1998.
15 See the discussion in Richard Rogers and Ian Morris, 'Operating the Internet with Socio-Epistemological Logics', in Richard Rogers (ed.), Preferred Placement: Knowledge Politics on the Web, Jan van Eyck Akademie Editions, Maastricht 2000, pp.146–7.

16 Ibid., p.154.
17 www.mongrelx.org For a discussion of Mongrel, see Eugene Thacker, 'SF, Technoscience, Net.art: The Politics of Extrapolation', Art Journal, vol.59, no.3, Fall 2000, pp.69–71.

028/Heath Bunting,
Chalk Tag 1995

that is the nightmare of a significant portion of the Tory party, while their depiction of masked and sutured 'mongrel' faces covered in spittle is an uncompromising image of racial conflict and conflicted identity, rare in recent British art. [027]

Among the artists who have most successfully married online cultural intervention and politics are Heath Bunting and Rachel Baker, who have hosted diverse activities on their site, irational.org. We have seen that Bunting made some early Net pieces, wittily subversive of the structure and expectations of online culture. His works have been highly economical interventions, employing minimal means to make profound and often amusing conceptual points. They have also played upon the interaction between the online and offline worlds, showing that the online environment is not an autonomous realm incapable of affecting the physical environment.

If the Web is a surface on which artists can draw, and if these drawings are sometimes unofficial, subversive or scatalogical, a link can be made between net art and graffiti.[18] Bunting, who had earlier made graffiti work in chalk, was well placed to ponder and develop such parallels.[19] His *Project x* 1996, described as a '*graffiti street internet interface*', asks people who have seen

the web address as a piece of graffiti and are curious enough to visit the site, to say where they saw it, why they believed it had been done, and what they thought of it; they can also see what other people made of the piece.[20] This work cleverly marries two aspects of the Web: the gathering of data about its users (in this case not done clandestinely but in customer-survey mode) and the overlap between the public practice of graffiti and Internet art. Bunting was attracted to graffiti because it has an effect on everyone, not just those in the art world.[21] The distribution of Internet art and graffiti is similar, as is the act of faith among their practitioners that there exists a wider audience for their art beyond the small band of attentive cognoscenti. Whilst few graffiti writers can know much of their audience beyond the responses of their local competitors, Bunting sought to make them and their views known to himself and each other.

Bunting's online work as a whole both assaults the boredom and convention of administered working life, and holds out a vision of playful, participatory culture founded on dialogue. Bunting's political stance was attacked in a nettime posting apparently written by well-known media theorist, Timothy Druckrey:

18 For crossover activity between net activism and graffiti, see Eryk Salvaggio, 'Free Art Games', Rhizome posting, 2 June 2000; for an excellent site devoted to graffiti, see Art Crimes at www.graffiti.org
19 Bunting's tags can be found at www.irational.org/heath/tags/

20 See www.irational.org/heath/x/ For a description and interpretation of this work, see Jon Thomson, 'Old Tricks', *Art Monthly*, no.227, June 1999, p.52.
21 Tilman Baumgärtel, 'Interview with Heath Bunting', nettime posting, 20 August 1997.

Bunting is best known among the digiratti for his intended subversive actions and attacks on corporate and consumer culture. Attacking professionalism of all kinds, he was picked up by the very professional Catherine David for last summer's Documenta X, the prestigious international art exhibition in Kassel, Germany. In a manner astonishingly akin to Documenta X, with its redundant visits to 70s conceptual art, Bunting's naïve stance revealed his ignorance of the hard lessons learned 20 years ago by less inexcusably innocent precursors. Had he been paying attention, he could have learned sooner that there is no outside to corporate culture or more importantly, that 'outside' is just another target market.[22]

Since Bunting had to make his name and a living (being profiled in *Wired* magazine and accepting a paid position at the Banff Centre for the Arts in Canada), the article claimed that he could not but be implicated in the culture that he set out to criticise, and helps legitimate it by his very critique. This intelligent and critical article was not in fact written by Druckrey, but by someone who had posed as him – quite possibly Bunting himself. Confronted with having to make compromises so as to make critical work, what better way to protect yourself than to write the critique that you must surely face? Bunting has talked about the problems that participating in Documenta X caused him, and about the pressure to commodify his work, a pressure he intended to resist.[23] Even so, the charges of the article, relevant to a wide tendency of political work, stand and bear examination.

The critique is especially pointed because the standard rhetoric of the online technophile is that of rebellion and revolt. One striking instance is an early book devoted to the impact of the Internet on the arts by V.A. Shiva which is subtitled 'A Guide to the Revolution' and contains a section called 'Tools for Revolt', yet is entirely orthodox in its vision of art working for business, and as a business.[24] Similarly, as we have seen, the revolution that *Wired* tirelessly promotes requires only that business be left to its own devices. The toothless tropes of rebellion and revolution have become standard terms in corporate propaganda. As the editorial line of the US cultural magazine, *The Baffler*, has it, capital no longer requires uniformity from its producers and consumers but the opposite: now it is non-conformity, difference, dissent and revolt that is mandatory. Listing the numerous commercial commands to break the rules, change the rules, be different, innovate, stand out from the crowd and so on, Thomas Frank

22 'Timonthy Druckrey', 'Heath Bunting: Wired or Tired?', nettime posting, 21 December 1997.

23 Baumgärtel, 'Interview with Heath Bunting', nettime posting, 20 August 1997.
24 V.A. Shiva, *Arts and the Internet: A Guide to the Revolution*, Allworth Press, New York 1996.

notes that startled old timers (and repressed, puritan or strait-laced individuals generally) are useful precisely because they confirm the rebels' sense of their own rebelliousness.[25] In a wonderfully condensed illustration of the idea that 1960s counter-culture has been thoroughly assimilated by capital, William Burroughs appears in a television advert for Nike.[26]

Leaving aside its political content, the vanguard, innovatory, artist-on-the-edge image of activists like Bunting is not so far from the capitalist fantasy of Net pioneers exploring the new frontier. As Pit Schultz puts it, exploiting a parallel colonialist metaphor, Net-intellectuals believe themselves to be the leading edge of the coming 'Netzvolk', updated modernist supermen riskily performing at the boundary of commercialisation and institutionalisation.[27]

The work that Bunting produced for Banff can stand as a partial reply to such critiques. He set up a mailing system within the organisation that allowed correspondents to be anonymous. The resulting emails (archived at irational) make fascinating reading as the hierarchies and competing interests of the art centre, along with passions, paranoia and gossip, are exposed.[28] Here is an example on the neglect of old media in favour of new:

From: at-banff (98/8/13)

People at Banff, 'All art is propaganda', Trina Mould.

The most successful political manipulation disguises itself as 'neutral'.

The Banff Centre as a leading provider of concealed propaganda has to please the latest power elite.

Sculpture and print making were valuable pawns in anti-soviet state propaganda of the modernist age – 'we are so free over here, that we can spend all day playing with paper', but sadly the global political situation has changed with the fall of the Berlin wall.

So The Banff Centre has to find new clients and new tactics. Corporate capital has to claim the high ground over art/ crime & society to justify their anti community and environment activities, thus making them a desperate new client for our skill sets.

The Multimedia Institute was and still is a useful outfall for corporate crap, but now we need a parallel brand of deception:

25 See Thomas Frank, 'The Rebel Consumer', in Thomas Frank and Matt Weiland, (eds.), *Commodify your Dissent: Salvos from The Baffler*, W.W. Norton & Co., New York 1997, p.41.
26 Ibid., p.36.
27 Pit Schultz, 'The Final Content', nettime posting, 4 April 1997.
28 www.irational.org/ at-banff/

Its time for the cool commodity art sell as developed by the 'Young British Artists.' There is no space for the local or community in this elitist anti-society model.

e.g. Damien Hurst doesn't make his own work, he hires anonymous underpaid people to do it for him. He then sells his work to capital investors.

Anybody who questions this model is clearly an envious unsuccessful idiot.

Mr Hurst is a prize producer of right wing property propaganda. We have a lot to learn from him; lets change the department !

– from The Policy Consultant.

Much of Bunting's work sets up structures within which people can achieve unaccustomed freedom and playfulness of expression. Such works demonstrate a belief in the interest of art audiences' views – one that goes far beyond market demographics.

The point of the 'Druckrey' critique is partly that the state and capitalist art institutions find legitimation by incorporating works of art that appear to stand against them. Yet this is so only within strict limits. Little radical work has been permitted success, especially since the art world became heavily reliant on corporate money; contemporary attacks must be vague and mild (though harsher older ones, bearing sufficient patina, may be displayed). That the art institutions find a fringe of critique useful can hardly be used as an argument against mounting critique, especially against those who seek to develop a wider oppositional culture. Furthermore, this critique of critique has its greatest force against work shown within the art institutions themselves. It has less bite when directed against independent artists' sites. These exceed the bounds of the art world, do not require corporate largesse to realise some imposing physical form or display, and reach out to an indeterminate audience with unpredictable effects. It is not at all certain that any radical content in this realm will rebound to the good of state art institutions and corporations with image problems.

On the Internet, the border between political activism and cultural creation has proved particularly porous. The links between some of the cultural and political activists online are very close and would be unthinkable in the mainstream art world. The artists' centre, backspace, for example, hosted the site that carried information about the

J18 day of action that saw anti-capitalist demonstrations disrupt the City of London in 1999.[29] RTMark show how radical politics and cultural activism can come into synthesis. They pursue political ends through cultural means, and this form of political-cultural fusion is found not only online but is matched by the actions of street protestors attached to the new anti-capitalist politics, who have found ways of uniting actions comparable to performance, environmental and installation art with practical acts of subversion.[30] RTMark describe themselves as follows:

The core of the RTMARK system is a database on the World Wide Web that lists projects of sabotage and subversion, as well as financial rewards for their accomplishment. By allowing funders to speculate in projects anonymously, RTMARK displaces their liability, serving the same purpose to these investors as a corporation serves to its owners.[31]

These acts have included (as we have seen) sponsoring the Barbie Liberation Front to swap voice boxes of dolls in toy shops, support for Phone In Sick Day (workers denied a holiday on May Day take one anyway) and many schemes to battle copyright, including encouraging people to record subversive material over the copyright messages at the beginning of rented video tapes.

While much of their activity is just organised on the Net, RTMark also make online interventions, particularly spoof sites which mirror those of official organisations but load the pages with radical content. RTMark's WTO pages (using the old name of the organisation, GATT, for the site) impart frank information about the management of global trade to maintain the system of exploitation.[32] [029] They have done the same in a very funny site devoted to George W. Bush which was uploaded during the presidential election.[33] [030] Such a tactic is borrowed from the Situationists, being an employment of *détournement*, the use of slight alterations to turn familiar cultural material to radical ends.[34] Both sites have faced threats of legal action, and in November 2001 the WTO leant on the server hosting the GATT site to remove it from the Web. Going to gatt.org now takes the user to a copy of the official WTO site.

Given the ease of copying Web pages, and the ease with which masks can be worn online, such copying and faking of pre-existing sites is a favourite tactic. RTMark say that the idea of faking sites is to create a moment when users question their knowledge of what they are looking at, doubting its authenticity, and whether its authenticity really matters.[35]

29 See http://bak.spc.org/j18/site/
30 An example is Reclaim the Streets. See Aufheben, 'The Politics of Anti-Road Struggle and the Struggles of Anti-Road Politics: The Case of the No M11 Link Road Campaign', in George McKay (ed.), *DIY Culture: Party & Protest in Nineties Britain*, Verso, London 1998.

31 RTMARK, 'Sabotage and the New World Order', in Gerfried Stocker and Christine Schöpf (eds.), *InfoWar*, Springer, Vienna 1998, p.239.

32 See www.rtmark.com/gatt.html
33 See www.rtmark.com/bush.html
34 RTMark's work might have been too straightforwardly oppositional to suit the Situationists' requirements (see Guy Debord and Gil J. Wolman, 'Methods of Détournement', in Ken Knabb (ed.), *Situationist International Anthology*, Bureau of Public Secrets, Berkeley 1981) but the cultural context of such interventions is very

different now that *détournement* is a staple advertising technique.
35 RTMark representative interviewed by Richard Rogers. See Rogers 2000, 'Introduction', p.22.

Finally, a psychological analysis explains the root cause of the electorates' peskiness: envy.

Their [critics'] stance is obviously inconsistent. But it offers an important clue as to why they are focusing so much fire on the WTO.... For many of the WTO's frustrated critics, its powers are as much an object of envy as of anger. (ibid.)

Mike Moore speaks to the issues

The WTO's purpose is to broaden and enforce global free trade. Global free trade already gives multinational corporations vast powers to enforce their will against democratic governments. Expanding these corporate powers--as the WTO intends to do in Seattle and beyond--will further cripple governments and make them even less able to protect their citizens from the ravages of those entities whose only aim is to grow richer and richer and richer.

Does free trade mean a better standard of living?

During the last thirty years, the U.S. market has been "opened" and deregulated more, and more quickly, than that of any other developed country. But the average hours worked per year in the U.S. increased greatly between 1980 and 1997, while in every other developed country but one, they declined. Compared with 1973, Americans must now work six weeks more per year to achieve the same standard of living--and not surprisingly, Americans are increasingly dissatisfied with their lives....

Does free trade mean a high growth rate?

Already today, European countries are being

There is a danger that the lack of context that enables this effect also limits the work, since mere confusion, rather than a radical undermining of expectations, could be the result. RTMark's practice, however, is sustained and thus tends to establish its own audience and context. Its satire contains an implicit positive vision of how the world should be.

A theoretical model of the character of corporations and the mass media underlies much of this tactical activism. Based on Michel de Certeau's book, *The Practice of Everyday Life*, which explored popular, radical misuses of mass culture, and developed by a number of Net theorists, particularly David Garcia and Geert Lovink, the practice of 'tactical media' stresses mobility in the face of fast-moving technological and social change.[36] Similarly, for artistic-theoretical group, Critical Art Ensemble, the corporations are like the Net itself – nomadic, fluid, unfixed, horizontally rather than vertically organised, and highly responsive to changes in the environment within which they make money.[37] Action taken to alter them must take account of their mobile nature, and must be tactical. The issue is put clearly by RTMARK: 'the flexibility of corporate power, its lack of a center, comes at a price: it has no brain. It may be as tenacious as a virus, but it also has the intelligence of one: mechanical, soulless, minuscule.'[38]

Since it reacts to attack by mutation, the argument goes, a sustained series of minor assaults, each tailored to the new situation brought about by their predecessors, can drive real change. It is ironic that this view of corporate power buys into the conservative view of the market and its creatures as natural forces. In fact, corporations remain highly structured and hierarchical entities with geographical bases (generally in global cities), and are far from being indifferent to vertical organisation. Corporate and state power are perfectly capable of acting in concert, of long-term forward planning, and of systematic destruction of their opponents. Indeed, the entire neoliberal and postmodern turn is proof of that.[39] Critical Art Ensemble's misdescription of the corporate world is typical of much of their output. While their sharp critique of the social uses of technology, written in relatively clear language, and their carnivalesque recommendations for art action (graffiti-spraying robots, for example) are entertaining, their attachment to a postmodern political chaos theory, sunk in irrationality, has fostered suspicion.[40] Tactical media are an important element in the struggle against neoliberalism, and they may indeed bring about small increments

36 For a discussion of tactical media, see Josephine Berry, '"Another Orwellian Misnomer?" Tactical Art in Virtual Space', *Inventory*, vol.4, no.1, 2000, pp.58–83; Michel de Certeau, *The Practice of Everyday Life*, trans. Steven Rendall, University of California Press, Berkeley 1984; David Garcia and Geert Lovink, 'The ABC of Tactical Media', nettime posting, 16 May 1997.

37 See Critical Art Ensemble, *The Electronic Disturbance*, Autonomedia, Brooklyn 1994, pp.23–5

38 RTMARK, 'Sabotage and the New World Order', in Stocker and Schöpf 1998, p.242.
39 Noam Chomsky has written much about the sustained, massively funded corporate propaganda efforts to change the political climate. See, for instance, his book *World Orders, Old and New*, Pluto Press, London 1994, chap.2.

40 For CAE, see www.critical-art.net/ For a critical account and interview, see Mark Dery, 'Critical Art Ensemble', *Mute*, no.10, 1998, pp.24–33.

of change but, as activists have been realising with ever greater force, they must at some point come together in wider strategic projects.

Much online political art is engaged in propaganda but there have also been clashes that have exceeded issues of representation, with fateful consequences for both sides. One of the most important issues over which they clashed was the naming of sites. Branding, long a tactic of business, was raised to a new level of power and sophistication through the 1990s as vast resources were devoted to the establishment and maintenance of those complex packages of name, image and emotional associations.[41] The Web has been a prominent area for the expansion of brands into the culture, an attempt to transform them from mere labels into cultural agents. Just as in the offline art world, Absolut has paid artists (including Andy Warhol, Francesco Clemente and Chris Ofili) to depict its vodka bottles, so on the Net, in collaboration with *Wired*, it has hosted writing by the magazine's editor Kevin Kelly in such a way as to frame a set of ideas with its brand.[42]

Branding is particularly important on the Net because, lacking the familiar hierarchy with which physical place is marked, a special attempt must be made to inculcate feelings of trust in a site. Furthermore, online brands are usually a means of navigation: nike.com is both a brand and the path to the company's site. Brands have become among the most powerful points that define virtual space, pulling users into their orbits. As Paul Garrin (whose work we will come to shortly) puts it:

A name is an essential and universal element. On the net, the uniqueness of the name is imperative. In capitalism, the idea of uniqueness means 'value'... commodity. One of the key elements of oppression and control is to control the notion of identity.[43]

Brand names are defended fiercely, with McDonalds, for instance, being renowned for harassing small shopkeepers and restaurateurs who are unfortunate enough to share its name.[44] Suing over the unauthorised use of trade names can also be an effective way of shutting down dissenting views. The supermarket chain Kmart shut down a 'Kmart Sucks' site in this way, rather than using the libel laws, and so avoiding arguments about the company's activities.[45] Artworks that have parodied corporate sites have run into similar legal difficulties. Rachel Baker made a site promising Web users who registered for a Tesco's loyalty card points as they surf, provided they filled in a registration form that asked questions such as 'Do you often give your

41 This is the main subject of Naomi Klein's book, *No Logo: Taking Aim at the Brand Bullies*, Flamingo, London 2000.
42 Klein 2000, p.34. The piece can now be reached through Absolut's website.

43 Paul Garrin interviewed by Pit Schultz, nettime, 13 June 1997; also published as 'Three Interviews with Paul Garrin 1997–98', in Bosma 1999, p.224.
44 Klein 2000, pp.177–8.
45 See Klein 2000, p.182.

personal data to marketers?' and 'How much is your personal data worth to marketing agents?' She soon received a letter from Tesco threatening an injunction and damage claims.[46] Heath Bunting has had similar trouble from American Express. The corporations simultaneously attempt to make their brands culturally ubiquitous and to control tightly the discourse that circulates around them, which may be a contradictory project, but is one pursued with vigour. The general issue here – highlighted by detritus.net, devoted to defending recycled cultural material from the lawyers – is that, whilst well-known brands are an important part of common cultural currency, litigious companies ensure that they cannot be freely used by artists or activists.[47] This is a significant undermining of freedom of speech.

What brought these issues of cultural property into most dramatic focus was the extraordinary confrontation between etoy and eToys. Etoy, as we have seen, is an art collective notorious for the *Digital Hijack*. EToys is a very large online company selling toys. Their domain names, etoy.com and etoys.com, differ by only one letter (it is unusual for an art site to use the .com extension but it makes good sense for etoy since they emulate corporate practices). Etoy had registered their name some years before eToys.[48]

The dispute between the two began in 1999 when eToys received complaints from potential customers who had missed the 's' and ended up at the art site, finding nudity, obscene words and even a photograph of the Oklahoma City bomb site, along with the caption 'Such work needs a lot of training.' As a spokesperson for eToys put it:

There was profanity, there were sado-masochistic images, there were images of terrorist activity. That's upsetting to many people. That's not a comment on whether it has artistic merit. It's about our responsibility to our customers, and our responsibility to address what was beginning to be confusion in the marketplace. Obviously, we also took into account that one of the stated intents of etoy is to disrupt business.[49]

The last admission is a significant one. In any case, by using the supposed danger to children browsing for toys, the company won a temporary injunction in a US court closing down the etoy site.

EToys offered the art site substantial compensation in cash and shares if they would change their name. This was to misunderstand the character of etoy, and the value to them of retaining their artistic integrity, and indeed their registered brand name, in the sight of Net-users. Etoy member Zai commented:

46 For the letter, see www.irational.org/tm/ archived/tesco/ ; for the work, see www.irational.org/tm/ archived/tesco/front2.html
47 http://detritus.net/ This site carries copies of suppressed projects such as Mark Napier's Barbie site.
48 For information about the eToys dispute, see www.toywar.co.uk See also www.RTMark.com

49 Ken Ross cited in Steve Kettmann, 'Toying with Domain Names', 11 December 1999, www.wired.com/nowc/ politics/0,1283,32936,00.html

Our emotions, our artistic integrity, our whole thing is the domain name. Probably the logical response is to get some money rather than lose. But our project was always radical, so it is better for us to risk everything and fight.[50]

Two different conceptions of economy were clashing, one based on the market value of a brand that must remain unsullied, the other on gift-giving, the exchange of opinion, and reputation among a community of interest.

The closure of the etoy site was a dramatic development: a large commercial site had attacked an art site with litigation and, while the dispute was being settled, had exercised its power to remove them from the Internet. The company's calculation was no doubt that the art site, no matter what the justice of their case, would give up when faced with the cost of court action.[51] EToys had, however, picked the wrong group to tangle with. As Rita Mae Rakoczi, a lawyer and RTMark member, wondered: 'why did they choose to pursue in an openly hostile manner an art group best known for a piece called the "Digital Hijack", which made sophisticated use of technology to playfully attack users' browsers? It wouldn't take an Einstein to predict trouble.'[52]

Trouble duly arrived. Etoy ran a fundraising and propaganda campaign from an unnamed (numbered) site, showing toy businessmen and etoy artists on parade. [032] Zai commented that the lawsuit itself had turned into a huge project and was 'a continuation of the art'.[53] Meanwhile, RTMark launched a vocal propaganda campaign, including a spoof of the eToys site, that set out to do no less than destroy the toy company. The threat might have seemed foolish, but RTMark and their online supporters knew what they were about.[54]

Among the tools used against eToys was a program called Floodnet, designed by Brett Stalbaum.[55] Floodnet, as its name suggests, overloads a site with calls to load its pages, and also returns pointed error messages. For instance, in an attack in support of the Zapatista rebels on the Mexican government's official site, Floodnet returned the message 'human_rights not found on this server'. If an attack is to be successful, many people must launch Floodnet against the targeted site at the same time, gaining legitimacy by weight of numbers, much as a political march does.[56] Stalbaum, at least, is clear that Floodnet, in addition to being a tool of political protest, is also a work of art – a 'collaborative, activist and conceptual art work of the net'.[57]

This denial-of-service attack hobbled the eToys site on at least some of the crucial days

50 Cited in Clare Barliant, 'e-Toy Story', www.villagevoice. com/issues/9948/barliant.php
51 This point is made by etoy themselves. See Geri Wittig, 'Interview with etoy', *Rhizome*, 12 February 2000.
52 Cited in RTMark's press release for 25 January 2000, www.RTMark.com/ etoyprtriumph.html

53 See Richard Leiby, 'EToys vs. Etoy: A Clash of Commerce and Art', *Washington Post*, 10 December 1999.
54 See www.rtmark.com/ etoylinks.html
55 For Stalbaum's account of Floodnet, see www.thing.net/~rdom/ecd/ ZapTact.html

56 Recent secretive attacks upon major commercial servers were apparently done by proxy, with similar tools operating from users' computers without their consent. For an account written from the point of view of securing systems against such attack, see Stephen Shankland, 'As New Year Nears, Threat of Net Attack Program Mounts', 23 December 1999, http://news.com.com/ 2100-1001-234822.html
57 Stalbaum, www.thing.net/ ~rdom/ecd/ZapTact.html

033/RTMark, *eToys share price*
chart **1999**

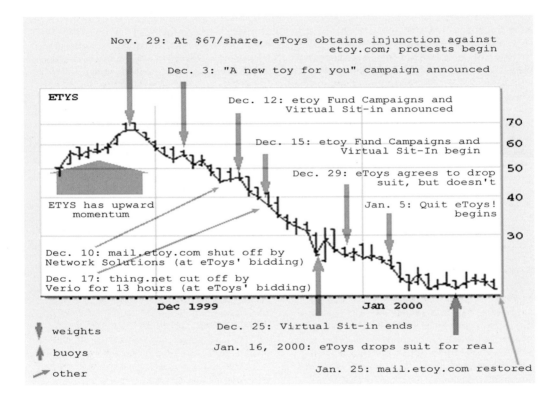

Nov. 29: At $67/share, eToys obtains injunction against
etoy.com; protests begin

Dec. 3: "A new toy for you" campaign announced

Dec. 12: etoy Fund Campaigns and
Virtual Sit-in announced

Dec. 15: etoy Fund Campaigns and
Virtual Sit-In begin

Dec. 29: eToys agrees to drop
suit, but doesn't

Jan. 5: Quit eToys!
begins

ETYS

ETYS has upward
momentum

Dec. 10: mail.etoy.com shut off by
Network Solutions (at eToys' bidding)

Dec. 17: thing.net cut off by
Verio for 13 hours (at eToys' bidding)

Dec 1999 Jan 2000

Dec. 25: Virtual Sit-in ends

Jan. 16, 2000: eToys drops suit for real

Jan. 25: mail.etoy.com restored

weights

buoys

other

before Christmas, preventing online ordering. Worse, eToys could no longer rely on the figures logging the number of customers to its site. These are very important to a Net company's share price, especially given the high value of these shares in relation to company turnover and profits, and the shares' perceived fragility.

It is hard to prove that the activists' assault on eToys was solely or largely responsible for the deep decline in the company's share price. What can be said is that the decline began when the protests did, and that the shares lost 70 per cent. of their value. [033] Unsurprisingly, eToys dropped its case, and agreed to pay etoy's costs. This confrontation showed that corporations can be vulnerable when the terrain and means of dispute are intelligently chosen. It also showed that large numbers of people – or at least enough people – were prepared to act in favour of cultural freedom. There is a rider to this affair: the dispute took place in the months before the general deep fall in high-technology and Internet stocks. When that came, the already weakened eToys, once a company valued at $9 billion, filed for bankruptcy in February 2001.[58]

This legal dispute fitted in well with etoy's general run of work, which had involved cmulating the practices of corporations with a set of corporate strategies and mission statements. This was to make art out of a transformation of corporate structure, playing with its components conceptually just as others played visually with the elements of the interface. Etoy even took to issuing shares, which, while not recognised by stock markets, do fluctuate in value. People who invest in these shares get dividends, not in money but in seeing the realisation of etoy's cultural output. Where does this practice lead? Josephine Berry has argued that etoy, in their pursuit of a brand image, in their issuing of 'shares' for their supporters to buy and their awarding of loyalty points, have come so close to the corporate activities that they set out to undermine as to be indistinguishable from them. The crucial test for Berry is function, for art risks its autonomy when it moves into market manipulation and legal disputes, especially when they are effective.[59] There is a conservative tinge to this view that would insist on art's uselessness: failed interventions can always be interpreted as conceptual art experiments, but successful ones must leave the realm of art for politics.

While this dispute was indeed a tactical victory, RTMark are clear that on the greater issue, little progress has been made. The general legal principles of branding and copyright remain

58 See John Cassy, 'Etoys Files for Bankruptcy', *Guardian*, 28 February 2001.

59 Josephine Berry, 'Do as they do, not as they do', *Mute*, no.16, 2000, pp.22–3.

untouched, and sites remain under threat from litigious corporations, including that of the art and technology magazine, *Leonardo*.[60]

While the Web is widely believed to be non-hierarchical, the naming of sites is strictly controlled. The master list of domain names is stored on a few computers that stand at the top of the Net hierarchy. When one of these computers failed, it caused a good deal of disruption. As Berners-Lee notes, 'technical weakness is itself less of a concern than the social centralisation that parallels it.'[61] Allowable names, particularly the extensions such as 'com', 'gov', 'org', 'ac', and the further nation-state extensions such as 'uk' and 'de' are managed centrally (just as there was no need to put 'Great Britain' on postage stamps, this being the privilege of the inventor of a new communications apparatus that was also the major world power, so there is no 'us' extension). Naming is now managed by the corporation ICANN, whose recent decisions on establishing further extensions have been the subject of much controversy.[62] To get a new extension recognised is a long and costly process with no guarantee of success. Site names are controlled, then, with a mix of enforced convention and litigation.

One of the most remarkable initiatives taken against the control of naming on the Net has been Paul Garrin's project *Name.Space* which provides an online area in which names can be used freely without incurring legal action or other forms of suppression.[63] Garrin is an artist and activist who has consistently opposed the commercialisation of the Net, which he sees as threatening freedom of expression within the very system of communication that has the greatest potential to develop participatory politics. Garrin points to examples of online businesses suppressing views they find inconvenient, and urges users to rely on small local service providers or to set up their own:

Participate in and support the growing number of independent sites on the World Wide Web. Create sites and link to other independent sites. Take control of the web and create content – independent worldwide distribution is now in our hands. Establish a strong presence and make your voices heard before what is left of the public space on the internet is legislated away by the cronies of the Christian Right in government and the multinational corporations who want to create a global 'virtual megaMall'.[64]

As we have seen in our discussion of search engines, such action is indeed vital to

60 RTMark, '2000 Annual Report', 29 December 2000; www.rtmark.com/2000/html
61 Tim Borners-Lee (with Mark Fischetti), *Weaving the Web: The Past, Present and Future of the World Wide Web by its Inventor*, Orion Business Books, London 1999, p.137.
62 See, for example, Neil McInstosh, 'ICANN Cause Confusion', *Guardian*, Online section, 23 November 2000.

63 http://name-space.com
64 Paul Garrin, 'The Disappearance of Public Space on the Net', 6 January 1996; www.0100101110101101.org /home/glasnost/stasi/privacy/ public_space_on_the_net.html

the development of independent and visible sites on the Internet. Those sites without sufficient links pointing to them become, in effect, invisible.

Garrin's idea was to create a service that people can use within the Internet (an intranet) in which new names can prove themselves simply by demand for their use. Top-level names would come and go according to use, rather than being fixed by administrative dictat.[65] One of the advantages of free naming is that names can specifically reflect content, and sites are not classified into rigid categories, nor branded with the initials of their nation. *Name.Space* is dedicated to keeping the top-level name space public, allowing for many local name registries to share the same top-level names without conflict. Whereas the Internet system works with the model of domains – of territory and thus of domination, says Garrin – in his model, names inhabit overlapping spaces, and sites may eventually come to wander in and out of hiding.[66] Garrin states that *Name.Space*'s present status as an intranet is similar to that of demo software, designed to foster public interest and to show that the principle is conceptually and technologically sound.[67] As with the development of independent sites, *Name.Space* relies on public recognition and participation, and will stand or fall on these grounds.[68]

Name.Space is not anti-commercial as such, and indeed has to survive as a commercial venture, since the idea is to use the market to produce an information system more responsive to public expression. It is designed as a means of providing space for the operation of alternative media free of institutional or corporate censorship, while at the same time using the language of the free market to expose the hypocrisy of those who want the Internet regulated for their own assured financial gain.[69] As Garrin puts it: 'The goal of Name.Space is to buy as much bandwidth and processor power as possible to ensure that there is always a home for free media and alternative voices and visions on the ever changing Internet.'[70]

Is *Name.Space* an art project? In a revealing exchange, Pit Schultz put it to Garrin that it certainly was, saying that it was 'maybe the best net.art project I know of' but only under the crucial condition that it did not work (an idea that should be familiar by now). Garrin did not directly reply to the art question but asserted that the system does work.[71] Indeed, in going on to explain why *Name.Space* has had few long-term participants, Garrin describes not only the political immaturity of hackers who might otherwise have been drawn to it, but the suspicion of theorists towards a functioning alternative:

65 Technical, legal and press information about *Name.Space*, can be found at www.name-space.com
66 Ibid.
67 Pit Schultz, 'Interview with Paul Garrin', nettime posting, 13 June 1997.
68 Ibid.

69 Ibid. See also Garrin, 'Regarding your Questions on Name.Space', nettime posting, 21 January 1997.
70 Schultz, 'Interview with Paul Garrin'.
71 Ibid.

The problem is that Name.Space is about *real action* which requires the responsibility to act on one's propositions and suffer the consequences or reap the benefits. Certainly not as safe as plain old ASCII. It becomes another dilemma for them whether to think or to act, or how to reconcile thoughts into action.[72]

The Net gives to artists the possibility of making their works act as political and social agents, without the mediation of state institutions, commercial dealers and the print or broadcast media. Some shy away from this exposed position, especially if it involves them directly in commercial activity (some have complained that Garrin is running a business but, it must be said, very few artists are not).

Other online developments complement Garrin's programme. Data has been freed from its physical vehicles – words, sounds, and still and moving pictures drifting from their material substrates of paper and plastic – so challenging the model of consumerism in which people have been content to pay for objects that carry data. The music industry is struggling to control and profit from the distribution of digital music files, particularly against peer-to-peer (P2P) programs that allow users to share files directly (turning the informal copying and exchange of music between acquaintances into a global free-for-all). This is a process that terrifies the music industry, which has reacted with a mix of litigation and attempts to commercialise file-sharing. Efficient methods of file compression and the cracking of DVD encryption threatens film in the same way. While *Name.Space* frees names from exclusive ownership, peer-to-peer programs free data files from the names that exclusively govern them, and will prove extremely difficult to police. The effects on already reproducible media are radical enough, but to the zealously guarded value of the art object, as we shall see, they present a greater challenge still.

The dispute over trade names and intellectual property is fundamental to the development of the Net. The ability to cite freely, to purloin images that are salient within the general culture, to pursue a conversation without vetting by lawyers is crucial to democracy and free speech. The ability to paste text and other material into new documents, changing the context of that material, is one of the great advantages of online discussion, and the assembly of artworks from pre-existing elements is a central strategy of online art. As Henry Jenkins puts it:

72 Schultz, 'Interview with Paul Garrin'.

If one follows the flow of ideas on a Web forum for more than a few posts, it becomes harder and harder to separate one person's intellectual property from another's. We quote freely, incorporating the original message into our own. When netizens discuss television, we quote freely, pulling chunks of aired material into our posts, and adding our own speculations. Other people respond, add more material, and pretty soon the series as viewed by list participants differs radically from the series as aired.[73]

So television programmes come to be treated as common property, an attitude that displeases TV companies. Legally, some of the most powerful and pervasive cultural symbols are ruled out of free discourse; Disney, to take one notorious example, does not hesitate to sue even nurseries that make unauthorised copies of its characters. Again, a situation that existed offline has been brought into dramatic visibility online. The dispute over site names is only a particularly clear illustration of the general power struggle over cultural ownership and free speech.

73 Henry Jenkins,
'Digital Land Grab';
www.technologyreview.com/
articles/jenkins0300.asp

Free from Exchange?

As growing Internet use allowed software to be distributed widely and cheaply, Net-users not only challenged conventional systems of commerce but invented an alternative model of their own. Technically adept enthusiasts write their own programs and distribute them online. While there is nothing to stop programmers charging for their work, it is considered a matter of principle that these programs are supplied with their source code so that other users can alter or improve them. In this way, a collaborative system of exchanging software emerged, in which programmers work to improve, update and debug what is, in effect, publicly owned code. Popular programs are continually improved by a global community of programmers who communicate through the Net. Remarkably, these freely available programs now range from small utilities like screensavers to entire operating systems. Linux, initiated by programmer Linus Torvalds, a free version of the powerful operating system Unix, was the first project to draw on the online world as its pool of talent. It has developed (as leaked Microsoft memos admit) into a serious threat to the dominance of Windows.

A significant cause of the Internet's rapid growth has been that the software that runs it is not proprietary but in the public domain.[1]

1 Eric S. Raymond,
The Cathedral and the Bazaar: Musings on Linux and Open Source by an Accidental Revolutionary, O'Reilly, Sebastapol, CA 1999, p.171.

The deliberations of the Network Working Group that established the Internet were driven by a similar ethos to free software activists, based particularly on the principles of collaboration and lack of secrecy.[2] Attempts at conventional commercialisation, by contrast, have killed off pieces of Internet software, since people and companies have been reluctant to negotiate legally for their use, and are nervous of being sued for patent infringement.[3]

This free exchange of software has led some commentators to compare the online gift economy with the ceremony of potlatch, in which someone gives extravagant gifts or even sacrifices goods to raise their prestige. Yet there is a fundamental distinction between the two, since the copying and distribution of software is almost cost-free.[4] Someone who hosts a dinner party expends material goods, and after the party is over, the food and drink are gone. With software, it is different. If a programmer gives away a program that they have written, the expenditure involved is the time taken to write it – millions of people can have a copy without the inventor being any poorer. Furthermore, in the larger scheme of things, in which programmers exchange the products of their labour, 'free loaders' (those who use free software but do not contribute to its

evolution) hardly cost the community anything, and can safely be ignored.[5]

In these circumstances, argue the activists of the free software movement – most prominently Richard Stallman, programmer of Unix components – to charge for software as though it were a material good that could be taken away from someone, and to hedge it about with the legal restrictions that govern material goods, is anachronistic and counter-productive. Stallman argues, not that programmers should make no money from their efforts, but that the commercial software market is set up solely to make them as much money as possible. This means that many people are denied the use of software, and (because the source code of commercial programs is kept secret) the right to tailor it to their particular needs.[6] The result, to rule illegal the sharing of a good that is not exhausted by sharing, is no less than a pollution of social relationships.[7]

An ideological tussle has developed over this form of software development between radical idealists (represented by Stallman) who really want software to be free, and the pragmatists (represented by Eric Raymond) who would rather not frighten the corporations, and prefer the movement to be known as 'Open Source'. The term 'free', argues Raymond, is associated with

2 John Naughton, *A Brief History of the Future: The Origins of the Internet*, Weidenfeld and Nicolson, London 1999, p.138; Katie Hafner and Matthew Lyon, *Where Wizards Stay Up Late: The Origins of the Internet,* Simon and Schuster, New York 1996, pp.144 et seq.
3 Berners-Lee notes that this was the fate of Gopher, owned by the University of Minnesota, following an attempt to charge for the software in 1993. Tim Berners-Lee (with Mark

Fischetti), *Weaving the Web: The Past, Present and Future of the World Wide Web by its Inventor*, Orion Business Books, London 1999, p.79.
4 For the argument that the two are similar, see Richard Barbrook, 'The High-Tech Gift Economy', in Josephine Bosma et al (eds.), *Readme! Filtered by nettime: ASCII Culture and the Revenge of Knowledge*, Autonomedia, Brooklyn 1999; the source for contemporary interest in potlatch is Bataille, 'La Notion de dépense',

La Critique sociale, no.7, January 1933; and in English as 'The Notion of Expenditure', in *Visions of Excess: Selected Writings, 1927–1939*, ed. Allan Stoekl, University of Minnesota Press, Minneapolis 1985. Bataille drew on Marcel Mauss, *The Gift: The Form and Reason for Exchange in Archaic Societies*, trans. W.D. Halls, Routledge, London 1990.
5 This point is made by Raymond 1999, p.152.

6 For a good survey of these views, see Richard M. Stallman, 'Why Software Should Not Have Owners'; www.gnu.org/philosophy/why-free.html; also 'Lecture at KTH', 30 October 1986; www.gnu.org/philosophy/stallman-kth.html
7 Joe Barr, 'An Interview with Richard Stallman', *Linux World*, 10 February 2000; www.linuxworld.com/linuxworld/linuxworldtoday/lwt-indepth7.html

hostility to intellectual property rights or even with Communism. The Open Source initiative wants to replace those associations with 'pragmatic tales, sweet to managers' and investors' ears, of higher reliability and lower cost and better features.'[8] For Raymond, Open Source software such as Linux is produced under something approaching free-market conditions in which selfish agents maximise their own utility and so produce a self-correcting, spontaneous order. Raymond argues that the system is set up to maximise productivity, with programmers competing to make the most efficient code, and that 'the social milieu selects ruthlessly for competence'.[9] While programmers might appear to be selflessly giving gifts, their altruism masks the self-interested pursuit of prestige in the hacker community.[10] Raymond's pragmatism has been supported by Torvalds who has favoured the growth of commerce around Linux, while deriding the idealists.[11] The Open Source approach, says Raymond, fits in with 'a broadly libertarian view of the proper relationship between individuals and institutions.'[12]

As against Raymond's view of collaborative work between programmers, which he compares to land claims in open country (a frontier perspective, with some extremely unpleasant ideological undertones), other activists view the Net as a public commons, and are worried that commercial interests are driving a new movement of enclosure, just as nascent capitalism drove rural folk from the common land on which they had grazing rights. There is the threat to the status of Linux as an Open Source program, coming from programmers who were happy to work for free before very large profits were made from various commercial versions such as Red Hat, and there are popular closed-source versions of the Internet offered to mobile users, notably the mobile phone software standard Wap.[13]

Despite the success of Linux and the server program Apache, the future of free software is uncertain. The failure of Netscape which moved to Open Source development in 1998, in its battle against Microsoft's Internet Explorer has been an important indication of the weaknesses of such ventures. Raymond makes the important point that if Linux is ever to challenge Windows in the mass market, then it has to be not only on technical grounds, in which it excels, but also on design and interface psychology, areas in which hackers (so expert that they have forgotten what computers feel like for new users) have traditionally neglected.[14] Nevertheless, free software has unsurprisingly done well during the recession and the crisis of the high-tech

8 Raymond 1999, p.206.
9 Ibid., p.71.
10 Ibid., pp.64–5.
11 Ibid., pp.85 6.
12 Ibid., p.226.

13 On these issues, see Bill Thompson, 'Can we Keep the Internet Mutual?', *Guardian*, Onlino coction, 6 July 2000.
14 Raymond 1999, p.222.

industries, while Linux presents enough of a threat to Microsoft for its CEO, Steve Ballmer, to condemn it as a 'cancer'.[15]

It is this model of collaboration, along with the sharing of data such as music files, that has provoked some of the most politically charged theorising about the Net. For the media theorist Richard Barbrook it is no less than online 'anarcho-communism', a form of political economy that mixes radical instincts with self interest, pragmatism and the regular function of capitalism.[16] It opens up the possibility of a highly participatory culture in which the ownership of information has little meaning, and so holds out the prospect of a radical change in the character of the economy as a whole.[17] In contrast, for Pit Schultz such talk is an illusion: capitalism cannot be criticised from within capitalism; even gifts work within the economy of reputation, credibility and cultural capital, and in any case today the outside of the market is almost unthinkable.[18] Yet the combination of gift-giving, collaboration and openness, each element needing its partners, is beyond mainstream capitalism's field of view. While Microsoft is moving towards the idea that its customers should lease continually updated modules of programs as they need them, nevertheless, a price would still be paid, the

source code would still be closed, and the distinction between producer and consumer would remain intact. Stallman's main point retains its force: why should programmers – and one might add any cultural producers – working with data that can be reproduced and distributed for very nearly no cost, make so much money from their productions that ownership of these goods is unnecessarily restricted? If the question cannot be satisfactorily answered, hackers and activists will break through those restrictions, liberating data into the public realm.

In their influential book, *Empire*, Michael Hardt and Antonio Negri argue that the new mode of production makes cooperation completely immanent to the act of labour. People need each other to create value, but no longer necessarily capital and its organisational powers. Rather it is communities that produce, and as they do so, reproduce and redefine themselves, and the outcome is no less than 'the potential for a kind of spontaneous and elementary communism'.[19]

Again, it might appear that this discussion has taken us far from online art, and again boundaries here are far from being fixed and distinct. The award of the prestigious art prize, the Golden Nica, at the 1999 Ars Electronica to Linux raised fundamental questions about the definition

15 Ballmer's remarks were made to the *Chicago Sun-Times* in June 2001; see Glyn Moody, 'Free Software Survives Downturn', *Guardian*, Online section, 10 January 2002.
16 See Barbrook in Bosma 1999.
17 For an optimistic prognosis, see Richard Barbrook, 'The Regulation of Liberty', *Telepolis*, 14 September 2000.
18 Pit Schultz, 'The Final Content', nettime posting, 4 April 1997.

19 Michael Hardt and Antonio Negri, *Empire*, Harvard University Press, Cambridge, Mass. 2000, pp.294, 304.

of the online artwork and the character of non-commercial collaboration. There is obviously a vast difference between Linux and most cultural projects: Linux is a shared collective project in which there are agreed aims and criteria. Speed, reliability, compatibility and simplicity are virtues agreed upon by the Linux community. Art is generally not like this, not because collective judgements are never arrived at, but because the criteria that underpin them are often unstated, and individuality – not to say eccentricity – is institutionally favoured. As Raymond notes, in art projects where the utility of peer review is lower, the incentives for using the Open Source model almost evaporate.[20] This point, however, leaves open the question of the evolution of artwork to take advantage of this system, and we have seen that some artists have used the Internet precisely to open a forum for users' opinions.

The development of Internet art is a little like that achieved by free software, though not applied to a single product being tailored for collective use, but over a group of works which publicly display their code for copying and tweaking.[21] There has been much collaboration – as evidenced by Cosic's description of the studios of the early Net artists being virtually next door. Part of the impetus behind this collaboration is practical, being simply the pooling of technical expertise. In part, it has emerged out of the practice of borrowing code. The logical end of this process, as Bookchin and Shulgin point out, is the practical (not merely theoretical) death of the author.[22] There have, however, been limits to this collaboration. Works may draw upon and cite others but generally remain the product of a named site or named artists. While much online coding is open, and can be changed by anyone who has the skills, some important Net tools, including Flash, are closed source, or at least have an option to close the source to outside interference.

Sometimes the places in which online artists collaborated were physical, as for example in London's well-known studio backspace that ran until 2000, and at which Baker, Bunting and others made projects.[23] Meetings at art fairs, symposia, festivals, conferences and so on have also been extremely important. A continuing and intense conversation – online but also face-to face – takes place between Internet artists who make up a small and quite cohesive world. As Cosic puts it, 'I go to conferences. That's net.art actually.'[24] The open character of these exchanges stands in marked contrast to the often secretive and disingenuous discourse of the mainstream art world, in which it can be most telling to dwell

20 Raymond 1999, p.226.
21 For an attempt to apply the Open Source model to online art production, see Saul Albert, 'Open Source Tactics for Collective Art Practice', nettime posting, 24 February 1999.

22 Natalie Bookchin and Alexei Shulgin, 'Introduction to net.art (1994–1999)', www.easylife.org/netart/
23 See www.backspace.org
24 Josephine Bosma, 'Vuk Cosic interview', nettime posting, 27 September 1997.

upon what is not said. This openness was given systematic and touching expression in 0100101110101101.org's project, *life_sharing* in which they opened the entire contents of their hard disk to the Internet, revealing everything from artworks to email and (Open Source) programs.[25]

Collaboration has been at its most explicit and free in discussion, particularly on the mailing forums. The mailing forums, or BBS systems, and other forms of information exchange, were first established by technically minded people in the small online world.[26] As the Internet grew, special-interest groups proliferated. AIDS activists, particularly in the US, facing exclusion from the mass media and with an urgent need for the rapid dissemination of up-to-the-minute information, were among the first to exploit BBSs fully.[27] It is in these forums, particularly on the nettime and Rhizome lists that much of the most stimulating debate about Internet art and online culture can be found.

Like transient online art, and hypertext publishing generally, interventions in mail forums comment on one another, and form part of a changing and developing conversation. As K. Eric Drexler pointed out in a pioneering essay on the potential of hypertext, conversation on paper develops slowly (certainly in academic

circles) due to the time needed for review, resubmission, publication and distribution, and the same is true of any riposte that may be published. What is more, the final result remains unchanged and isolated from the comments it has provoked. (Much the same can be said of physical works of art in galleries and museums, generally torn from a particular temporal, spatial and intellectual context.) Hypertext allows for rapid revision, collapses the time-scale involved in getting a response and can link all related texts together.[28] We should expect the development of conversation conducted through online art works and texts to be quicker and more intense – and it is.

Despite the valuable role that it has played in the exchange of information and the development of interest groups, much BBS discussion can be banal and incoherent.[29] As Licklider put it, 'men are noisy, narrow-band devices', and the disadvantage of unstructured, non-hierarchical debate and collaboration can be a loss of coherence.[30] Even among a fairly small group of people with a well-defined set of interests, it can be hard to sustain a serious discussion. It can also sometimes be difficult, reading threads of postings from, say, nettime, to follow the evolution of the arguments. Berners-Lee thinks that this lack of structure stands in the way of meaningful discourse and

25 www.0100101110101101.org
26 For a fine account of early online communities, see Howard Rheingold, *The Virtual Community: Finding Connection in a Computerized World*, Secker & Warburg, London 1994.
27 Michael Tidmus, 'Anecdotal Evidence: A Survey of Hypercard Computer Projects', *Leonardo*, vol.26, no.5, 1993, pp.397–404.

28 K. Eric Drexler, 'Hypertext Publishing and the Evolution of Knowledge', originally published in *Social Intelligence*, vol.1, no.2, 1991, pp.87–120; online version at www.foresight.org

29 I have previously been too hasty in condemning BBS debate. nettime and other forums do show that it can be productive, despite its problems. See Julian Stallabrass, *Gargantua: Manufactured Mass Culture*, Verso, London 1996, pp.51–3.
30 Joseph Licklider, 'Man-Computer Symbiosis', *IRE Trans-actions on Human Factors in Electronics*, vol. HFE-1, March 1960, pp.4–11.

believes that one way for computers and humans to collaborate would be to have a software tool that registers the logic of an argument and the current state of conversation – weeding out, presumably, redundancy, repetition and contradiction.[31]

Even so, in the art world such forums most closely approach the ideals of democratic participation and meaningful interaction. The nettime organisers saw themselves as emerging out of a critical leftist agenda that had grown tired and over-academic. Their encouragement of Net critique was a way of reactivating that discourse with a large dose of pragmatism.[32] It has indeed gone a long way towards formulating a rich and complex view of online culture. Nettime's problems partly stem from its success, as the list grew unwieldy and there became too many postings for people to follow.[33] Some of the pioneers of Internet art had used nettime as a forum within which to exchange ideas and comment on each other's work. Bunting has complained that as the list grew larger, it moved from being a network of artists engaged in collaboration to becoming more like a place where one would exhibit one's works to an audience.[34] Nettime's problems have been those that have faced many BBS systems, as people use them for self-advertisement, or as controversies

spiral out of control and beyond the limits of polite discourse.[35] Nevertheless, with such systems, there is a feeling of a collective programme, of an over-arching project to which individuals make contributions in works or words. As with the free software movement, there is an implicit collective project founded on gift-giving and reputation, with little thought of immediate recompense. Such forums for discussion and exhibition are open, disputatious, democratic and egalitarian, and permit a glimpse of a future culture that is founded, not on broadcast, but on dialogue.

31 Berners-Lee 1999, p.187.
32 See the introduction to Bosma 1999, pp.17–19.
33 On this, see Pit Schultz, 'Moratorium', nettime posting, 23 June 1997.
34 Josephine Bosma, 'Ljubljana Interview with Heath Bunting', nettime posting, 11 June 1997.

35 On such problems, see Rheingold 1994, pp.36–7.

The Art Institutions

The history of 'media art' – art that uses electronic communications – is a peculiar one, of regular false dawns and lost histories as its previous waves have dissipated, leaving little trace on the art world as a whole.[1] A positive effect of the recent success of Internet art has been the excavation of the art that can now be seen to have acted as its precursor.

One of the early users of electronic communications in art, Robert Adrian, analysed the reasons for this neglect: there was no big product at the end of such work, and thus no art stars (as there were in video); it was hard to identify the 'work' and the 'artist' firmly in collaborative and distributed network projects; and most of all:

The older traditions of art production, promotion and marketing did not apply, and artists, art historians, curators and the art establishment, trained to operate with these traditions, found it very difficult to recognise these projects as being art. Net art challenges the concept of art-making as a more or less solitary and product-producing activity.[2]

Yet there is good reason to believe that this current wave will be different, since it is the first that has been tied into a widely taken-up technology that is not limited to a single medium,

1 This point is made by Jurgen Claus, 'Expansion of Media Art: What Will Remain of the Electronic Age?', in Timothy Druckrey and Ars Electronica (eds.), *Ars Electronica: Facing the Future: A Survey of Two Decades*, The MIT Press, Cambridge, Mass. 1999, pp.180–4.
2 Tilman Baumgärtel, 'Interview with Robert Adrian', nettime posting, 8 July 1997.

034/Vuk Cosic, *MoMA*,
from *Life* 1997

and is not bound by the broadcast paradigm. The fate of Internet art is tied to that of the Web.

Given the extraordinary growth of the Internet, art institutions have had to deal with online art, even though they have often found themselves at odds with its makers. The ethos of much online art is opposed to the established hierarchies and niceties of the mainstream art world, particularly its courting of corporations and very wealthy individuals for sales and patronage. The suspicion towards art institutions, particularly in the neoliberal economies, is well founded for they have had to adapt to the realities of the market as state funding was cut back or withdrawn. Galleries and museums thoroughly commercialised their activities, and are now in hock to both corporate and state interests.[3] Among the corporations that find art sponsorship attractive are those, such as BP, that burnish their image with largesse directed at the cultural elite, in the hope of deflecting attention from their environmental and human rights records.[4] For Paul Garrin, institutions like ZKM and the Guggenheim 'set their agenda according to the pulse of Siemens and Deutsche Telekom', and they have to forget social criticism or political context or 'forget their deutschmarks'.[5] It is no accident, then, that independent online work has been so far more political and critical than art seen in galleries and museums, because on the Net, sponsors and art institutions long accustomed to anticipating sponsors' concerns, do not determine what does and does not get seen.

Sometimes, attempts by galleries to incorporate Internet art go awry, as values collide. Graham Harwood of Mongrel, for instance, when asked to make a piece for Tate's website, produced a subversive intervention, focusing in part on the lacunae of Tate's collections, many of which are far from being the products of historical accident.[6] Blank frames made clear these omissions, while other works in Tate's collection were mongrelised with cut-and-paste modifications. [035] Tate's anodyne statements about itself were also replaced by texts from other sources, some dwelling upon the history of the museum, including the Millbank prison, and the role of Tate in urban pacification:

Tate Liverpool opened in 1988 in a converted warehouse in the Albert Dock ... In the summer of 1981 the Toxteth riots played a part in making a Liverpool outstation feasible, as they shook the government and secured the Merseyside Development Corporation's sense of purpose. The riots had not been the result of unemployment in Liverpool, though this was clearly a factor,

3 See Chin-tao Wu, 'Embracing the Enterprise Culture: Art Institutions Since the 1980s', *New Left Review*, no.230, July–August 1998, pp.28–57, and her book, *Privatising Culture: Corporate Art Intervention Since the 1980s*, Verso, London 2002.

4 BP has been criticised for (among other things) their involvement in grave human rights violations in Colombia and the environmental consequences of its operations in the Arctic. For a brief account, see www.mcspotlight.org/beyond/companies/bp.html

5 Garrin also claims that ZKM considered buying some of his work but dropped the idea because they were afraid of the controversy. 'Three Interviews with Paul Garrin 1997–98', in Josephine Bosma et al. (eds.), *Readme! Filtered by nettime: ASCII Culture and the Revenge of Knowledge*, Autonomedia, Brooklyn 1999, p.225.

6 For a good account of this work, see Matthew Fuller, 'Breach the Pieces', http://www.tate.org.uk/webart/mat2.htm

but of the ultimate collapse in relations between the police and mainly black residents of Toxteth, who were sick of what seemed to be officially tolerated harassment. A chain of events was set in motion which began with the appointment of Michael Heseltine, Secretary of State for the Environment, as Minister for Merseyside, with the instruction to offer a 'package' to help the city. [Alan] Bowness, then Director of the Tate, seized the opportunity to approach Heseltine with Lord Hutchinson ... They spoke for ten minutes and Heseltine pronounced the Tate Liverpool a wonderful idea.[7]

Nervousness in the Tate about the project, particularly over whether to include the sponsor's logos in the altered site, led to a delay that Harwood used to his advantage, posting the piece on his own site, and raising the possibility of censorship in the press.[8] Tate, naturally, had little choice but to allow the work to go ahead. Having done so, it made the brave decision to send a proportion of visitors, not through Tate's home page with its explanatory introduction to the Mongrel action, but directly to the altered pages.

While the resistance of parts of the online cultural community to assimilation, and its hostility to the art world lent it a certain edgy allure that proved attractive to art institutions, the relationship did not necessarily work in reverse. Some online activists claimed that making communications was something quite different from making objects, and that the art world only sought to renovate itself through connection with the online world. As Robert Adrian put it in 1997:

Why should we, as artists struggling to find ways to survive on the tricky edge of a new digital communications environment, be trying to breathe new life into the corpse of the traditional art institutions? For the money, fame and glamour?[9]

Furthermore:

The similarities with 'mail-art' are obvious – and net.art can probably expect as much feedback from the 'art-establishment' as mail-art got. At least I hope so – it would be terrible if the art establishment wrapped it in its gorilla embrace![10]

Yet the art institutions have now moved in on Internet art with large resources. Major international art events, including Documenta, the Whitney Biennial and the Venice Biennale have showed Internet art, and large institutions, especially in the US and Germany, have moved to establish online programmes. There are various benefits for the art institutions in this move. It is a relatively cost-effective way to appear contemporary, and especially to be seen to address issues of globalisation.

7 Frances Spalding, The Tate: A History, London 1998; as cited at www.tate.org.uk/ netart/mongrel/liverpool/ history.htm
8 See Mylene Van Noort, 'Has the Tate Gone Too Far?, Guardian, Online section, 25 May 2000.

9 Robert Adrian, 'Art on the Net', nettime posting, 14 March 1997. Robert Adrian is an artist and theorist who has also worked under the name 'Robert Adrian X'.
10 Robert Adrian, 'Net.art things?', nettime posting, 1 April 1997.

Young curators can be employed to handle the content of an art institution's server without much affecting its regular gallery programme. Showing Internet art also allows art institutions to claim to be reaching an audience outside their usual remit. Since new technology companies and online banks were until recently awash with cash and anxious to raise their profiles, it was furthermore an easy source of money.

The greatest danger of art institutions embracing Internet art is that in doing so they will change It to fit their purposes. An interview with David Ross, director of the San Francisco Museum of Modern Art, highlights such dangers. While claiming that he does not prejudge things that he does not immediately understand, Ross also makes a claim about museum expertise:

We're trying to identify the activity that is net art. Since we know what older art looks like, we can start to develop standards and a critical evaluation framework for looking at net art based on our idea of what art should act like or look like.[11]

This statement exemplifies the attitude of assimilation into the familiar that one would expect, in which the future must look comfortably like the past. One way to ensure this is to commission established gallery artists to make Net works, a way of making online reality conform to the museological vision. Ada'web, run between 1994 and 1998 by curator Benjamin Weil, used established artists to make online work: Jenny Holzer, for instance, put up her barbed truisms on sites anonymously, and allowed users to alter them.[12] The Dia Center for the Arts has followed a similar strategy, showing artists such as Francis Älys and Susan Hiller. Curation of online work has sometimes been referred to as 'filtering', protecting viewers from the glut of Internet art, and finally encouraging artists to make sure that their work will pass through the institutional mesh.[13]

The dangers of this filtering are clear because, while there are certainly forms of art, such as mail art, that have for decades evaded institutionalisation at the price of obscurity, there are also media that have transformed themselves so as to become at home in the gallery and museum. The attitude of the art institutions to Internet art is often compared to their response to video. This is not a helpful comparison if it leads Internet art to be thought of as another medium, for, as we have seen, it is the marriage of all media. What has been similar, though, is art-world resistance to the use of a new, increasingly cheap and accessible technology embraced by artists.

Video art's fate in the museum offers a dire warning to Internet art. The gallery and the

11 Reena Jana, interview with David Ross, *Flash Art,* January–February 1999, p.34.

12 Benjamin Weil (via Pit Schultz), 'Art on Net', nettime posting, 10 April 1997. Holzer's work, *Please Change Beliefs* is at http://adaweb.walkerart.org/project/holzer/cgi/pcb.cgi
13 Anon., 'RUSH – The Net Art Gold Rush', conceptualart.org, 25 September 2000.

036/Thomson & Craighead,
Triggerhappy [Web-based
version] 1998

museum did come to embrace video but generally by remaking it as video-installation, displaced from the TV monitor onto large-scale projections, spectacle being purchased at the price of losing mass-production and wide distribution. Video became something that resembled a traditional fine art object. It may be that the embrace of Internet art will be similar, turning this most distributable and immaterial communication into a hybrid techno-craft practice of making objects and environments.[14]

Various problems are raised when art institutions do not merely host Internet art on their servers but bring it into physical space. The basic difficulty is that there is not much point in simply lining up machines in a gallery to allow people to look at Internet art. Only one or two people can use a machine at once, many people are self-conscious about browsing while others are looking on, and those who do look on tend to have an unsatisfactory experience of the work. It is true that galleries can provide free browsing and point users towards art sites they might otherwise never see, but generally Internet art is better seen in private or informal spaces.

Some artists have made pieces that address these peculiarities of display. In Thomson & Craighead's *Triggerhappy* 1998, available on the

Web though not in itself reliant on networked communication, users play a game of Space Invaders in which the descending aliens are replaced by sentences taken from Foucault's celebrated essay, 'What is an Author?'[15] [036] As words are shot to pieces, the sentences lose coherence. Academics besieged by the ever-growing glut of texts to be digested, fought over or deconstructed can strongly identify with this work. In the gallery version, the contrast between user and spectator is brought to the fore: the person who is playing the game has no time to read the texts; those watching and reading cannot play.[16]

Documenta X, curated by Catherine David, was the first outing for Internet art at a large art exhibition and many praised the vision that brought online art to such a prestigious event. The ethos of much Internet art was congenial to the aim of that Documenta, in which David unfashionably and courageously attempted to renew the engagement between art and politics, and indeed did much to change the climate in which such questions had been automatically dismissed.[17] Nevertheless, the results for online art were far from happy. It was tucked away in a room with office furnishings, and the computers on which it was shown were not connected to the Internet.

14 This is a criticism that could be justly levelled at the show I curated at Tate Britain, *Art and Money Online* (2001); all I can say in my defence is that one learns by doing, and that at the time it seemed to me that the advantages offered by displaying little-known work in a mainstream institution outweighed the disadvantages.

15 www.triggerhappy.org Michel Foucault, 'What Is an Author?', in *Language, Counter-Memory, Practice: Selected Essays and Interviews*, ed. Donald F. Bouchard, Cornell University Press, Ithaca, NY 1977.

16 For an account of *Triggerhappy*, see J.J. King, 'Web Word War', in Janet Abrams (ed.), *If/Then Play*, Netherlands Design Institute, Amsterdam 1999.

17 See Catherine David and Jean-François Chevrier (eds.), *Politics–Poetics: Documenta X – The Book*, Cantz Verlag, Ostfildern-Ruit 1997.

Participating artists, including Jodi, objected to the way in which the presentation of their work had been taken out of their hands, particularly since the functional office-style use of computers is part of what their art sets out to oppose. Jodi had made a work mapping the main structures of the Internet but replacing the names of the major service providers with those of alternative art sites. If the work had been online, clicking on these names would have taken the user to the site, and would have provided a utopian vision of the Net dominated by radical culture. As it was, since Jodi were unwilling to make concessions to Documenta by changing the work, clicking on a link simply caused the machine to crash.[18]

Alexei Shulgin has argued that because of these unsatisfactory experiences of gallery display, the art institutions will not be able to co-opt Internet art. When galleries construct fake online experiences, putting files onto gallery servers for fast and reliable access, they work against the very environment for which the art was created: 'If I knew that the connection is fast I would do something completely different with big images and lots of graphics! It's a big contradiction.'[19]

ZKM's exhibition net_condition (1999), curated by Peter Weibel and Timothy Druckrey, represented the first major attempt by a gallery to encompass the history of Internet art. This was an impressive, large-scale view of the terrain of Net art, particularly its engagement with politics, staged in the lofty spaces of Karlsruhe's media gallery.[20] Nevertheless, the display of online art in this show highlighted certain contradictions. Again, the audience was not given the opportunity to experience Internet art in its usual environment: the browsers were modified – indeed hobbled – so that only one work could be seen on any particular machine. Perhaps the curators did not want people checking their Hotmail accounts or entertaining themselves with the Net's bawdier material, but the resulting display felt authoritarian, and also enforced on the viewer the ridiculous movement from one work (and monitor) to another, as though looking at pictures hung in a gallery. Here, indeed, works of Internet art were displayed like animals in a zoo, each to its own cage.

A ZKM innovation, designed by Jeffrey Shaw, the Net.art Browser 1999 [037], attempted not entirely successfully, to deal with the contradictions of online gallery display. The browser consisted of a large screen that slid horizontally along a wall painted with the names and sites of prominent net.artists – a pantheon

18 Tilman Baumgärtel,
'Interview with Jodi, Telepolis,
6 October 1997.
19 Tilman Baumgärtel,
'Interview with Alexei Shulgin',
nettime posting, 4 November
1997.

20 It should be noted that
net_condition was part of a
larger media project, and that
the show itself spanned several
venues, though the largest part
was at ZKM. See Peter Weibel,
'The Project', in Peter Weibel
and Timothy Druckrey (eds.),
net_condition: Art and Global
Media, The MIT Press,
Cambridge, Mass. 2001.

037/Jeffrey Shaw,
Net.art Browser 1999
Photographs by Franz
Wamhof/ZKM

of a brief history curated by Benjamin Weil. As the screen, operated by an infra-red keyboard, ran over the names, it displayed them as live links, and the user could go to the site. While the parade of names was a curiously classificatory device, the display was a nice idea, enabling many people to look at the works at once. The problem came with the mode of control, for only one or two people could use the keyboard at once, so once again a division was imposed between those controlling the display and those (awkwardly) observing. The very idea of putting together such a parade of historical net.art carried with it a tinge of absurdity, and, as Josephine Berry points out, may well have contained a dose of irony.[21] Equally, though, the stern institutional atmosphere of ZKM, the works in the rest of the show and the supporting literature, did not lend itself to levity.

A work shown at *net_condition* by Natalie Bookchin, Shulgin, and Blank and Jeron, *Introduction to net.art* 1994–9, explored the relationship between Internet art and the art institutions, laying out the rules of the game on kitsch marble tablets. In 1998 Blank and Jeron had invited people to 'recycle' their homepages in a work called *Dump Your Trash*; those who did so would be rewarded with a picture of the page rendered in virtual marble.[22] *Introduction…* was an instruction manual and a moral code for the propagation of Internet art, the two artists acting as Moses descending with the Commandments. [038] This was a very rich, systematic take on the varieties of online art, its relations with the art institutions, and its possible fates. On the current status of net.art, it announced:

1 net.art is undertaking major transformations as a result of its newfound status and institutional recognition.
2 Thus net.art is metamorphosing into an autonomous discipline with all its accoutrements: theorists, curators, museum departments, specialists, and boards of directors.[23]

There follows a list of the elements that are likely to make up this art's 'materialisation and demise', including the production, archiving and preservation of objects for gallery display, along with a series of options for dealing with institutions and corporations, which suggest that subversion and protest or subservience and reform are only various kinds of opportunistic tactics on the road to artistic success.

Of *Introduction…*, Josephine Berry comments:

21 Josephine Berry, 'The Unbearable Connectedness of Everything', *Telepolis*, 28 September 1999.
22 Blank and Jeron, *Dump Your Trash*; http://sero.org/dyt

23 This text is available online at www.easylife.org/netart/catalogue.html

039/Maciej Wisniewski,
Netomat 1999

This work functioned as a kind of retroactive manifesto which simultaneously enumerated and destroyed the oeuvre's claims by ironically carving what was championed as extra-institutional, anti-bureaucratic and anti-historical into stone tablets. In a stark gesture of foreclosure these tombstones of net.art dispelled any dreams of having eluded the commodification of art through its dematerialisation in cyberspace.[24]

ZKM's *net_condition*, the first art-world attempt to historicise Internet art, was the perfect setting for this mournful and funny piece.

Both the *Net.Art Browser* and *Introduction…* were tinged with the funereal. The exhibition coincided with a widespread feeling that net.art had been overtaken by events, and that its demise was near (or even present). At the opening of *net_condition*, Vuk Cosic went so far as to lay flowers at the base of the *Browser*. Alex Galloway, in a review of the Net art of 1999, stated that this was the year in which the old staples, products of low bandwidth, had passed away: ASCII art, form art and conceptualism had given way to slick software tricks, and the use of plug-ins and Java.[25] Among the most innovative works to use these tools was Maciej Wisniewski's browser *Netomat* 1999.[26] The user types queries into a box at the bottom of the screen and *Netomat* responds by producing a drifting pattern of images, texts and videos, overlaid with sound. [039] While I/O/D's *Web Stalker* abandoned the page to give users an idea of the structure of the Internet, *Netomat* did so to produce a more entertaining spectacle. It is no accident that *Netomat*, a popular work with over a million downloads to its credit, has evolved as a commercial project since its launch at the Postmasters' Gallery in New York, the ambition being to turn the work into a platform for managing messages and producing online content.

Such software tools, particularly Flash, do less to develop the interactive character of the Web than to increase its allure as spectacle. As their use developed, the window of opportunity in which dedicated amateurs could produce websites that could be directly compared to those made for large corporations, at least in looks, was lost. Thus the mourning for the demise of net.art took place within a few years of its birth – in part because art and commerce moved onto the Web simultaneously, but also because of artists' acute awareness of the fragility of their avant-garde tactics, and the fate of those who went before them. This was also the period during which a number of prominent practitioners of net.art announced their retirement from the scene.

24 Josephine Berry, 'The Thematics of Site-Specific Art on the Net', PhD thesis, University of Manchester, 2001; www.daisy.metamute.com/ ~simon/mfiles/mcontent/ josie_thesis.htm
25 Alex Galloway, 'net.art Year in Review: State of net.art 99', *Switch*: http://switch.sjsu.edu/ web/v5n3/D-1.html

26 Maciej Wisniewski, *Netomat*: www.netomat.net

040/Masha Boriskina,
*My Boyfriend Came Back
from the War* 2000
Gouache on paper
[see 020]

041/Nick Crowe,
The New Medium 1999, detail
Mom & Dad
Courtesy Mobile Home,
London

A page of Lialina's Teleportacia site carries her *will-n-testament*, bequeathing her works and writings to various benefactors, including fellow Internet artists.[27] Those who engage in this mourning idealise the early period of net.art production, and by marking it off as a discrete movement, attempt to maintain their places within its frozen pantheon.

Blank and Jeron, as we have seen, allowed people to 'Order your homepage sculpted from real marble'. This was a partly ironic offer to materialise and memorialise one's homepage, thus resisting the flux of accelerated online time. To recast webpages as art objects is becoming a standard ironic move, and this materialisation is often tied to elegy, as in Nick Crowe's copies of memorial pages to the dead etched on sheets of glass.[28] [041] Masha Boriskina has made gouache renderings of various well-known net artworks.[29] [040] That the *Introduction*, matching the institutionalisation that *net_condition* represented, produced commodities from its critique was no accidental move.

When online art comes to inhabit the museum and the gallery, sponsors seek to have an effect on the work shown or its interpretation. Thomson and Craighead were told that if they did not alter a work due to be shown in the San Francisco Museum of Modern Art's exhibition *010101: Art in Technological Times*, to allow exiting from the piece easier, and exclude the sponsor's name from the title, they would be removed from the exhibition. Thus their *Do You Yahoo?* became *E-Poltergeist*. In the small show that I curated at Tate Britain, *Art and Money Online*, the sponsor, Reuters, insisted on changes to the text in the exhibition booklet to better advertise their involvement, and I was surprised to see at the opening a wall panel, entirely new to me, not only praising the company (which is to be expected) but also putting Reuteur's own interpretation of the show (which was blander, more optimistic and more enamoured with the wonders of new technology than my own). My only comfort in this was that no-one seems to read panels entitled 'The Sponsor'.

For online activists, perhaps the most pernicious aspect of showing Internet art in the gallery is that it becomes unambiguously art. Dirk Paesmans says that when Jodi's work is seen on the Net, it carries no label saying 'art', but when it moves into a gallery space, that label is automatically applied and must be dealt with in the display.[30] Thus the art world brings to Internet art a series of unwanted transformations: the unambiguous brand, 'art', through display in

27 http://will.teleportacia.org
28 Nick Crowe's exhibition, *The New Medium*, was shown at the Lux Gallery, London, in January 2000.
29 http://art.teleportacia.org/masha/exhibition.html

30 Tilman Baumgärtel, 'Interview with Jodi', nettime posting, 28 August 1997.

places devoted to its worship; the tearing of online art from its environment; the contamination of corporate propaganda; and its materialisation into saleable, hoardable objects and installations.

Yet online art also presents a series of fundamental challenges to the way in which the mainstream art world currently operates. The existence of Internet art makes visible various contradictions within the systems of capitalism and art, particularly of ownership and copyright. We have seen that commercial art-world practices are restrictive and old-fashioned. The Internet tends to transform these even when it is simply used to sell objects that could equally well be displayed in a gallery. Online galleries have been selling works that run into high six-figure dollar sums, but they do not have the same methods of managing their clientele and negotiating prices; rather, works are often reproduced on a site along with price labels, just as in any shop. Artists are encouraged to produce cheaper, larger editions to supply these galleries.[31] Many works are purchased by corporations for which the major concerns are far from strictly aesthetic – the fit of the artist's brand name with their own, size, convenience and price. The process of selling online is a demystifying one in which works of art stand out more clearly as what they are: tradable commodities purchased for a mix of motives, including decoration, social cachet and investment.

There is another effect of these sites that matches and aids the demystification of art. Marlena Corcoran has written of the uniform appearance of art on the Web in small, regular frames and bright, high contrast colour. Such display suggests not only uniformity but interchangeability.[32] This is an intensification of the effect that Walter Benjamin so famously analysed in his discussion of reproducibility, in which the unique experience of the work of art, tied to a particular time and place, withers with the mechanical dissemination of its image.[33] Freed of their material weight, works of art become tokens in a cultural game, a shuffling of novel combinations of symbols. Putting art on the Web does not in itself cause this phenomenon – which is as evident in museum shops' postcard displays as online – but makes plainer art's wider condition.

Art online goes far beyond this mild modernisation of the commercial art market. Indeed, it strikes at the market's heart. First, there is the issue of authorship which is continually called into question and undermined online. The signature or the signature style are the assurance of value. Online, there are fake artists such as 'Keiko Suzuki',

31 On the rise of the online galleries, see Sean Dodson, 'Galleries Go For the Virtual Show', *Guardian*, Online section, 2 March 2000.

32 Marlena Corcoran, 'Digital Transformations of Time: The Aesthetics of the Internet', *Leonardo*, vol.29, no.5, 1995, p.376.

33 Walter Benjamin, 'The Work of Art in the Age of Mechanical Reproduction', in *Illuminations*, ed. Hannah Arendt, Fontana, London 1973. For an application of Benjamin's essay to digital art, see Susan Buck Morss, 'Art in the Age of its Electronic Production', in Duncan McCorquodale, Lolita Jablonskiene and Julian Stallabrass (eds.), *Ground Control: Technology and Utopia*, Black Dog Publishing, London 1997.

042/Nick Crowe,
SERVICE2000 2000
Courtesy Mobile Home,
London

a name under which art is made, including the display of messages written to the artist by men (probably) offering their sexual favours.[34] There are also anonymous groups of artists. Fakery is not confined to plays with identity: Nick Crowe's *SERVICE2000* 2000 was an amusing assault on public and commercial galleries in which he made spoof versions of their sites with cutesy graphics and trivia which resided at plausible addresses. [042] Sadly, the work expired as the galleries hurriedly bought up the domain names.

Another challenge is that the conventional role and status of the curator is hard to maintain on the Web. Online curation does not involve the movement (or commissioning) of rare or unique objects to sit together in a particular space, but rather linking or the transmission of identical copies that may co-exist in many spaces and in many combinations. An example is Bookchin's excellent history of Internet art, and there are numerous alternatives on other sites.[35] When curating is merely link-making, the power to define the present and narrate the past is placed in many hands.

Finally, the most pressing issue facing the art world is the question of exclusivity and ownership. Net art, like any data, can be easily copied and distributed at approaching zero cost. When the curators of Documenta X announced that they were going to remove their online section from the Web after the physical show had ended, Cosic copied the entire site to his own, where it remains.[36] Some may see this as an act of Duchampian appropriation, and it is true that the site has a different meaning when framed within Cosic's art site than it did as the official site of the prestigious art expo, but this action also clearly demonstrated that the ownership and control of Internet art was up for grabs. The Italian group 0100101110101101.org have also cloned other artists' works, focusing on those sites that have attempted to make their contents exclusive or saleable. They have hacked the password-protected art site, hell.com, and pirated material from Olia Lialina's Teleportacia site which she was trying to sell.

Such activities worry the commercial world, and it is not defenceless. The technology of 'digital signing' ensures that sites and files cannot function outside their original location. This means that a user would have to go to the site of a particular gallery to see a work hosted by it, and would go a long way to reinstate conventional commercial models of ownership and access. However, such a technology cuts against the ethos of common ownership on the

34 See Josephine Bosma, 'Interview with Keiko Suzuki', nettime posting, 29 November 1997.
35 http://calarts.edu/~line/history.html
36 www.ljudmila.org/~vuk/dx/

Web and there is likely to be much opposition to its implementation, including that of the most practical kind – hacking.

Sometimes, pieces of Internet art have been sold and apparently owned. Douglas Davis's *World's First Collaborative Sentence* was 'acquired' by a collector, Eugene M. Schwartz, and later donated to the Whitney by his widow. Just what it means to own such a work is unclear, though in the case of the Whitney, it represents a commitment to maintain the *Sentence*. Schwartz literally altered the work by owning it, to the extent at least of typing his intention to buy into the *Sentence* itself.[37] Olia Lialina's site plays on the commercialisation of Internet art, offering works for sale, deriding the impoverishment of online artists, and embracing criticism of her stance by publishing it on her site.[38] She has made a serious attempt to sell work, arguing that buyers can use the name of a site to ensure its unique character and authenticity (naming, it will be remembered, being an aspect of the Internet that is centrally controlled).[39] Jodi have sold webpages, and in general have no objection to their work being sold like any other artwork.[40] There have also been attempts to sell multiples – in the form of floppy discs or CD-ROMs, for instance – as spin-offs from online art.[41] In general, however, little money has been made selling Internet art, though livings can sometimes be had through commissions. It is telling that when the Walker Art Center acquired Benjamin Weil's ada'web site, no money changed hands, because it was impossible to assess the site's value.[42]

Making work that is difficult to buy or own creates hardship for artists. In a work that raised the issue of the impoverished online artist, *Skint* 1996, Heath Bunting solicited credit-card contributions by uploading his plea for funds to various sites. [043] He received some donations, including one substantial sum, though there were others he did not cash, figuring that the credit card numbers were probably stolen.

Connected to these issues of Internet art's marketability, there is an attitude among some prominent online artists that their amateur status, and their playful work, is something valuable to be held on to against the dangers of professionalism. Bunting, interviewed in 1997, argued:

> Professionalism is seen as a step forward from amateurism, but for me it doesn't work. You lose a lot of things when you gain your professional status. You become totally integrated. This year I am in Ars Electronica and Documenta X, which is interesting to go to, but I don't want to become a commodity artist. I am listed in the top 100, 200 artists in the world this year, which

37 Tilman Baumgärtel, 'Interview with Douglas Davis', Rhizome, 17 May 2000.
38 This is discussed in Frédéric Madre, 'The Net.Art Money-Go-Round', *Mute*, no.12, 1998, pp.18–19.
39 Matthew Mirapaul, 'Putting a Price Tag on Digital Art', *New York Times*, 19 November 1998.

40 Josephine Bosma, 'Interview with Jodi', nettime posting, 16 March 1997.
41 On such strategies, see Janelle Brown, 'The Net as Canvas', salon.com, 15 March 2000.

42 On this difficulty, see Mirapaul. A good discussion of the collecting of online art can be found in Robert Atkins, 'State of the (On-line) Art', *Art in America*, vol.87, no.4, April 1999, pp.89–95.

means I am a good investment: I don't want to be a good investment. I just want people to think about what I am doing and not think about how much it costs.[43]

On a more practical note, he continued to say that net.art tries not to carry too much baggage, and a lot of it is about hoaxing, faking and rewriting. 'So if you say: this is an artwork, you've blown your cover immediately.'[44]

Vuk Cosic has a different though related tactic:

I am a little bit puzzled with the term 'art'. Not because I decline the epithet artist – it's a nice hat to wear and the girls like it, too. But actually it is a little bit worrying how it puts you into a certain corner. So instead of deleting the word 'art' as etiquette for what I do, I gave the word 'art' to *everything* I do.[45]

As art is associated with elitism, exclusivity, conspicuous consumption, a one-way relation to its audience, and is thoroughly entangled with economic power, there are plenty of good reasons to insist on being amateur, or to inflate the term 'art' to the point of absurdity, or to ditch it entirely.

Given all this, why do Internet artists increasingly show their online work on the sites of art institutions? Many artists need these institutions, and there are few who have such a purist attitude to their practice that they are not prepared to use them. The museums and galleries are the easiest solution to the problem of invisibility. Artists can also post their works on well-known art sites that act to sanction the work, allowing it to be associated with other pieces and making it much easier to find.[46]

Who looks at online art? While avoiding the art label (or tagging works on sites like graffiti) may allow the work access to a wider audience, those who look for it rather than merely come across it, are a select group. The online art audience (compared with gallery-goers) is potentially very large but they are a subset of those with access to the Internet. Rhizome, one of the main places to see Internet art, is a good indication of the size of this audience, and its popularity is impressive, with 4 million hits on its site in December 2000.[47] As we have seen, those people are both wealthy and well-educated, and this explains the corporate determination to dominate and commercialise the space. Art audiences have a similar profile to online users, and this likewise explains the willingness of corporations to purchase publicity in galleries by sponsoring exhibitions and making gifts. Yet the two audiences are not a perfect match. The Net audience was originally dominated by

43 Josephine Bosma, 'Ljubljana Interview with Heath Bunting', nettime posting, 11 June 1997.
44 Ibid.
45 Tilman Baumgärtel, 'Interview with Vuk Cosic', nettime posting, 30 June 1997.

46 For a discussion of these 'art servers', see Armin Medosch and Manu Luksch, 'Apropos Art Servers Unlimited', in Frank Boyd et al, (eds.), New Media Culture in Europe, Uitgeverij de Balie/The Virtual Platform, Amsterdam 1999.
47 Peter Schaeur, 'Keeping Net Art Live', The Art Newspaper, no.113, April 2001.

technologically able young men, and while the gender balance has now tipped in favour of women, age is still a major determinant. The petit-bourgeois cultural attachments of parts of this audience (for instance, to science fiction and fantasy worlds) sit uncomfortably with the apparently loftier preoccupations of the art world.

In 1997, Alexei Shulgin, noting that Internet art is available to anyone with access to an online computer, yet is in fact seen only by a very small circle of people, rightly says that this situation is 'a major paradox of net art'.[48] The art audience has grown with the numbers online, but whether the proportion has changed is an open question. Furthermore, Andreas Broeckmann argues that Internet art is dependent on online and face-to-face rituals of participation that make it difficult for outsiders to understand. While this appears to be another paradoxical matter for an art that is, in principle, available to all, it may be an inevitable consequence of a participatory culture.[49] Even when an art site does become popular, the audience is no cross-section even of the online elite. Jane Prophet, one of the makers of *Technosphere* 1995 [046] which attracted many thousands of people to make virtual creatures to inhabit its virtual environment, says that its users were generally wealthy, computer-literate,

international but mostly English-speaking, and in part brought in by offline mass-media coverage of the work.[50]

We have seen that Web users are subject to continual commercially driven surveillance. On many sites users gain greater access by registering, enabling companies to apply names, postcodes and other valuable commercial information to records of their browsing habits. Artists have made works that highlight these processes of logging visitors' habits. A work by John F. Simon, called *Alter Stats* 1995–7, brought to visitors' attention both a good deal of data about their computers and their track to his site, along with information about the number of hits on the site, and their own place within these statistics.[51] After two-and-a-half years, the site was closed, with the final statistics being presented as a three-dimensional graph of the visits to this particular art site. [044] It gives a picture of the hourly and seasonal traffic on a not particularly popular art site.

There is another way in which Internet art users stand out from the online crowd. Their inattentiveness is notorious: the competition over search-engine placement is so fierce because very few users bother with anything other than the first twenty listings, and most will only click on

48 Tilman Baumgärtel, 'Interview with Alexei Shulgin', nettime posting, 4 November 1997.
49 Andreas Broeckmann, 'Are You Online? Presence and Participation in Network Art', *Ars Electronica*, p.438.
50 Jane Prophet, 'Sublime Ecologies and Artistic Endeavors: Artificial Life and Interactivity in the Online Project *Technosphere*', *Leonardo*, vol.29, no.5, 1996, p.341.

51 See www.numeral.com/alterend.html

the first apparently suitable link.[52] Regular viewers of Internet art need dedication and patience, as well as knowledge. The current condition of online art, with its error pages, glitches, slow access and reliance on supplementary programs that must be separately downloaded can be a frustrating experience. Sites that work well at some times can be impossible to access at others. Jurors for one digital art prize took the view that if they could not access a site after three attempts, the work would not be considered.[53] SFMOMA puts up a warning screen before each of its online artworks:

Due to the technical complexity and experimental nature of these sites, you may experience some difficulty in viewing them. We have endeavored to make sure that all material is accessible if you use the programs and plug-ins listed in the technical notes for all projects, but some images or sounds may not appear in all cases. In addition, please note that these are copies of the Web sites and they are not connected to the World Wide Web. Therefore, links and queries will be inoperable.

Even supposedly privileged academic and institutional users often find it hard to access slow art sites over shared and heavily used lines. Faster lines for domestic users are, naturally, concentrated among the privileged. Works that require very fast connections (like ADSL lines), despite all the democratic rhetoric that surrounds online culture, are pitched at a very small and elite audience.

A strong and consistent pulse in Internet art has been a critical response to the art world's exclusivity and elitism. The character of online elitism is of a different kind from that found in the art world, which is embedded in location, architectural grandeur, and the display and ownership of rare objects. Even so, the Net's elitism is real enough. It is not purely a matter of physical and economic access but also of learning, of literacy plus familiarity with the interface and the workings of the online world. This mix of skills is generally acquired by exposure to First World consumer society. Internet art is not, of course, the only response to cultural elitism: activist and community-based arts, which develop an audience rather than draw upon one that is assumed to pre-exist, have been another. When the two have crossed over, the greatest effect has been achieved. The Net can be an effective co-ordinating tool but both online and offline activism is required. This has been true in an exemplary fashion of RTMark's activities, and also those of RTI. Another model, closer to community art, is the work of the Danish group, Superflex, in setting up digital

52 Rogers, 'Introduction', in Richard Rogers (ed.), *Preferred Placement: Knowledge Politics on the Web*, Jan van Eyck Akademie Editions, Maastricht 2000, p.15.
53 See Ken Feingold, 'Error 404: File Not Found', *Leonardo*, vol.30, no.5, 1997, p.450.

broadcast systems in housing estates, enabling people to air their views to their neighbours (isolated by architecture and the centripetal forces of life in contemporary capitalist society), so fostering the building of local solidarity.[54] It is no accident that all these activities are situated at the very borders of art. The question of deeper cultural transformation is linked to the connection of online culture to broader social and political movements that are questioning the parameters of capitalism itself, not only on the Net but about environmental issues, sweated labour, the patenting of AIDS drugs, the mental pollution of advertising, and a whole range of other issues. The trajectory of online art and the art commodity is inseparable from this wider picture.

Even so, the narrower consequences of the growth of online culture for the protected practices of the art world are far-reaching. In the past, as we have seen, the art world came to an accommodation with new media, changing itself a little and the media a great deal. Photography and video, for instance, took on compromised forms, withdrawing their sting of reproducibility with fine prints, limited editions and gallery installation. On the Internet, this will be harder to stage. For photography and video, reproduction was relatively cheap and simple but distribution was often expensive and difficult. With the Internet, the means of cheap distribution are built in. So much of art-world exclusivity clusters around the qualities of rarity, ownership, access and scale, all of which must be artificially imposed on the Internet, or hardly apply. And when they are imposed – even tongue in cheek, as at hell.com – there are plenty of activists around with the motivation and the skill to crack them open.

54 For an excellent guide to this work, see Maria Brewster (ed.), *Supermanual: The Incomplete Guide to the Superchannel*, FACT, Liverpool (n.d.). See also www.superchannel.org

Art, Intelligent Machines and Conversation

In 1998, Olia Lialina complained that talk about Internet art always ended up revolving around the same question: what is it? She offered some stimulating alternative fields of inquiry:

Browser interface in the structure of Net art
Downloading time as a means of expression in the works of Eastern European net artists
Frames and windows in Net narration
Different approaches to finding footage or servers
Domain names and 'under-construction' signs from 1995 to 1997[1]

Lialina is right that the question has been raised insistently – and we may add disputatiously. That online artists (if they are that) are wary of the label 'art' raises the issue of Internet art's definition with some urgency. In a discussion with the members of Jodi, Alexei Shulgin said that for him the dot in 'net.art' was important because it prevented the concept from being taken too seriously: 'A movement or a group can't have a name like some computer file.' Furthermore, net.art (like the Internet itself), encompassed everything and so resisted definition.[2] On the face of it, Shulgin seems to be correct. After all, an operating system, a database and a site devoted to sponsoring subversive acts have all been declared works of art.

In the fascinating discussion about the

1 Olia Lialina, 'Lialina – Cheap Art', nettime posting, 19 January 1998.
2 Josephine Bosma, 'Independent Net.Art', nettime posting, 6 July 1997.

definition of net.art that took place in the nettime forum, the various contributors often invoked other art forms as precursors. As Robert Adrian pointed out, these included video, sculpture, telematic art, land art, installation, mail art, media art, Fluxus and the readymade. He added, 'I can add minimal art, computer graphics and Zerography to the list without even stopping to think.' The Internet's marriage of reproductive and communicative technologies

form a kind of tunnel through which the disparate forms of Industrial culture are being squeezed and merged. It is a kind of collaging, not a collaging of images and sounds only but of cultural material, of memories, histories and media.[3]

It is just this synthesis of content, media and transmission that makes definition so difficult.

Nevertheless, a number of claims have been made about the definition of Internet art (or more broadly of 'media art' of which online art would be a subset). There is first a strong claim that media art does not use the computer as a tool but as its subject matter, using a technology to engage in thinking about that technology.[4] At first sight, this definition provides a clean cut through the messy and diverse world of online culture. Following it strictly, works that reflect on the structure of the Internet would be included but much of the

politically and socially engaged work included in this book would not. Yet that clarity cannot be maintained, if only because the effects of computer networking are so pervasive, both on- and offline. If it is hard to tell where thinking about technology stops, this definition, as it expands and blurs, loses its edge.

Another definition, by contrast, is that art 'in the Net' (as opposed to merely 'on the Net') must exploit the particular qualities of hardware and software to the extent that it is 'unthinkable without its medium, the Internet'.[5] This second definition would rule out, for instance, conceptual work placed on the Net that takes the Net as its subject, but which could conceivably have used video to make the same point. Its advantage is that it clearly distinguishes Internet art from previous art that used communication networks, including telephones, faxes or the post. Instead, it stresses the computer's role in initiating and regulating processes in the work of art.

These two definitions are both recursive (art should refer to itself) but one is directed at the Internet as subject matter, the other at its technical substratum. Both of them are reminiscent of Clement Greenberg's formalism and, like that modernist urge to divide serious artistic endeavour from the cultural flotsam that

3 Robert Adrian, 'Net.Art on nettime', nettime posting, 11 May 1997.
4 See Gerfried Stocker and Christine Schöpf, preface to Timothy Druckrey and Ars Electronica (eds.), Ars Electronica: Facing the Future: A Survey of Two Decades, The MIT Press, Cambridge, Mass. 1999, p.14.

5 Andreas Broeckmann, 'Are You Online? Presence and Participation in Network Art', in Druckrey and Ars Electronica 1999, p.438. See also Broeckmann's nettime posting, 'Net.Art, Machines and Parasites', 8 March 1997.

threatens to submerge it, they are understandable calls to order in a highly mobile and disparate scene.[6] The first claim is analogous to saying that the subject of painting must be painting itself; the second to saying that there is a set of technical concerns essential to painting – such as flatness – that all advanced painting must draw upon. While both gain plausibility because of Internet artists' self-conscious embrace of modernist themes and styles, both taken strictly exclude too much and taken loosely too little.

Another claim is that Internet art must involve some element of communication and even collaboration with others. A single artist may initiate a project but the final result should lie beyond their control.[7] Again, such a definition has advantages but only in that it allows us to focus on a particular quality of Internet art, and again taken strictly it is too restrictive, taken laxly it lapses into truism. It does not allow us to distinguish clearly enough between mail art, fax art and the early telematic works that used networked computers and current Web-based art. This view would draw an unbroken lineage of collaborative, machine-mediated art right back to Lázló Moholy-Nagy, who in 1922 came up with the idea of ordering paintings from a factory by telephone.[8]

If such definitions fail to gain a full purchase upon Internet art, it is partly because that art, unlike painting, has no medium but instead exists within the field of the simulation of all reproducible media. The Internet unites the work and the delivery system so that data, interface, navigation and means of propagation come together in complex interaction. Any work of online art necessarily involves all of these, but its point of focus may dwell on one or several, highlighting, for example, connection speed, the way a database is searched and accessed, a particular type of communication between individuals, or hypertext narrative. The various component qualities of Internet art are in themselves not qualitatively new: reproductive media have existed for centuries; the use of mechanical communication channels likewise; manipulability and interactivity also have a long history; virtuality and simulation were born with the computer in the middle of the last century. In Internet art, however, they are combined, at a new intensity and immediacy. Thus reproduction is perfect and limitless (which is not true of printing or photography), and communication is often fast enough to permit real-time interaction. We might think of Internet art as a field encompassing these various elements, and rather than drawing sharp boundaries around it, perhaps it is better to say that there are some works that more closely approach a

6 Clement Greenberg, 'Avant-Garde and Kitsch', in The Collected Essays and Criticism, vol.1, Perceptions and Judgements, 1939–1944, ed. John O'Brian, University of Chicago Press, Chicago 1986.
7 This view is aired in Joachim Blank, 'What is netart ;-)?', nettime posting, 22 April 1997. It is also Alexei Shulgin's view; see Josephine Bosma, 'Interview with Alexei Shulgin', nettime posting, 14 May 1997.

8 See László Moholy-Nagy, The New Vision, Wittenborn, New York 1947, p.79.

9 The model here is Wittgenstein's writing on the 'family resemblance' definition of the word 'game'. See Ludwig Wittgenstein, Philosophical Investigations, trans. G.E.M. Anscombe, Basil Blackwell, Oxford 1978, pp.31–5.

complete idea of what Internet art is than others.[9]

Yet the very idea of Internet art (even as a convenient shorthand) is a controversial one, especially when definitions fix upon recursion to draw the lines: does it too clearly delimit a particular realm of activity, making it ripe for appropriation and reification? Perhaps the distinguishing feature of online culture is precisely that it is impossible to say where art starts and finishes (again, in a reworking of an old modernist dream in which art ceases to exist as an autonomous concern, as all life becomes aesthetic); or (more negatively, though it may be another way of saying the same thing) that when the aesthetic permeates everything, it is no longer possible to talk of art. The Net's apparent abolition of distance threatens just this subsumption of art and everyday life. The object of corporate surveillance is to register every consumer whim and to cater to it instantly, to anticipate the whim and satisfy it before it is fully formed.[10] For Slavoj Žižek, speculating on the logical conclusion of this process (one that is, it should be said, remote from the current experience of Net users) the boundaries between the living and the artificial, between objective reality and its appearance are undermined, and the identity of the perceiving self perishes: 'Potentially, total subjectivisation (the reduction of reality to an electro-mechanically generated cyberspace 'window') coincides with total objectivisation (the subordination of our 'inner' bodily rhythm to a set of stimulations regulated by external apparatuses).'[11]

The abolition of distance will also be the abolition of neighbourliness; universal availability will induce 'unbearable claustrophobia'; excess choice will breed an inability to choose: in all, the vision of cyberspace leads to radical closure, 'an infinity far more suffocating than any actual confinement'.[12] That is the nightmare, and it should be taken seriously, but it vastly underestimates inequality on the Net (it must be asked, for whom is this vision intended?), and it leaves no room for agency, or for the reactive effects such a system, if established, would set in train. (Indeed, the Net as it actually exists, far from satisfying every desire, can often provoke deep disillusion; researchers surveying the proportion of the population online were surprised to discover how many people declared themselves to be former Internet users.)[13]

As we have seen, the highly dynamic, evolving realm of the Net has provided space for artists to inhabit; a space of technological imperfections that can be exploited, breaking down the expectations encouraged by standard software; a space for the politically excluded to find voice;

10 See my essay, 'Formas de la identitad en el ciberespacio' [Being Yourself in Cyberspace], *Revista de Occidente*, no.206, June 1998, pp.77–97.

11 Slavoj Žižek, *The Plague of Fantasies*, Verso, London 1997, p.135.
12 Ibid., p.154.
13 On ex-Net-users, see the research of Virtual Society?: The Social Sciences of New Technologies: http://virtualsociety.sbs.ox.ac.uk

spaces that can be built by unpaid, highly skilled, collective labour; and spaces for the development of discourse. Precisely because the Net moves so fast, and is not a settled system, such opportunities will open as fast as they close.

The issue of an art that is always at hand, and which appears to lack a distinct aesthetic, has a more general echo in the anaesthetic character of contemporary art as a whole, as it increasingly becomes little more than a minor arm of the culture industry. Yet the uncertainty over the aesthetic status of Internet art, far from being a drawback, can be productive, and all the better if it is separated from the art institutions, or parasitic upon them. There is no art if the aesthetic is disposed of, but equally the presence of the aesthetic does not guarantee art. The aesthetic at issue here is wider than that normally associated with the visual high arts (which is one reason why so many otherwise sophisticated art types express disappointment with online art), being more in the character of the appreciation of aesthetics in a set of ideas, an equation or a design. Without the materially signalled hierarchies of the offline art world, online art can be hard to respond to, for so much art-world judgement flows from context, including the placing of a piece, and the apparatus that

surrounds it – from other viewers to publications. While many works of art are framed by museum or art sites, on the Net, at least for the time being, many of these clues are lacking.[14]

Nevertheless, institutional acceptance of online work by museums, galleries, funding bodies, art schools and even art historians is now widespread. For those who hold to an institutional definition of art, Internet art must qualify. This judgement though may be qualified by asking the question, what was it about those online phenomena that attracted the art institutions? Was it purely the inducements laid out in the previous chapter, or was there something about Internet art that made it recognisable as art? It should by now be plain that there was, not only in the many explicit art-historical references and borrowings but in familiar artistic tactics such as defamiliarisation, the juggling of symbols, the fostering of metaphorical thought, and the use of found objects.

However, another common reaction in the art world is to say that, even if online art is art, it is not interesting art. We saw that Pit Schultz, writing in 1996, had anticipated the emergence online of 'a noble and restrained art' that would produce works of true greatness.[15] In 1999, by contrast, Steve Dietz asked 'Why have there been no great

14 This point is made by Robert Atkins, 'State of the (On-line) Art', *Art in America*, vol.87, no.4, April 1999, p.90.

15 Pit Schultz, 'The Net Artists', nettime posting, 31 May 1996. One of the mail addresses listed in this posting is guillaume@apollinaire.org

net artists?', comparing the issue to Linda Nochlin's similar query about women artists.[16] In a brilliant passage, Dietz raised various contradictory 'problems' about Internet art:

The problem with net art is that it is so opaque.
The problem with net art is that it is so obvious.
The problem with net art is that not everyone can see it.
The problem with net art is that it takes too long.
The problem with net art is that it is ephemeral.
The problem with net art is that it's too expensive.
The problem with net art is that anyone can make it.
The problem with net art is that no one supports it.
The problem with net art is that it is being usurped.
The problem with net art is that it's boring.
The problem with net art is that it's too challenging.
The problem with net art is all those plug-ins.
The problem with net art is that it is so reliant on industry standards.
The problem with net art is that it's old hat.
The problem with net art is that it's too new.
The problem is that there is no great net art.[17]

Dietz goes on to argue that the very notions of greatness and of timeless masterpieces do not sit comfortably with an art so dependent upon and responding to fast-changing technology, while the idea of the lone, inspired creator conflicts with the consistent practice of borrowing and collaboration. Furthermore, as Grant Kester points out, the art world generally finds it hard to accommodate activism.[18] If there is a level at which 'greatness' has been achieved, it is not that of individual interventions but rather of the collective project, emergent in the conversation that takes place with works and words.

The outcome of that conversation has not only been a developing field of art, which, as we have seen, has been conceptually challenging and politically radical, but also the emergence of a distinctive theoretical discourse. At first, it seemed as though elements of postmodern theory, though they predated the Web by some years, had described its character all too well: it did indeed seem as temporally shallow as (for very different reasons) Jameson or Baudrillard would have us expect; the rhizome of Deleuze and Guattari seemed custom-grown to describe the character of the distributed network; the immediacy of access conjured up Baudrillard's abolished aesthetic; the skittish character of Net users' activity, and their adoption in some cases of multiple personalities, fitted well with elements of linguistically inclined psychoanalysis; and the entire structure of hypertext appeared to empower the reader and despatch the author.[19]

Yet, along with the ocean of verbiage (much

16 Steve Dietz, 'Why Have There Been No Great Net Artists?', in Vuk Cosic, Net.art Per Me, MGLC, [no place of publication] 2001, pp.56–64. Nochlin's essay, 'Why Have There Been No Great Women Artists?' was originally published in ArtNews in January 1971, and was reprinted in Thomas B. Hess and Elizabeth C. Baker (eds.), Art and Sexual Politics, Collier Macmillan, New York 1973.
17 Dietz 2001, p.60.

18 Grant Kester, posting to CRUMB, April 2001, in Cosic, Net.art Per Me, p.66.
19 Respectively, Fredric Jameson, Postmodernism or, the Cultural Logic of Late Capitalism, Verso, London 1991; Jean Baudrillard, Simulacra and Simulation, trans. Sheila Faria Glaser, University of Michigan Press, Ann Arbor 1994; Gilles Deleuze and Félix Guattari, A Thousand Plateaus: Capitalism and Schizophrenia, trans.

Brian Massumi, The Athlone Press, London 1988; Jean Baudrillard, Art and Artefact, ed. Nicholas Zurbrugg, Sage, London 1997, chap.1; Sherry Turkle, Life on the Screen: Identity in the Age of the Internet, Weidenfeld and Nicolson, London 1996; George P. Landow, Hypertext 2.0: The Convergence of Contemporary Critical Theory and Technology, The John Hopkins University Press, Baltimore 1997.

of it in print rather than online) that celebrated these connections, there quickly emerged a number of acute disturbances to this consensus. First there was the issue of detail: such theories worked on a level of extreme generality, and those thinkers, artists and activists close to the online scene objected to the blanket application of postmodern conventions to their novel and fast-changing situation. So, to take a very simple riposte to the enthusiasm for Deleuze and Guattari's rhizome, Matthew Fuller gently pointed out that the Net has a physical basis and a hierarchy of backbones, hosts, shells and 'thin filaments of cable under the waves'.[20] Rhizomes do not have backbones. Of the same character was Nicholas Zurbrugg's taking to task of postmodern theory, particularly the work of Jameson and Baudrillard, for being far too broad-brush to make sense of the subtleties and variation in much media and video art.[21]

Second, while many of the immediate products of computer technology fitted comfortably with elements of postmodern theory, its vertigo-inducing evolution did not. If postmodernism is the period in which technologies of reproduction triumphed, above all colour television as a mass medium, then the postmodern terminus (variously, the end of art, the end of history,

the end of humanity) could only be maintained by pretending that the TV screen was equivalent to the computer screen.[22] Yet it was clear from the first that users' interactions with the computer were radically different from those of passive media, and that computer-mediated communication networks were closely connected with the world of production. With the rise of global financial markets and new forms of trading that depended upon, in effect, instantaneous transactions, with the development of genetic manipulation and the computer modelling of a vast array of problems, the beginnings of nanotechnology, or on a more mundane level the computer control of industrial machinery, it was evident that the computer was not a tool of reproduction alone. Rather, it represented the synthesis of the technologies of production and reproduction.

More even than this, however, there was a theoretical reaction against the postmodern terminus, an urge to escape the fate laid out in so compelling and bleak a fashion in the writings of its theorist-stars (many of them disillusioned leftists). Or rather, even for their adherents, the texts had held out some liberatory charge when the social and cultural scene they had sketched out seemed a remote dystopia, but

20 Matthew Fuller, 'A Means of Mutation: Notes on I/O/D 4: The Web Stalker', www.axia.dcmon.co.uk/ mutation.html
21 Nicholas Zurbrugg, Critical Vices: The Myths of Postmodern Theory, G+B Arts International, Amsterdam 2000.

22 For the argument on television, see Perry Anderson, The Origins of Postmodernity, Verso, London 1998, pp.87–9; for the congruence of reproducible media and computer screen (cited in Anderson), see Fredric Jameson, Signatures of the Visible, Routledge, New York 1992, p.61, and Jameson 1991, pp.36–7.

now 'The rhizome is no longer a goal of textual liberation, it is the posthuman condition of losing oneself in hyperspace ... we feel the urgent need for the production of a collective subjectivity from within the Net, in order to counter its oppressive and alienating effects.'[23]

This was Pit Schultz and Geert Lovink in early 1996, writing an introduction to previous nettime postings, and there was to develop – uncertainly, as we have seen, and with many contradictions – a theoretical discussion that in sometimes Benjaminian fashion looked back fondly towards modernism, recovering its spectral, Utopian ideals, so as to look forward beyond postmodernism. It was, most of all, a set of theories that did not dwell in academia but was borne of and tested against activity.

One agent has featured little in our discussion so far, in part because it is still in its infancy – the machine itself. In imagination, at least, it will collaborate with humans in the creation of art, and aid the emergence of a truly collective, participatory culture. According to some visions, it will even achieve a synthesis of the harmfully fragmented contemporary cultural and intellectual scene.

The media now sit side-by-side in compartmentalised windows on computers that hold little meta-data about the content of their various files. As Mike Halverson has pointed out, the more algorithmic the transmission of input data in a medium, the more chaotic the storage of their output data: while it is relatively easy to order books, with their titles written in limited number of symbols and regulated by the alphabet, it is much harder to order photographs or sound recordings. Image, film and sound archives give immediacy to the past but also swamp accessibility with their chaos and sheer quantity.[24] This is likely to change as, for instance, speech-recognition software married with search agents plough through TV programmes picking up keywords and classifying them by subject. Thus computers will not merely store pictures, sounds and words but will hold meta-data that describes the character of that material, bringing Žižek's dystopian vision a step closer to realisation. Visionaries call for the immersion of users in cyberspace, a shared, consensual illusory space that will embrace all media.[25] Jaron Lanier, one of the thinkers who sketched out the notion of cyberspace, describes it as the synthesis of sign systems and experience, so that anything that can be said can be directly experienced.[26] Of reproductive media, nothing less than the recording of consciousness is the final goal.[27]

23 Pit Schultz and Geert Lovink, 'Introduction: The Print-Out of nettime', nettime posting, 15 January 1996.

24 Mike Halverson, 'Toward a Theory of Hardware', in Josephine Bosma et al., (eds.), Readme! Filtered by nettime: ASCII Culture and the Revenge of Knowledge, Autonomedia, Brooklyn 1999, p.63.
25 On cyberspace and its evangelists, see Julian Stallabrass, Gargantua: Manufactured Mass Culture, Verso, London 1996, chap.3.

26 Jaron Lanier, 'Riding the Giant Worm to Saturn: Post-Symbolic Communication in Virtual Reality', in Druckrey and Ars Electronica 1999, pp.242–3.
27 British Telecom has a research programme dubbed 'Soul Catcher', devoted to this aim. For a copy of one of their documents, see www.btexact.com/ideas/papers

045/Jodi, *SOD.1* (game modification) 1999
Right-hand Illustration shows the original *Wolfenstein 3D* game together with a modified view

If that future is hard to grasp currently, certainly when looking at Internet art, that is because it is not to be glimpsed in a marginal, small-scale and often technically primitive practice. Look rather to the games industry which, despite the strongly skewed demographic character of its audience, out-performs the film industry by a considerable margin in terms of turnover, and spectacularly in terms of profit.[28] In 2000 the UK market alone was worth nearly £1 billion (in a global market twelve times that size).[29] The rapid evolution of 3-D shooter games, for example, from *Wolfenstein* to *Doom* to *Quake's* various evolving stages to *Half Life*, demonstrates the rapid assembly of an immersive and increasingly convincing illusion.

Incidentally, various Internet artists have made work exploring the conventions and ideology of computer gaming, including Jodi's downloadable version of *Wolfenstein 3D* which they have named *SOD*. In *SOD* 1999, the game works as normal but the cartoon Nazi enemies and their base are rendered as abstract monochrome shapes. [045] The music and soundtrack of the original remain, however, putting a dramatic and incongruous gloss over this odd modernist battle of squares and triangles.[30]

Aside from convincing visual illusion, the intelligent agency of the machine's avatars grows apace. In gaming, they are often hobbled so as to be beatable by human players (the highest setting of one programmers' 'bots' for *Counterstrike*, released agents that a gaming magazine described as 'Dirty Harry on crack'). Yet these agents have the huge advantage of operating within a set of clearly defined rules. Making new rules is quite another matter. In thinking, for instance, about computer-generated interactive narrative, the problem is not in programming structured rules that narratives tend to follow, but in getting the machine to understand enough about the world to know what constitutes a narrative turn.[31]

A number of online works have used computer agents and tried to encourage emergent order or evolution. *Technosphere* was one of the earliest of such works to go online.[32] [046] It was a virtual environment inhabited by creatures that users could design and set loose. The creatures, virtual carnivores and herbivores, would forage and, if they did well, mate. Designers would be emailed news about how their creature was doing (had it mated, had it died?) but had no control over its fate in the virtual land. Strict limitations for users, in the design and control of their creations, were a consequence of autonomy handed to the machine in the form of simulated evolutionary programming. Similarly, Christa Sommerer and Laurent Mignonneau

28 See David Sheff, *Game Over: Nintendo's Battle to Dominate an Industry*, Hodder & Stoughton, London 1993.
29 Stuart Millar, 'Gaming Industry Warned To Think Bigger', *Guardian*, 7 July 2001.

30 This work is discussed in Jon Thomson, 'Shifting Spaces', 3 March 2000; www.eyestorm. com/feature/ED2n_article.asp? article_id=75 *SOD* refers to the subtitle of one of the *Wolfenstein* games, *Spear of Destiny*. If there is a modernist precursor to this representation of opposing forces in geometrical shapes, it is El Lissitsky's Russian Revolution poster, *Beat the Whites with the Red Wedge* 1919.

31 Janet H. Murray, *Hamlet on the Holodeck: The Future of Narrative in Cyberspace*, The MIT Press, Cambridge, Mass. 1997, p.201.
32 www.technosphere.org.uk

046/Jane Prophet, Gordon
Selley and Mark Hurry,
Technosphere 3
(Real-time 3-D version at
The National Museum of
Photography, Film and
Television, Bradford)

047/Christa Sommerer
and Laurent Mignonneau,
Interactive Plant Growing
1992–3
[further images on pages
following]

have worked with artificial-life scientist Tom Ray
to make *A-Volve* 1994, in which users design
'creatures' that compete for resources within a
pool. Their *Interactive Plant Growing* 1992–3, allows
users to influence the growth patterns of virtual
plants by moving their hands around in the space
close to real ones.[33] [047] It is true, as Sommerer
and Mignonneau state, that the artist surrenders
some responsibility for the work but to whom or
what: is it to the user or to the machine?[34] Emergent
order can be produced by groups of very primitive
single agents, as shown long ago by artificial-life
programmers. Increasingly, quasi-intelligent
agents capable of learning are emerging, even
in games such as *Creatures* or in robot pets.[35]
The interaction and communication of agents –
humans and/or machines – on the Net holds out
the possibility of an emergent order brought about
by intelligent units.

For the technophile theorists of the libertarian
Right, the direction of this networked mechanical
emergent order is clear. While the details of its
workings may remain obscure, it mirrors the
functioning of the free market. Unimpeded, it will
bear at least some of its acolytes to stratospheric
heights, a dematerialised state of connected,
augmented intelligence, and instantly satisfied
desires. Regulated by small-minded state

bureaucracy, it will stagnate to the eventual harm
of all. As we have seen, this is the view tirelessly
evangelised by *Wired* magazine, and is the subject
of *Wired* associate Nicholas Negroponte's book
Being Digital.[36] The force of this view is that
markets do produce knowledge about goods and
consumers' desires that exceed the collective
knowledge of all their participants; no one knew
that the Ford Edsel would flop or that mobile phone
use in the UK would grow so fast until the market
spoke. Yet to apply a market model to the exchange
of information highlights certain aspects (the
popular success or obscurity of certain 'memes')
and flattens others (particularly the content of
the communications and the competing interests
they represent).[37] Nevertheless, a powerful and
dominant mythology of the Net as a space of
unregulated competition and thus febrile
innovation has grown up.[38] Vuk Cosic and Luka
Frelih took to spraying the slogan 'Wired=Pravda'
around Ljubljana when Negroponte was visiting,
a pointed slogan on the ubiquity and quasi-official
status of this market-libertarian view.

The ideology of *Wired* also contains an
unpleasant alliance of crude Darwinian thinking
and techno-mysticism.[39] Mark Dery has exposed
this vein of thought, noting that *Wired* founder,
Louis Rosetto draws upon the writing of the

33 Christa Sommerer and
Laurent Mignonneau, 'Art as
a Living System: Interactive
Computer Artworks', *Leonardo*,
vol.32, no.3, 1999, pp.165–73.
34 Ibid., p.173.
35 On artificial life, see
Stephen Levy, *Artificial Life:
The Quest for a New Creation*,
Penguin Books, London 1992.

36 Nicholas Negroponte,
Being Digital, Hodder &
Stoughton, London 1995.
37 Richard Dawkins's
controversial application of
genetics to the propagation
of ideas has 'memes' as the
intellectual equivalent of genes.
See *The Selfish Gene*, Oxford
University Press, Oxford 1976.

38 The myth is nicely skewered
by Richard Barbrook and Andy
Cameron in an influential essay,
'The Californian Ideology', www.
alamut.com/subj/ideologies/
pessimism/califldeo_I.html
A version was also published in
Mute, no.3, 1995.
39 It is important that
Darwinism is not abandoned
to the ideologues of the Right.
For an alternative vision, see
Peter Singer, *A Darwinian Left:
Politics, Evolution and
Cooperation*, Weidenfeld &
Nicolson, London 1999.

Lamarckian and Jesuit philosopher, Pierre Teilhard de Chardin, who predicted the coming of an ultra-humanity converging on a transcendent point, 'the consummation of the evolutionary process'.[40] In this vision, the individual is subsumed into the unitary and supreme collective mind, all difference is synthesised in the higher whole, and all conflict resolved. Just as *Wired* libertarianism can comfortably co-exist with artists' enthusiasm for anarchism, so artists and cultural theorists can dream of digital transcendence. Among the most persistent and prominent of these techno-art boosters is Roy Ascott:

> computer networking provides for a field of interaction between human and artificial intelligence, involving symbiosis and integration of modes of thinking, imagining and creating, which, from the point of view of art, can lead to an immense diversity of cultural transformations, and, in science and philosophy, enriched definitions of the human condition. Computer networking, in short, responds to our deep psychological desire for transcendence – to reach the immaterial, the spiritual – the wish to be out of body, out of mind, to exceed the limitations of time and space, a kind of bio-technological theology.[41]

According to such views, technological progress will by itself bear humanity to a new and harmonious stage of history. As we have seen, while there is a current of opinion in online culture that sees the Internet as offering a way out of postmodern pessimism, the path is uncertain and halting. The modesty and humour of much Internet art is in explicit reaction to the overblown claims of this boosterish strain in cyber-theory.

The danger of permitting machine autonomy is clearly that computers may not augment but replace human producers. Norbert Wiener in his 1948 book on cybernetics, warned that in the coming world of responsive machines the average person will have nothing to sell that anyone will want to buy (when he tried to alert officials of the US trades union movement to this threat, he was met, naturally enough, with incomprehension). Wiener's logical deduction from this situation, by the way, was to say, not that the average person is disposable, but that society would have to embrace values other than buying and selling.[42] The technology that brings this threat also offers solutions, for computer communications and simulated evolutionary programmes can produce market knowledge without the need for actually testing products in the real world to the benefit of some and the harm of others. Andy Pollack and

40 Mark Dery, *Escape Velocity: Cyberculture at the End of the Century*, Hodder & Stoughton, London 1996, p.86.
41 Roy Ascott, 'Gesamtdatenwerk: Connectivity, Transformation and Transcendence', in Druckrey and Ars Electronica 1999, p.86.

42 Norbert Wiener, *Cybernetics: or Control and Communication in the Animal and the Machine*, Wiley, New York 1948, pp.37–8. As discussed in John Naughton, *A Brief History of the Future: The Origins of the Internet*, Weidenfeld and Nicolson, London 1999, p.65.

048/Redundant Technology
Initiative, Installation for the
exhibition *Net_Condition* at
ZKM (Centre for Art and
Media), Karlsruhe 1999

others have argued that computing can be used to make socialist planning function as efficiently as the market.[43] Naturally, the old Marxist question about Utopian plans applies: how does one get from here to there?

The increasing autonomy of machines may produce another effect: as machines appear to become more intelligent, human intelligence may appear to be more mechanical. Indeed, an interest in cognitive science lay at one of the origins of the Net, in Joseph Licklider's fascination with computers as models for human thought processes, which led him in 1960 to write his pioneering paper, 'Man-Computer Symbiosis'.[44] Janet Murray argues that the computer can help us to come to terms with such developments, becoming in its fostering of narrative no less than 'a cathedral in which to celebrate human consciousness as a function of our neurology'. Indeed the coming cyberdrama may help us reconcile our subjective experience of ourselves with our rapidly expanding scientific knowledge of biology. It may come up with the metaphors of process that will restore the sense of human individuality to our model of the mind. A computer-based literature might help us recognise ourselves in the machine without a sense of degradation.[45]

Here art once again acts as a salve against the dangerously destabilising effects of runaway technology. Marvin Minsky makes the more interesting point that advances in the brain sciences may change our view of art itself, especially if we come to understand how art affects us, and if works are made using that knowledge. People will increasingly ask what procedures or mechanisms within themselves are responding to a particular work, or element within a work.[46] While the goals of contemporary art move in response and reaction to the prevailing orthodoxies, and are rarely static, the result could nonetheless be a radical demystification of the processes of art. In any case, the simulation and automation of tasks by cybernetic machines has created the realm within which online artists operate, and has already done much to change ideas of what is to be expected from the work of art. As, in linked developments, machine agency develops and human actions become better understood, the effects on art are likely to be far-reaching.

As it currently stands, Internet art has shown its users something new, though its newness also has a tinge of oldness. Its situation is highly unstable since it must change as fast as the Net changes, as public online space comes

43 Andy Pollack, 'Information Technology and Socialist Self-Management', in Robert W. McChesney, Ellen Meiksins Wood and John Bellamy Foster (eds.), *Capitalism and the Information Age: The Political Economy of the Global Communication Revolution*, Monthly Review Press, New York 1998. I made a similar point in a conference paper written in 1996, and eventually published as 'The Ideal City and the Virtual Hive: Modernism and Emergent Order in Computer Culture', in John Downey and Jim McGuigan (eds.), *Technocities: The Culture and Political Economy of the Digital Revolution*, Sage Publishers, London 1999.

44 See Katie Hafner/Matthew Lyon, *Where Wizards Stay Up Late: The Origins of the Internet*, Simon and Schuster, New York 1996, pp.32–5. 'Man-Computer Symbiosis', *IRE Trans-actions on Human Factors in Electronics*, vol.HFE-1, March 1960, pp.4–11. The paper can be downloaded at http://memex.org/licklider.html

45 Janet H. Murray, *Hamlet on the Holodeck: The Future of Narrative in Cyberspace*, The MIT Press, Cambridge, Mass. 1997, p.282.
46 Marvin Minsky, 'The Future Merging of Science, Art and Psychology', in Druckrey and Ars Electronica 1999.

to compete with a multitude of closed communication systems and with interactive TV. Even so, of the conditions that sustained postmodernism – political reaction and the absence of viable alternative movements, a technology of passive reproduction, and a stable if sluggish economic situation – two, at least, appear to be in the process of passing away; Internet art, with its ties to the anti-corporate politics of Seattle and its exploitation of a rapidly evolving, aggressively confident technology combining production and reproduction, a technology that (like the ocean liners, cars and aeroplanes of modernism) captures the imagination, stands at the confluence of these new tendencies. Its 'modernism' is not the modernism of old, and cannot be, for its artists are acutely aware of the failures and limits of the past, but it harbours some of modernism's ideals – openness, permeation of the environment, and radical political engagement. It is a vision, though, that must continue to be fought for against those who would turn the Net into a tame, regulated broadcast space, serving as a pervasive and ubiquitous mall.

ADSL Asymmetric Digital Subscriber Line in which the speed of downloading is significantly faster than that of uploading

Altavista A widely used search engine

AOL America Online, widely used service and content provider

ASCII American Standard Code for Information Interchange, the basis of the character sets used in almost all computing

ARPA The Advanced Research Projects Agency of the US Department of Defense

Bandwidth The capacity of a communication channel

Broadband
Fast communications medium using multiple bandwidth channels each operating on a particular range of frequencies

Browser A program that allows the reading of hypertext

Bulletin Board System (BBS) A networked notice board

CCTV Closed-Circuit Television, generally used for surveillance

Cybernetics The study of control and communication in systems

Flash A file format for delivering graphics and animation over the Web

HTML Hypertext Mark-up Language, the basic coding language for web pages

Hypertext Text linked by nodes allowing navigation from one document, or part of a document, to another

GIF Graphics Interchange Format, a standard for compressed digital images

GNU Open Source Unix software designed by Richard Stallman: the acronym is a recursive joke, standing for GNU's Not Unix.

GUI Graphical User Interface. An interface that uses graphics as well as text, familiar on the Macintosh and Windows machines.

ICANN The Internet Corporation for Assigned Names and Numbers

Intranet A network with similar resources to the Internet, used within a particular organisation

IP Internet Protocol, providing the fragmentation, routing and reassembly of data that is the basis of online communication

IPO Initial public offering, a company's first sale of stock to the public.

ISDN High-speed data communications line

ISP Internet Service Provider

Java A programming language for the Internet allowing for the running of programs

LETS Local Exchange Trading System, alternative trading systems which avoid the use of money but allow greater flexibility than barter

Linux The Open Source version of the operating system, Unix

NAFTA North American Free Trade Agreement (between the United States, Canada and Mexico)

NASDAQ National Association of Securities Dealers Automated Quotation system, a stock market index dominated by high-tech firms such as Intel and Microsoft.

Netizen Internet citizen

Open Source Software that is circulated as source code and so open to modification by users

Plug-in A file that 'plugs in' to an application, such as a browser, to add a function. Many web pages will not load without the appropriate plug-ins being installed.

Search engine A program that searches the Web, displaying and ranking the sites that it finds

Server A networked computer that provides services to other machines

Spam / Spammer
Junk emails / a sender of junk emails

URL Uniform Resource Locator, the standard form of web page addresses

VR Virtual Reality, immersive interactive computer environments

WAP Wireless Application Protocol, standard applications that use wireless access to the Internet, including mobile phones

WTO World Trade Organisation

WWW World Wide Web

Yahoo A widely used search engine

Zerography Photocopied material

Bibliography
All website addresses given in the text references are reproduced on the Tate's website at www.tate.org.uk/shop/internetart/ so that readers can click on the addresses to go directly to the relevant site. While the links were current at the time of writing, some will expire over time.

Books

Janet Abrams (ed.), *If/Then Play*, Netherlands Design Institute, Amsterdam 1999.

Theodor W. Adorno, *The Culture Industry: Selected Essays on Mass Culture*, ed. J.M. Bernstein, Routledge, London 1991.

Perry Anderson, *The Origins of Postmodernity*, Verso, London 1998.

Georges Bataille, *Visions of Excess: Selected Writings, 1927–1939*, ed. Allan Stoekl, University of Minnesota Press, Minneapolis 1985.

Jean Baudrillard, *Art and Artefact*, ed. Nicholas Zurbrugg, Sage, London 1997.

—, *Simulacra and Simulation*, trans. Sheila Faria Glaser, University of Michigan Press, Ann Arbor 1994.

Tilman Baumgärtel, *net.art – Materialien zur Netskunst*, Institut für moderne Kunst, Nürnberg 2000.

Michael Benedikt (ed.), *Cyberspace: First Steps*, The MIT Press, Cambridge, Mass. 1991.

Walter Benjamin, *The Arcades Project*, trans. Howard Eiland and Kevin McLaughlin, The Belknap Press of Harvard University Press, Cambridge, Mass. 1999.

—. *Illuminations*, ed. Hannah Arendt, Fontana, London 1973.

Tim Berners-Lee (with Mark Fischetti), *Weaving the Web: The Past, Present and Future of the World Wide Web by its Inventor*, Orion Business Books, London 1999.

Josephine Berry, *The Thematics of Site-Specific Art on the Net*, PhD thesis, University of Manchester, 2001; www.daisy.metamute.com/~simon/mfiles/mcontent/josie_thesis.htm

Emma Bircham and John Charlton (eds.), *Anti-Capitalism: A Guide to the Movement*, Bookmarks Publications, London 2001.

Josephine Bosma et al. (eds.), *Readme! Filtered by Nettime: ASCII Culture and the Revenge of Knowledge*, Autonomedia, Brooklyn 1999.

John E. Bowlt (ed.), *Russian Art of the Avant Garde: Theory and Criticism, 1902–1934*, Thames & Hudson, London 1988.

Frank Boyd et al. (eds.), *New Media Culture in Europe*, Uitgeverij de Balie/The Virtual Platform, Amsterdam, 1999.

Maria Brewster (ed.), *Supermanual: The Incomplete Guide to the Superchannel*, FACT, Liverpool [n.d.]

Susan Buck-Morss, *The Dialectics of Seeing: Walter Benjamin and the Arcades Project*, The MIT Press, Cambridge, Mass. 1989.

Hans-Jörg Bullinger et al. (eds.), *Net Art Guide*, Fraunhofer IRB Verlag, Stuttgart 2000.

Peter Bürger, *Theory of the Avant-Garde*, trans. Michael Shaw, Manchester University Press, Manchester 1984.

Pierre Cabanne, *Dialogues with Marcel Duchamp*, trans. Ron Padgett, Thames & Hudson, London 1971.

Manuel Castells, *The Information Age: Economy, Society and Culture*, Blackwells, Oxford:
vol.I: *The Rise of the Network Society*, 1996
vol.II: *The Power of Identity*, 1997
vol.III: *End of the Millennium*, 1998.

Michel de Certeau, *The Practice of Everyday Life*, trans. Steven Rendall, University of California Press, Berkeley 1984.

Noam Chomsky, *World Orders, Old and New*, Pluto Press, London 1994.

Vuk Cosic, *Net.art Per Me*, MGLC, [no place of publication] 2001.

Critical Art Ensemble, *The Electronic Disturbance*, Autonomedia, Brooklyn 1994.

Sean Cubitt, *Digital Aesthetics*, Sage, London 1998.

Catherine David and Jean-François Chevrier (eds.), *Politics-Poetics: Documenta X–The Book*, Cantz Verlag, Ostfildern-Ruit 1997.

Mike Davis, *Magical Urbanism: Latinos Reinvent the US City*, Verso, London 2000.

Richard Dawkins, *The Selfish Gene*, Oxford University Press, Oxford 1976.

Gilles Deleuze and Félix Guattari, *A Thousand Plateaus: Capitalism and Schizophrenia*, trans. Brian Massumi, The Athlone Press, London 1988.

Mark Dery, *Escape Velocity: Cyberculture at the End of the Century*, Hodder & Stoughton, London 1996.

John Downey and Jim McGuigan (eds.), *Technocities: The Culture and Political Economy of the Digital Revolution*, Sage Publishers, London 1999.

Timothy Druckrey and Ars Electronica (eds.), *Ars*

Electronica: Facing the Future: A Survey of Two Decades, The MIT Press, Cambridge, Mass. 1999.

Terry Eagleton, The Illusions of Postmodernism, Blackwell, Oxford 1996.

EZLN, Crónicas intergal cticas EZLN: Primer Encuentro Intercontinental por la Humanidad y contra el Neoliberalismo, Planeta Tierra, Chiapas 1996.

Hal Foster, The Return of the Real: The Avant-Garde at the End of the Century, The MIT Press, Cambridge, Mass. 1996.

Michel Foucault, Language, Counter-Memory, Practice: Selected Essays and Interviews, ed. Donald F. Bouchard, Cornell University Press, Ithaca, NY 1977.

Thomas Frank and Matt Weiland (eds.), Commodify Your Dissent: Salvos from The Baffler, W.W. Norton & Co., New York 1997.

Bill Gates with Nathan Myhrvold and Peter Rinearson, The Road Ahead, revised ed., Penguin Books, London 1996.

Stephen Graham and Simon Marvin, Telecommunications and the City: Electronic Spaces, Urban Places,

Routledge, London 1996.

Clement Greenberg, The Collected Essays and Criticism. Volume 1, Perceptions and Judgements, 1939–1944, ed. John O'Brian, University of Chicago Press, Chicago 1986.

Katie Hafner and Matthew Lyon, Where Wizards Stay Up Late: The Origins of the Internet, Simon and Schuster, New York 1996.

Michael Hardt and Antonio Negri, Empire, Harvard University Press, Cambridge, Mass. 2000.

Thomas B. Hess and Elizabeth C. Baker (eds.), Art and Sexual Politics, Collier Macmillan, New York 1973.

Eric Hobsbawm, Behind the Times: The Decline and Fall of the Twentieth-Century Avant-Gardes, Thames & Hudson, London 1998.

Ikon Gallery, Out of Here: Creative Collaborations Beyond the Gallery, Birmingham 1998.

Fredric Jameson, Postmodernism or, the Cultural Logic of Late Capitalism, Verso, London 1991.

——, Signatures of the Visible, Routledge, New York 1992.

Fredric Jameson and Masao

Miyoshi (eds.), The Cultures of Globalization, Duke University Press, Durham, NC 1998.

Steven Johnson, Interface Culture: How New Technology Transforms the Way we Create and Communicate, Basic Books, New York 1997.

Naomi Klein, No Logo: Taking Aim at the Brand Bullies, Flamingo, London 2000.

Ken Knabb (ed.), Situationist International Anthology, Bureau of Public Secrets, Berkeley 1981.

Steven Kovats (ed.), Ost-West Internet: Elektronische Medien im Transformationsprozess Ost und Mitteleuropas, Edition Bauhaus/Campus Verlag, Frankfurt 1999.

Ray Kurzweil, The Age of Spiritual Machines: How We Will Live, Work, and Think in the New Age of Intelligent Machines, Orion Business Books, London 1999

George P. Landow, Hypertext 2.0: The Convergence of Contemporary Critical Theory and Technology, The John Hopkins University Press, Baltimore 1997.

Kalle Lasn, Culture Jam: The Uncooling of America™,

Eagle Brook, New York 1999.

Hannes Leopoldseder and Christine Schöpf (eds.), Prix Ars Electronica 96, Springer Verlag, Vienna 1996.

Stephen Levy, Artificial Life: The Quest for a New Creation, Penguin Books, London 1992.

Peter Lunenfeld, Snap to Grid: A User's Guide to Digital Arts, Media and Cultures, MIT Press, Cambridge, Mass., 2000.

—— (ed.), The Digital Dialectic: New Essays on New Media, MIT Press, Cambridge, Mass. 1999.

John Maeda, Maeda@Media, Thames & Hudson, London 2000.

Lev Manovich, The Language of New Media, The MIT Press, Cambridge, Mass. 2001.

Herbert Marcuse, Technology, War and Fascism: Collected Papers of Herbert Marcuse, vol.I, ed. Douglas Kellner, Routledge, London 1998.

Marcel Mauss, The Gift: The Form and Reason for Exchange in Archaic Societies, trans. W.D. Halls, Routledge, London 1990.

Robert W. McChesney, Ellen Meiksins Wood and John Bellamy Foster (eds.), Capitalism and the

Information Age: The Political Economy of the Global Communication Revolution, Monthly Review Press, New York 1998.

Duncan McCorquodale, Lolita Jablonskiene and Julian Stallabrass (eds.), Ground Control: Technology and Utopia, Black Dog Publishing, London 1997.

Duncan McCorquodale, Naomi Siderfin and Julian Stallabrass (eds.), Occupational Hazard: Critical Writing on Recent British Art, Black Dog Publishing, London 1998.

George McKay (ed.), DIY Culture: Party & Protest in Nineties Britain, Verso, London 1998.

William J. Mitchell, City of Bits: Space, Place and the Infobahn, The MIT Press, Cambridge, Mass. 1995.

László Moholy-Nagy, The New Vision, Wittenborn, New York 1947.

Lewis Mumford, Art and Technics, University of Columbia Press, New York 1952.

Janet H. Murray, Hamlet on the Holodeck: The Future of Narrative in Cyberspace, The MIT Press, Cambridge, Mass. 1997.

John Naughton, A Brief History of the Future: The Origins of the Internet, Weidenfeld and Nicolson, London 1999.

Nicholas Negroponte, Being Digital, Hodder & Stoughton, London 1995.

Theodor Holm Nelson, Literary Machines, Swathmore, Pa. 1981

New Museum of Contemporary Art, Sots Art, New York 1986.

Patricia Pisters and Catherine M. Lord (eds.), Micropolitics of Media Culture: Reading the Rhizomes of Deleuze and Guattari, University of Amsterdam Press, Amsterdam 2001.

Raymond Queneau, Cent mille milliards de poèmes, Gallimard, Paris 1961.

Eric S. Raymond, The Cathedral and the Bazaar: Musings on Linux and Open Source by an Accidental Revolutionary, O'Reilly, Sebastapol, CA 1999.

Howard Rheingold, The Virtual Community: Finding Connection in a Computerized World, Secker & Warburg, London 1994.

D.N. Rodowick, Reading the Figural, or, Philosophy After the New Media, Duke University Press, Durham, NC 2001.

Richard Rogers (ed.), Preferred Placement: Knowledge Politics on the Web, Jan van Eyck Akademie Editions, Maastricht 2000.

David Ronfeldt, John Arquilla, Graham E. Fuller and Melissa Fuller, The Zapatista Social Netwar in Mexico, RAND, Santa Monica 1998.

Andrew Ross (ed.), No Sweat: Fashion, Free Trade, and the Rights of Garment Workers, Verso, London 1997.

Theodore Roszak, The Cult of Information: A Neo-Luddite Treatise on High-Tech, Artificial Intelligence and the True Art of Thinking, University of California Press, Berkeley 1994.

Greg Ruggiero and Stuart Sahulka (eds.), Zapatista Encuentro: Documents from the 1996 Encounter for Humanity and Against Neoliberalism, Seven Stories Press/Open Media, New York 1998.

Saskia Sassen, Losing Control? Sovereignty in an Age of Globalization, Colombia University Press, New York 1996.

Dan Schiller, Digital Capitalism: Networking the Global Market System, The MIT Press, Cambridge, Mass. 1999.

Amy Scholder and Jordan Crandall (eds.), Interaction: Artistic Practice in the Network, Distributed Art Publishers, New York 2001.

Claude E. Shannon and Warren Weaver, The Mathematical Theory of Communication [1949], University of Illinois Press, Urbana 1998.

David Sheff, Game Over: Nintendo's Battle to Dominate an Industry, Hodder & Stoughton, London 1993.

Tsutomu Shimomura with John Markoff, Takedown, Martin Secker & Warburg, London 1996.

V.A. Shiva, Arts and the Internet: A Guide to the Revolution, Allworth Press, New York 1996.

Peter Singer, A Darwinian Left: Politics, Evolution and Cooperation, Weidenfeld & Nicolson, London 1999.

Chris Smith, Creative Britain, Faber and Faber, London 1998.

Julian Stallabrass, Gargantua: Manufactured Mass Culture, Verso, London 1996.

——, High Art Lite: British Art in the 1990s, Verso, London 1999.

Gerfried Stocker and Christine Schöpf (eds.), InfoWar, Springer, Vienna 1998.

Allucquère Rosanne Stone, *The War of Desire and Technology at the Close of the Mechanical Age*, The MIT Press, Cambridge, Mass. 1995.

Leon Trotsky, *The History of the Russian Revolution*, trans. Max Eastman, Pluto Press, London 1977.

Sherry Turkle, *Life on the Screen: Identity in the Age of the Internet*, Weidenfeld and Nicolson, London 1996.

Peter Weibel and Timothy Druckrey (eds.), *net_condition: Art and Global Media*, The MIT Press, Cambridge, Mass., 2001.

Ludwig Wittgenstein, *Philosophical Investigations*, trans. G.E.M. Anscombe, Basil Blackwell, Oxford 1978.

Chin-tao Wu, *Privatising Culture: Corporate Art Intervention Since the 1980s*, Verso, London 2001.

Slavoj Žižek, *The Plague of Fantasies*, Verso, London 1997.

Nicholas Zurbrugg, *Critical Vices: The Myths of Postmodern Theory*, G+B Arts International, Amsterdam 2000.

Articles

Robert Atkins, 'The Art World and I Go On Line', *Art in America*, vol.83, no.12, Dec. 1995, pp.58–65.

——, 'State of the (On-line) Art', *Art in America*, vol.87, no.4, April 1999, pp.89–95.

Richard Barbrook, 'The Holy Fools: Mute Mix', *Mute*, no.11, 1998, pp.57–65.

Caroline Bassett, 'With a Little Help from our (New) Friends', *Mute*, no.8, Winter 1997, pp.46–9.

Alex Bellos, 'Digital Hope in the Slums', *Guardian*, 18 Nov. 1999, Online section, pp.16–17.

Josephine Berry, '"Another Orwellian Misnomer?" Tactical Art in Virtual Space', *Inventory*, vol.4, no.1, 2000, pp.58–83.

——, 'Do as they do, not as they do', *Mute*, no.16, 2000, pp.22–3.

——, 'The Unbearable Connectedness of Everything', *Telepolis*, 28 Sept. 1999.

Julian Borger, 'Workers' Rights "Abused in the US"', *Guardian*, 30 Aug. 2000.

Josephine Bosma, 'Is it Commercial? Nooo… Is it Spam? Nooo – it's Net Art!', *Mute*, no.10, 1998, pp.73–4.

Finn Bowring, 'LETS: An Eco-Socialist Initiative?', *New Left Review*, no. 232, Nov.–Dec. 1998, pp.91–111.

Vannevar Bush, 'As We May Think', *Atlantic Quarterly*, July 1945; also at www.theatlantic.com/ unbound/flashbks/computer/ bushf.htm

John Cassy, 'Etoys Files for Bankruptcy', *Guardian*, 28 Feb. 2001.

Ron Chepesiuk, 'Where the Chips Fall: Environmental Health in the Semiconductor Industry', *Environmental Health Perspectives*, vol.107, no.9, Sept. 1999.

Marlena Corcoran, 'Digital Transformations of Time: The Aesthetics of the Internet', *Leonardo*, vol.29, no.5, 1995, pp.375–8.

Salvador Dalí, 'De la beauté terrifiante et comestible de l'architecture modern'style', *Minotaure*, nos.3–4, 1933, pp.69–75.

Douglas Davis, 'The Work of Art in the Age of Digital Reproduction (An Evolving Thesis: 1991–1995)', *Leonardo*, vol.28, no.5, pp.381–6.

Mark Dery, 'Critical Art Ensemble', *Mute*, no.10, 1998, pp.24–33.

Leon Forde, 'Roadmaps for the Superhighway', *Guardian*, Online section, 29 June 2000.

Sean Dodson, 'Galleries Go for the Virtual Show', *Guardian*, Online section, 2 March 2000.

K. Eric Drexler, 'Hypertext Publishing and the Evolution of Knowledge', originally published in *Social Intelligence*, vol.1, no.2, pp.87–120; online version at www.foresight.org

Ken Feingold, 'Error 404: File Not Found', *Leonardo*, vol.30, no.5, 1997, pp.449–50.

Matthew Fuller, 'Ten Reasons Why the Art World Loves Digital Art', *Mute*, no.11, 1998, pp.26–7.

Michael Gibbs, 'I Can't Find It', *Art Monthly*, no.238, July–Aug. 2000, p.60.

John Gittings, 'China Blocks Internet Explosion', *Guardian*, 27 Jan. 2000.

——, 'Shanghai Noon', *Guardian*, Online section, 24 Aug. 2000.

Rachel Greene, 'Web Work: A History of Internet Art', *Artforum*, vol.38, no.9, May 2000, pp.162–7, 192.

Jörg Heiser, 'Palmreading: Does Money Grow on Trees?', *Frieze*, no.49, 1999, p.53.

Reena Jana, interview with David Ross, *Flash Art*, Jan.–Feb. 1999, pp.34–5.

Bill Joy, 'Why the Future Doesn't Need Us', *Wired*, April 2000.

Paul Kelso and Guy Adams, 'As One in Four Homes Go Online, the Country's Digital Divide Widens', *Guardian*, 11 July 2000.

Jamie King, 'Alongside Us, Them', *Mute*, no.15, 1999, p.17.

J.J. King, 'Bringing it all Back Home: Life on the New Flesh Frontier', *Mute*, no.12, 1998, pp.49–53.

Joseph Licklider, 'Man-Computer Symbiosis', *IRE Trans-actions on Human Factors in Electronics,* vol.HFE-1, March 1960, pp.4–11.

Geert Lovink, 'From Speculative Theory to Net Criticism', *Mute*, no.8, 1997, supplement, pp.1–2.

Neil McInstosh, 'ICANN Cause Confusion', *Guardian*, Online section, 23 Nov. 2000.

Frédéric Madre, 'The Net.Art Money-Go-Round', *Mute*, no.12, 1998, pp.18–19.

Kevin Maguire, 'UK Workforce Attacks Amazon', *Guardian*, 14 April 2001.

Jane Martinson, A Media Giant Caught in the Web', *Guardian*, 11 Jan. 2000.

Stuart Millar, 'Gaming Industry Warned to Think Bigger',

Guardian, 7 July 2001.

Matthew Mirapaul, 'Putting a Price Tag on Digital Art', *New York Times*, 19 Nov. 1998.

Glyn Moody, 'Free Software Survives Downturn', *Guardian*, Online section, 10 Jan. 2002.

Ewan Morrison, 'Ten Reasons Why the Art World Hates Digital Art', *Mute*, no.11, 1998, pp.23–5.

Geoffrey Nunberg, 'The World Wise Web', *Guardian Editor*, 14 April 2000.

Jane Prophet, 'Sublime Ecologies and Artistic Endeavors: Artificial Life and Interactivity in the Online Project *Technosphere*', *Leonardo*, vol.29, no.5, 1996, pp.339–44.

Christa Sommerer and Laurent Mignonneau, 'Art as a Living System: Interactive Computer Artworks', *Leonardo*, vol.32, no.3, 1999, pp.165–73.

Julian Stallabrass, 'Formas de la identidad en el ciberespacio' [Being Yourself in Cyberspace], *Revista de Occidente*, no.206, June 1998, pp.77–97.

Ravi Sundaram, 'The Nineteenth Century and the Future of Technocultures', *Mute*, no.11, 1998, pp.46–51.

——, 'Recycling Modernity:

Pirate Electronic Cultures in India', *Third Text*, no.47, Summer 1999, pp.59–65.

Peter Schaeur, 'Keeping Net Art Live' [interview with Alex Galloway], *Art Newspaper*, no.113, April 2001.

Eugene Thacker, 'SF, Technoscience, Net.art: The Politics of Extrapolation', *Art Journal*, vol.59, no.3, Fall 2000, pp.64–73.

Bill Thompson, 'Can we Keep the Internet Mutual?', *Guardian*, Online section, 6 July 2000.

Jon Thomson, 'Old Tricks', *Art Monthly*, no.227, June 1999, pp.52–3.

Michael Tidmus, 'Anecdotal Evidence: A Survey of Hypercard Computer Projects', *Leonardo*, vol.26, no.5, 1993, pp.397–404.

Mylene Van Noort, 'Has the Tate Gone Too Far?', *Guardian*, Online section, 25 May 2000.

Norbert Wiener, *Cybernetics: or Control and Communication in the Animal and the Machine*, Wiley, New York 1948

Gary Wolf, 'The Curse of Xanadu', *Wired*, June 1995; www.wirednews.com

Chin-tao Wu, 'Embracing the Enterprise Culture: Art Institutions Since the 1980s',

New Left Review, no.230, July–Aug. 1998, pp.28–57.

Paul Zelevansky, 'Shopping on the Home Image Network', *Art Journal*, vol.56, Fall 1997, pp.46–54.

First published 2003 by order of the Tate
Trustees by Tate Publishing, a division of Tate
Enterprises Ltd, Millbank, London SW1P 4RG
www.tate.org.uk

British Library Cataloguing in Publication Data
A catalogue record for this book is available from
the British Library

ISBN 1 85437 345 5

Distributed in the United States and Canada by
Harry N. Abrams, Inc., New York

Library of Congress Cataloging in Publication Data
Library of Congress Control Number: 2002104371

Designed by Untitled
Printed by Snoeck-Ducaju & Zoon, Ghent, Belgium